Canon® EOS Digital Rebel Digital Field Guide

Charlotte K. Lowrie

WILEY

Wiley Publishing, Inc.

Canon® EOS Digital Rebel Digital Field Guide

Published by
Wiley Publishing, Inc.
111 River Street
Hoboken, N.J. 07030
www.wiley.com

Copyright © 2005 by Wiley Publishing, Inc., Indianapolis, Indiana

Published simultaneously in Canada

ISBN-13: 978-0-7645-8813-6
ISBN-10: 0-7645-8813-3

Manufactured in the United States of America

10 9 8 7 6 5 4 3 2

1K/QW/QW/QV/IN

For general information on our other products and services or to obtain technical support, please contact our Customer Care Department within the U.S. at (800) 762-2974, outside the U.S. at (317) 572-3993 or fax (317) 572-4002.

Wiley also publishes its books in a variety of electronic formats. Some content that appears in print may not be available in electronic books.

Library of Congress Control Number: 2005923201

WILEY is a trademark of Wiley Publishing, Inc.

About the Author

Charlotte Lowrie is an award-winning freelance journalist and professional photographer based in the Seattle area. She was the managing editor of MSN Photos for more than four years, and is currently the managing editor of Photoworkshop.com's *Double Exposure* online magazine. In addition, she writes for several newsstand photography magazines and Web sites. She shoots commercial and editorial assignments as well as stock photography. She is also the author of *Teach Yourself Visually Digital Photography*, 2nd Edition, also published by John Wiley & Sons.

You can see more of her work at www.wordsandphotos.org.

Credits

Acquisitions Editor
Michael Roney

Project Editor
Cricket Krengel

Technical Editor
Calvin Wong

Copy Editor
Kim Heusel

Editorial Manager
Robyn Siesky

Vice President & Group Executive Publisher
Richard Swadley

Vice President & Publisher
Barry Pruett

Project Coordinator
Maridee Ennis

Graphics and Production Specialists
Jonelle Burns
Lauren Goddard
Denny Hager
Jennifer Heleine
Lynsey Osborn
Amanda Spagnuolo

Quality Control Technician
John Greenough
Jessica Kramer
Brian H. Walls

Cover Design
Michael Trent

Proofreading and Indexing
Vicki Broyles
Arielle Mennelle
Rebecca R. Plunkett

This book is dedicated with love to my children, Bryan and Sandra, and my son-in-law, Scott, who through the years have showed amazing patience and given me tremendous support as I pursued my passions for writing and photography.

Contents at a Glance

Contents

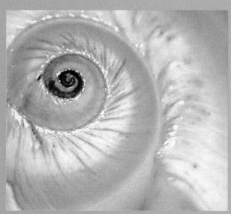

**Part II: Creating
Great Photos with
the Digital Rebel 59**

**Chapter 3: Photography
Basics 61**

Chapter 4: Let There Be Light 73

Chapter 5: The Art and Science of Lenses 83

Chapter 6: Techniques for Great Photos 93

Introduction

One of my favorite photographers, Henri Cartier-Bresson, said in his book *The Mind's Eye: Writings on Photography and Photographers,* "Of all means of expression, photography is the only one that fixes forever the precise and transitory instant. We photographers deal in things that are continually vanishing, and when they have vanished, there is no contrivance on earth that can make them come back again...for photographers, what has gone is gone forever."

In this quote, Cartier-Bresson encapsulated the immediacy of photography, its singular ability to capture a fleeting moment in time, and the need to capture moments before they're gone forever. Regardless of the subjects you most enjoy photographing, the ability to capture timeless moments is what photography, and this book, are about.

You may already have realized that the Digital Rebel makes digital photography easy and fun. But if you're ready to take the next step in using the camera and developing your skills as a photographer, this book will help you achieve both. I've packed the book with easy-to-use techniques — techniques that will help you make pictures like those you've seen and wished that you had taken.

It's All About Having Fun

Photography has always been fun. Digital photography makes it even more so. The Digital Rebel opens the door to limitless fun, practice, experimentation, and a creative freedom — freedom to try things that were too expensive to try with film photography or too advanced to try with a compact camera.

I encourage you to take the Digital Rebel to its creative limits. Don't worry if you don't have a large collection of lenses. For even complex photos, the lens that came with the camera is often enough to give you the range you need to get great results. And if you do have a bag full of lenses, you'll find great uses for them in this book.

In.1 An inexpensive, basic 50mm lens provides great results. Of course, a good subject helps, too.

As you use this book and try the photo projects, always remember that it is the photographer who makes the picture, not the camera — although having a camera as great as the Digital Rebel is definitely a plus.

Getting the Most from This Book

If you just can't wait to take some shots with your new Digital Rebel, the Quick Tour is exactly what you need. It takes you step-by-step through taking your first pictures and getting a finished product — whether it be for the Web, to print and frame, or just to e-mail to a friend. Once you've satisfied your curiosity by taking those first few shots, Chapters 1 and 2 take you on a detailed tour of camera features, functions, and setup procedures. You may already be familiar with some of the information, but it's worth browsing through the chapters with an eye toward anything that may be new. The strategy fills an important goal: helping you get to know the camera thoroughly. Ultimately, you want to get to know your camera so well that you can use it with confidence even in the dark.

Subsequent chapters review the basics of photography, light, and lenses. After years of working with all levels of photographers, I've found that many photography hobbyists know some, but not all of the basics of photography. These chapters can be a great foundation for beginners and a helpful refresher for more experienced photographers.

Most important, these chapters will help you understand how controls and functions on the Digital Rebel work together with your photography knowledge to make a picture. When you know how the exposure is made, you'll be much more confident when changing settings and knowing what results you can expect.

In.2 As you learn how the exposure elements work together, you'll be more confident in experimenting with camera settings.

After all the basics are covered, the book switches gears to discuss specific photography topics. Chapter 6 is rather long at first glance, but within its many pages, you will find a wealth of information aimed at helping you make the most of specific scenarios. It is broken down into popular photography subject categories ranging from portraits and travel to abstract and sports, each one providing do-it-yourself techniques for making the best possible pictures.

Within each subject topic, you'll find:

✦ Example photos

✦ Discussions about each type of subject

✦ Inspiring ideas for making pictures of these subjects

✦ A practice photo with specific information on how the picture was made including setup, lighting, lens, exposure mode and exposure settings, and helpful but optional accessories

✦ Composition and perspective pointers

Also scattered throughout the chapter are creative idea suggestions and techniques for handling difficult photography scenes. Finally, chapter 7 provides an overview of downloading, editing, and printing the pictures that you make.

Now is a great time to get started reading and shooting. The editor, the staff at Wiley, and I all hope that you'll enjoy using this book as much as we enjoyed creating it for you.

Quick Tour

Welcome to the world of digital SLR photography. Your new Canon Digital Rebel is a gateway into a creative world of visual fun and excitement.

The thought of taking pictures and getting them onto your computer may seem overwhelming if you're new to digital photography, but the Digital Rebel and new versions of image-editing software make the process much easier and faster. Not only will you have the fun of instant gratification, but you will also have a powerful tool to improve both your pictures and your photography skills. And you'll soon discover that the amount of control you have over the final image is unprecedented.

At this point, you should have already completed the essentials, such as attaching the lens, charging the battery, inserting a media card, and reading the manual. Once you've come that far, this Quick Tour will help you quickly get started using the Digital Rebel to take your first pictures and get them onto the computer.

Taking Your First Pictures

With the battery charged and inserted, the memory card inserted, and the lens attached, you're ready to set up the camera to take your first pictures.

To get a feel for the camera, you can set the camera to Full Auto by turning the Mode dial on top of the camera to the green rectangle, and then turn on the camera. In Full Auto mode, the camera sets all exposure settings for you, and you can use the Digital Rebel just as you would use a point-and-shoot camera.

Just press the shutter button halfway down — the shutter button is located on the top right of the camera — to focus on a subject. The camera finds the subject closest to the camera, chooses the appropriate autofocus points (displayed in the

◆ ◆ ◆ ◆

In This Chapter

Take your first pictures

Setting up the Digital Rebel

Basic Zone shooting

Creative Zone shooting

Setting the autofocus point

Setting the Metering mode

Transferring images to the computer

◆ ◆ ◆ ◆

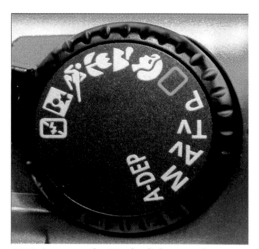

The images you take are displayed briefly on the LCD. To scroll through pictures, press the Playback button, shown in figure QT.2, which is located on the left side of the camera, and then press the left and right arrow keys to move through pictures (shown in figure QT.3).

Once you have a feel for the camera, you can spend some time setting up the camera.

Setting Up the Digital Rebel

QT.1 Just turn the Mode dial to set the Exposure mode that you want to use. Full Auto mode is a good starting point.

Setting up the Digital Rebel is simple, and requires only a few basic steps to get started.

viewfinder as a dot within a rectangle), and focuses on the subject. Now, press the shutter button down the rest of the way. In Full Auto mode, the Digital Rebel records JPEG images at the default camera settings. If the light is low, the Digital Rebel automatically pops up and fires the built-in flash. That's how easy taking your first picture is with the Digital Rebel.

QT.2 The Playback button on the Digital Rebel.

QT.3 You can use the left and right arrow keys to scroll through pictures that you're playing back. The arrow keys shown here are from the EOS 300.

Set the date and time

Setting the date and time provides a handy record that you can use to recall when pictures were taken and that you can use to help organize pictures on the computer.

To set the date and time, follow these steps.

1. **Press the Menu button on the back of the camera.**

2. **Press the right-arrow key to select the Set-up 1 tab.**

3. **Press the down arrow key to select Date/Time.** The Date and Time screen appears.

Tip *Never open the media card slot door while the access light is lit. The access light shows that the camera is recording the last picture you took to the media card. Opening the media card slot door results in losing the image being recorded.*

Cross-Reference *For an overview of camera controls, see Chapter 1.*

4. **Press the Set button to save the entry and move to the next item.**

5. **Press the up- or down-arrow keys to make changes.**

6. **Repeat Steps 4 and 5 for each date and time entry.**

7. **Press the Set button.** Do not press the Set button until you are finished changing the options.

8. **Press the Menu button to close the menu.**

Set the image recording quality

The file format and quality level used to take your pictures is one of the most important decisions you make. These settings ultimately determine not only the number of images you can store on the media card, but also the sizes at which you can later enlarge and print images from the EOS Digital Rebel. The better the image quality you choose, the larger the print you can make.

 Cross-Reference *For an overview image quality settings, see Chapter 2.*

To set the image recording quality follow these steps.

1. **Press the Menu button on the back of the camera.** The Shooting menu is displayed.

2. **Press the down arrow key to select Quality.**

3. **Press the Set button.** A drop-down menu appears.

4. **Press the down-arrow key to select the option you want.**

5. **Press the Set button again.**

6. **Press the shutter button halfway down to return to shooting mode.**

Set the ISO

The ISO setting determines how sensitive the Digital Rebel image sensor is to light.

The higher the ISO number, the more sensitive the sensor is to light and the less light that's needed to make a picture.

 Cross-Reference *For an overview of ISO, see Chapter 3. For an overview of camera controls, see Chapter 1.*

To set the ISO, follow these steps:

1. **Choose a Creative Zone mode with the Mode dial.**

Note *If you are not sure which Creative Zone mode to choose, see the section later in the Quick Tour where each of these modes is briefly explained.*

2. **Press the ISO button.**

3. **Turn the Main dial to select the ISO.** Watch the LCD panel so you can select the setting you want.

 If you have a Rebel XT, when you press the ISO button, the ISO speed menu appears on the monitor. Press the down or up arrow key to select the ISO that you want, and press the Set button.

Set the white balance

White-balance settings tell the camera the type of light that is in the scene so that the camera can render white and other colors accurately.

To change the white balance, follow these steps:

1. **Press the WB (White Balance) button on the back of the camera.**

2. **As you watch the LCD panel, turn the Main dial until the setting that matches the light in the scene is displayed.**

3. **Half-press the shutter button to return to shooting mode.**

 On the Rebel XT when you press the WB (White Balance) button on the back of the camera, the White balance menu appears on the monitor. Press the arrow keys to choose a setting that matches the light in the scene, press the Set button, and then press the shutter button to return to shooting.

Basic Zone Shooting

For easy and quick shooting, you can choose one of the Basic Zone modes. These modes are grouped together on the Mode dial with symbols that depict the type scene they are best suited for. For example, Portrait mode is denoted by the image of a person's head.

In Basic Zone modes, all you do is set the camera to the type of scene that you're shooting, and the camera automatically sets the exposure for you — very much like many point-and-shoot cameras. Focus the camera on the subject by pressing the shutter button halfway down, and then depress it fully to take the picture.

 For an overview of camera controls, see Chapter 1.

The Digital Rebel offers these Basic Zone modes:

✦ Full Auto

✦ Portrait

✦ Landscape

✦ Close-up

✦ Sports

✦ Night Portrait

✦ Flash off

Creative Zone Shooting

Creative Zone modes offer automatic, semi-automatic, or manual control over some or all exposure settings. Some of these modes are similar to the mode settings on film SLR cameras. Using different Creative Zone modes, you can determine whether the background is sharp or blurred, and whether action is frozen or shown as a blur.

 For a complete discussion of Creative Zone modes, see Chapter 1.

The following list introduces the Creative Zone modes and presents a brief summary of how to use each one.

✦ **Program AE.** This is displayed as P on the Mode dial and is a fully automatic, but *shiftable* mode. Shiftable means that you can change programmed exposure by changing (or shifting) either the shutter speed or aperture while the camera automatically adjusts the other setting to maintain the same or equivalent exposure. Turn the Mode dial to P, focus on the subject by pressing the shutter button

halfway down. Then press the shutter button fully to take the picture.

✦ **Shutter-priority AE.** This is displayed on the Mode dial as TV (Time value). In this mode, you set the shutter speed, and the camera automatically chooses an appropriate aperture. Turn the mode to TV, and then turn the Main dial to set the shutter speed. Focus on the subject by pressing the shutter button halfway down. Then press the shutter button fully to take the picture.

✦ **Aperture-priority AE.** This is displayed on the mode dial as Av (Aperture value). This mode allows you to set the aperture (f-stop) to control depth of field while the camera automatically chooses the appropriate shutter speed. Turn the mode to Av, and then turn the Main dial to set the aperture (f-stop). Focus on the subject by pressing the shutter button halfway down. Then press the shutter button fully to take the picture.

✦ **Manual exposure.** This is displayed on the Mode dial as M. Turn the mode to M and turn the Main dial to set the shutter speed. Then press and hold the Aperture/Exposure (Av) compensation button on the back of the camera while turning the Main dial to set the aperture (f-stop). Focus on the subject by pressing the shutter button halfway down. Then press the shutter button fully to take the picture.

✦ **Automatic depth of field.** This mode, displayed on the Mode dial as A-DEP, automatically calculates the best depth of field between near and far subjects. Turn the mode to A-DEP, focus on the subject by pressing the shutter button

halfway down. Then press the shutter button fully to take the picture. In A-DEP mode the camera chooses aperture and shutter speed. By pressing the Av button and turning the Main dial you can change the overall exposure.

To switch to a Creative Zone mode, turn the Mode dial to the mode you want.

Setting the Autofocus Point

The Digital Rebel offers seven autofocus points that allow you to focus on the subject whether the subject is in the center of the frame or off-center. Selecting an autofocus point allows you to set the sharpest point of focus in the image.

 On the Rebel XT, you can also set the Autofocus mode.

 Autofocus mode is covered in more detail in Chapter 1.

In Basic Zone modes, the camera automatically selects the Autofocus point. You can select the Autofocus point in all Creative Zone modes except A-DEP.

To select the autofocus point, follow these steps.

1. **Set the Mode dial to a Creative Zone mode.**

2. **Press the AF point selection button on the back of the camera.**

3. **Turn the Main dial to rotate through the Autofocus points until the Autofocus point you want is highlighted in the viewfinder.**

Setting the Drive Mode

The Drive mode determines whether you can shoot one image at a time, or shoot several images in rapid sequence. The Digital Rebel has three drive modes that are appropriate in different shooting situations: Single, Continuous, and Self-timer/Remote control.

You can set the Drive mode when you're shooting in one of the Creative Zone modes.

To change Drive modes, follow these steps.

1. **Watch the LCD panel as you press the Drive mode button on the top of the camera.**

 The Drive mode button is located on the back of the Rebel XT.

2. **Cycle through the three drive modes by pressing the Drive mode button mode repeatedly until the mode you want is displayed in the LCD panel.**

Setting the Metering Mode

To make a good exposure, the camera has to know the amount of light that illuminates the subject or scene. The camera's built-in light meter measures the amount of light in the scene, and, based on the ISO, the camera calculates the aperture and shutter speed combinations required to make the exposure.

The Digital Rebel has three metering options that differ by the amount of the subject the meter measures to calculate exposure. The metering modes are:

* **Evaluative.** This metering mode analyzes light from virtually the entire viewfinder area.

* **Partial.** This metering mode meters from the centermost nine percent of the screen.

* **Center-weighted Average.** This metering mode includes light from the entire viewfinder but gives more weight to the area within the center five AF points.

In Basic Zone modes, the Digital Rebel automatically uses the evaluative metering mode. In Creative Zone modes the camera uses evaluative metering but the user can change to Partial metering by using Autoexposure lock.

On the Rebel XT, you can set the Metering mode in Creative Zone modes.

To learn more about Metering modes, see Chapter 1.

Transferring Images to the Computer

Before you transfer images to your computer, be sure you have installed the Canon Solution Disk. The disk includes programs for viewing, organizing, and editing your images.

The easiest way to download images is to use a card reader. A card reader is a small, inexpensive device that plugs into the computer with a USB cable. When you're ready to download images, you insert the media card into the card-reader slot.

After installing the card reader according to manufacturer recommendations, follow these steps to download images.

1. **Remove the CF card from the camera and insert it face-up into the card reader, pushing firmly to seat the card.**

2. **On the Windows desktop, double-click My Computer.**

3. **In the list of Devices with Removable Storage, double-click the icon for the CF card.** The card reader appears in the list as a Removable Disk.

4. **Drag the DCIM folder to the computer's hard drive.** You can also double-click the DCIM folder to display and drag individual image files to a folder on the hard drive.

5. **Start the Canon ZoomBrowser EX program and open the folder that contains the images you downloaded.**

Once you have the pictures on the computer, you can display an image as the desktop background image on your screen, and you can create a slideshow of images, share photos in e-mail or on photo Web sites, and create your own Web site.

In addition, many Web sites have groups of people who use the Digital Rebel and share experiences, tips, and photos. Be sure to check out the Appendix for a list of the most popular Web sites and additional resources for getting the most from your Digital Rebel.

Using the Digital Rebel

P A R T

I

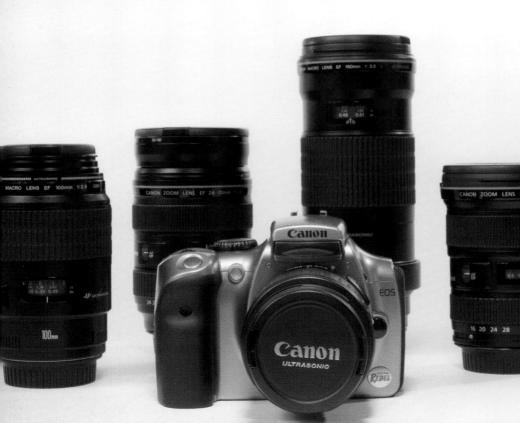

Exploring the Digital Rebel

Any professional photographer knows that the most important first step in photography is learning the camera so thoroughly that he or she can operate it blind-folded. Then you can make camera adjustments instinctively and confidently without missing a shot.

You may not think that you'll need to know your camera that well, but knowing your camera inside and out not only instills confidence, but it allows you to react quickly and get those important brag-book shots that you might otherwise miss or wish had been better.

Because of the design, the EOS Digital Rebel makes mastering the camera easy and fun. Body controls translate into ease of use, while the full-function features offer exceptional creative control. And internally, Canon's high-resolution CMOS (complementary metal-oxide semiconductor) sensor dependably delivers vivid, crisp images, especially at the highest image-quality settings.

Camera and Lens Controls

remember that the more you use the camera, the faster you'll master it.

The following sections will help you achieve the goal of mastering the Digital Rebel. And

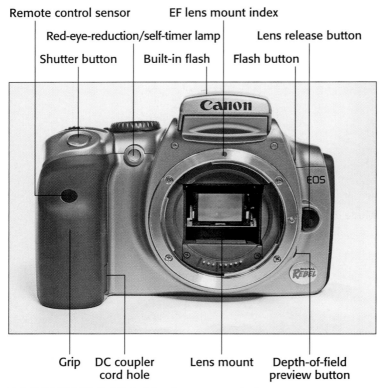

Remote control sensor
EF lens mount index
Red-eye-reduction/self-timer lamp
Lens release button
Shutter button
Built-in flash
Flash button

Grip
DC coupler cord hole
Lens mount
Depth-of-field preview button

1.1 EOS 300 Digital Rebel front camera controls.

Drive mode selection button

Power switch Hot shoe

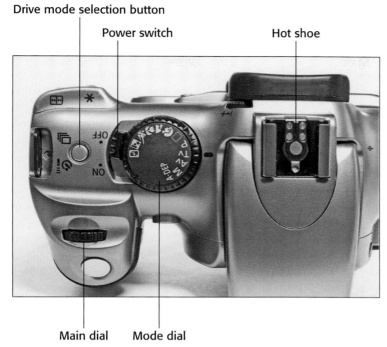

Main dial Mode dial

1.2 Digital Rebel top camera controls.

Lens mount index Zoom ring 58mm filter thread

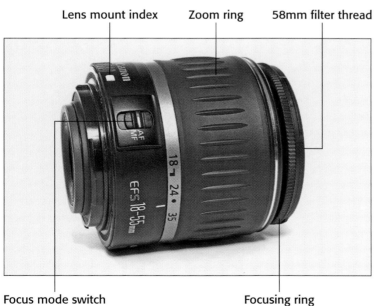

Focus mode switch Focusing ring

1.3 Lens controls.

Rear Camera Controls

You will use the rear camera controls most often. The Digital Rebel offers shortcut buttons that are handy for making quick adjustments as you're shooting. In particular, the WB (white balance), ISO, Menu, and AF (Auto Focus) selector are handy for making quick changes.

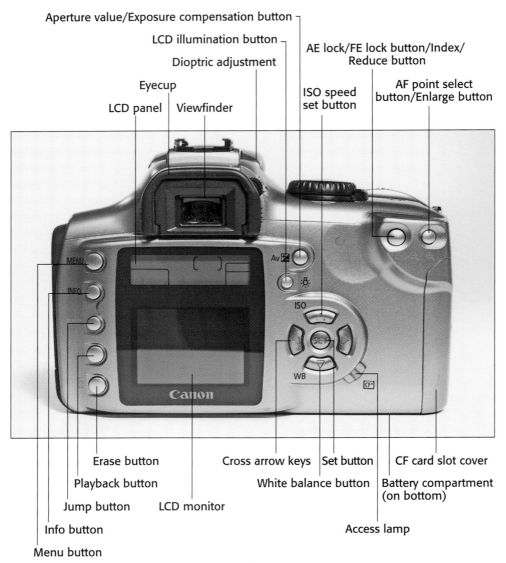

Aperture value/Exposure compensation button

LCD illumination button

Dioptric adjustment

Eyecup

LCD panel Viewfinder

AE lock/FE lock button/Index/ Reduce button

ISO speed set button

AF point select button/Enlarge button

Erase button

Playback button

Jump button LCD monitor

Info button

Menu button

Cross arrow keys Set button

White balance button

Access lamp

CF card slot cover

Battery compartment (on bottom)

1.4 Rebel XT Digital Rebel rear camera controls.

The LCD

An advantage of digital photography is obviously the ability to immediately view an image on the LCD monitor after it is taken. At the top of the LCD monitor area is a panel that shows everything you need to know about exposure settings, frames remaining, battery status, and camera settings.

Tip Some information on the LCD panel and in the viewfinder is only displayed for about 5 seconds. It can be restored by a tap on the shutter button.

LCD Panel

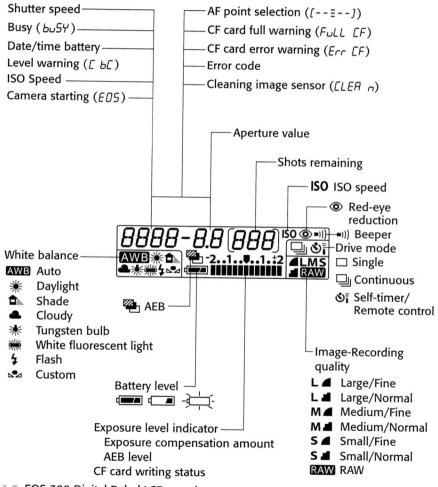

Shutter speed
Busy (*buSY*)
Date/time battery
Level warning (*C bC*)
ISO Speed
Camera starting (*EOS*)

AF point selection (*[--Ξ--]*)
CF card full warning (*FuLL CF*)
CF card error warning (*Err CF*)
Error code
Cleaning image sensor (*CLEA n*)

Aperture value

Shots remaining

ISO ISO speed

⊚ Red-eye reduction

•))) Beeper

Drive mode
☐ Single
🔲 Continuous
🕐 Self-timer/ Remote control

White balance
AWB Auto
☀ Daylight
⌂ Shade
☁ Cloudy
☀ Tungsten bulb
☀ White fluorescent light
⚡ Flash
🖐 Custom

AEB

Image-Recording quality
L ◢ Large/Fine
L ◢ Large/Normal
M ◢ Medium/Fine
M ◢ Medium/Normal
S ◢ Small/Fine
S ◢ Small/Normal
RAW RAW

Battery level

Exposure level indicator
Exposure compensation amount
AEB level
CF card writing status

1.5 EOS 300 Digital Rebel LCD panel.

Viewfinder Display

On the Digital Rebel, the optical viewfinder displays approximately 95 percent of the image that the sensor captures. In addition to displaying the scene you're shooting, the viewfinder displays the aperture and shutter speed, flash readiness level, and frames remaining during continuous shooting.

Auto Focus (AF) points are etched in the focusing screen. If you manually change AF points, the viewfinder highlights AF points as you rotate the Main dial. If the camera automatically selects the AF point, the selected point is displayed in red on the focusing screen when you press the Shutter button halfway down.

To ensure that the viewfinder image and focusing screen elements are adjusted for your vision, you can adjust the diopter from -3 to +1 dpt. Simply move the diopter switch, located to the right of the viewfinder eyecup, up or down until the image in the viewfinder is sharp.

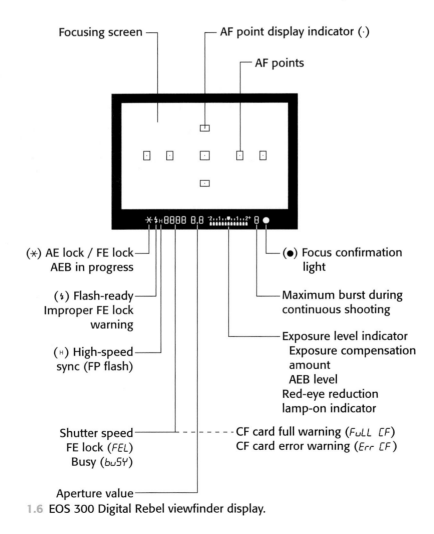

Focusing screen —

AF point display indicator (·)

AF points

(✳) AE lock / FE lock
AEB in progress

(✦) Flash-ready
Improper FE lock
warning

(ʜ) High-speed
sync (FP flash)

Shutter speed
FE lock (FEL)
Busy (buSY)

Aperture value

(●) Focus confirmation
light

Maximum burst during
continuous shooting

Exposure level indicator
Exposure compensation
amount
AEB level
Red-eye reduction
lamp-on indicator

CF card full warning (FuLL CF)
CF card error warning (Err CF)

1.6 EOS 300 Digital Rebel viewfinder display.

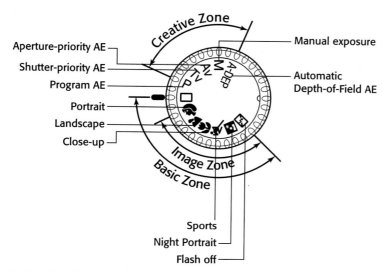

Aperture-priority AE
Shutter-priority AE
Program AE
Portrait
Landscape
Close-up

Manual exposure
Automatic Depth-of-Field AE

Sports
Night Portrait
Flash off

1.7 Digital Rebel mode dial.

Mode Dial

The Mode dial is divided into two sections: the Basic Zone and the Creative Zone. The Basic Zone includes modes designated by icons, including Full Auto mode (designated by a green rectangle) and scene-specific modes as shown in figure 1.7.

On the other side of the dial is the Creative Zone indicated by letter abbreviations. In these modes you have either partial or full control over camera settings. This means that you can control depth of field, how subject motion is shown in the image, white-balance, and AF point selection. Creative Zone modes range from semiautomatic and Manual modes to a fully automatic but "shiftable" Program mode, which is described in detail later in this chapter.

Programmed Modes

Exposure is determined by, among other settings, the ISO, shutter speed, and aperture

whether set by you or the camera. In Canon's programmed modes, the camera automatically sets all of the settings but you can provide some control over the way the picture looks by specifying the type scene you're shooting.

Basic Zone modes

For quick shooting, the Basic Zone modes are a great choice because you only set the camera to the type scene that you're shooting, and the camera automatically sets the exposure for you.

For example, if you're taking a portrait and you want a softly blurred background, selecting Portrait mode sets a wide aperture (f-stop), which allows the subject in the foreground to be sharp, but blurs the background. For even faster shooting, you can use Full Auto mode to have the camera set everything.

In Basic Zone modes, the camera automatically sets the Image quality to JPEG,

although you can select the level of JPEG quality. The camera also automatically selects the Auto-focus mode, metering mode, ISO, white balance, focus, drive, and flash modes.

Full Auto mode

In Full Auto mode, the Digital Rebel automatically sets all settings. Because the camera does everything, this is a good mode to use for quick snapshots. However, this is not always true because the camera defaults to using the flash, even in scenes where you may not want to use the flash.

> **Tip** *Remember that in all modes, the lens you choose enhances your creative control.*

In Full Auto mode, the camera automatically sets:

✦ AI focus with automatic auto-focus point (AF) selection. This means that the camera automatically switches between One-Shot AF and AI Servo AF based on the subject movement or lack of movement.

✦ Single-shot (one-image-at-a time) drive mode.

✦ Automatic flash.

> **Note** *See Table 1.2 in this chapter for more information on each of these settings.*

Portrait mode

In Portrait mode, the Digital Rebel sets a wide aperture (small f-stop number) that makes the subject stand out against a softly blurred background. In Portrait mode, the camera automatically sets:

✦ One-shot autofocus and automatic auto-focus point (AF) selection.

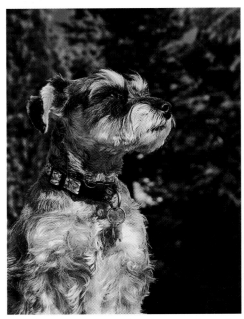

1.8 This picture was taken in Portrait mode and shows excellent sharpness in the subject's face and body against a blurred background, which helps emphasize the subject. For this image, taken at ISO 100, the camera's automatic exposure was f/8 at 1/200 second.

✦ Continuous drive mode so that shots can be taken continuously.

✦ Automatic flash with the option to turn on red-eye reduction.

> **Tip** *To enhance the effect of bringing the subject out of the background that Portrait mode provides, you can use a telephoto lens or have the subject move farther from the background.*

As with other programmed modes, you can use scene-specific modes for a variety of other types of subjects. For example, Portrait mode works well for nature and still-life photos indoors and outdoors. If the camera detects insufficient light, the flash fires automatically.

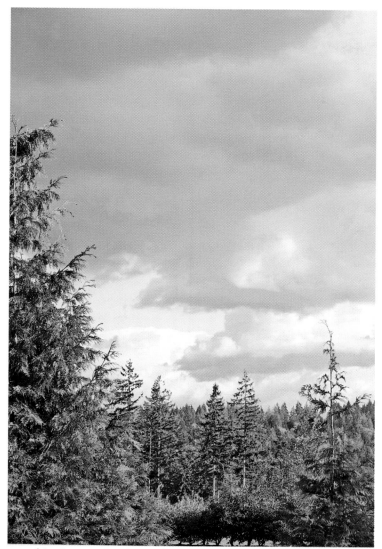

1.9 This picture taken in Landscape mode shows excellent sharpness back to front. Taken at ISO 100, the camera set at f/10 at 1/200 second.

Landscape mode

In Landscape mode, the Digital Rebel chooses a narrow aperture (narrow f-stop) to ensure that both background and foreground elements are sharp and the fastest shutter speed possible depending on the amount of light in the scene. As it does in all modes, the camera evaluates the light in the scene to determine the settings.

In lower light, the camera uses slower shutter speeds to maintain a narrow aperture for good depth of field. As the light fades, watch

1.10 This picture was taken in Close-up mode. The Digital Rebel automatically chose f/5.0 at 1/320 second at ISO 100 for this exposure.

the viewfinder or LCD panel to monitor the shutter speed. If the shutter speed is 1/30 second or slower, or if you're using a telephoto lens, be sure to steady the camera on a solid surface or use a tripod. In Landscape mode, the camera automatically sets:

✦ One-shot autofocus and automatic auto-focus point (AF) selection.

✦ Single-shot drive mode.

✦ Flash-off mode.

Close-up mode

In Close-up mode, the Digital Rebel allows a close focusing distance. You can enhance the close-up effect further by using a macro lens. If you're using a zoom lens, zoom to the telephoto end of the lens.

All lenses have a minimum focusing distance that varies by lens. For the best images, focus at the lens's minimum focusing distance. In Close-up mode, the camera automatically sets:

✦ One-shot autofocus with automatic auto-focus point (AF) selection.

✦ Single-shot drive mode.

✦ Automatic flash with the option to turn on red-eye reduction.

Sports mode

In Sports mode, the Digital Rebel freezes subject motion by setting a fast shutter speed. While this mode is designed for action and sports photography, you can use it in any scene where you want to suspend motion.

In this mode, the Digital Rebel automatically focuses on the moving subject and tracks the subject until good focus is achieved. If you continue to hold the shutter button down, the camera maintains focus for continuous shooting. In Sports mode, the camera automatically sets:

✦ AI Servo autofocus with automatic auto-focus point (AF) selection. In AI Servo AF, the focus tracks a moving subject, and exposure is set when the picture is taken.

✦ Continuous drive mode. For continuous shooting on the EOS 300D, a maximum of four shots can be taken. On the Rebel XT, the continuous burst rate depends on the image quality settings: On JPEG (Large/Fine), the maximum is 14, on RAW, the maximum is five shots, and on RAW + JPEG, the maximum is four shots.

✦ Flash off.

Night Portrait mode

In Night Portrait mode, the Digital Rebel combines flash with a slow synch speed to correctly expose both the person and the background. With a longer exposure such as this, it's important that the subject remain still during the entire exposure to avoid blur. Be sure to use a tripod or set the camera on a solid surface to take night portraits.

This mode is best used when people are in the picture rather than for general night shots

because the camera blurs the background somewhat as it does in Portrait mode. For night scenes without people, use Landscape mode and a tripod. In Night Portrait mode, the camera automatically sets:

✦ One-shot autofocus with automatic auto-focus point (AF) selection.

✦ Single-shot drive mode.

✦ Automatic flash with the ability to turn on red-eye reduction.

Flash off mode

In Flash off mode, the Digital Rebel does not fire the built-in flash or an external Canon Speedlite regardless of how low the scene light is. In low-light scenes using Flash off mode, be sure to use a tripod. In Flash off mode, the camera automatically sets:

✦ AI autofocus with automatic auto-focus point (AF) selection. This means that the camera automatically switches between One-Shot AF and AI Servo AF based on the subject movement or lack of movement, and the camera automatically selects the auto-focus point.

✦ Single drive mode.

✦ Flash off.

 Tip *You can easily change to any of the Basic Zone modes: turn the Mode dial to Full Auto or one of the Basic Zone modes, press the Shutter button halfway down to focus, and take the picture.*

Creative Zone modes

Creative Zone modes offer automatic, semiautomatic, or manual control over some or all exposure settings. Aptly named, this zone includes two automatic modes, P Program AE and A-DEP, which offer creative opportunities not found in the automatic Basic Zone modes. The three remaining Creative Zone modes, Tv Shutter-priority AE, Av Aperture-priority AE, and Manual exposure mode, put full or partial creative control in your hands. These exposure modes are very similar to the mode settings that you may have used on film SLR cameras.

P Program AE mode

Program AE, shown as P on the Mode dial, is a fully automatic but shiftable mode.

How is Program Mode Different from Full Auto Mode?

In both Program and Full Auto modes, you can change the program that is comprised of the shutter speed and aperture settings. However, on the Rebel XT, Program mode also allows you to set the following functions that you can't set in Full Auto mode. Some of these are also selectable in Program mode on the EOS 300D.

✦ **Shooting settings:** AF mode and point selection, drive mode, metering mode, program shift, exposure compensation, AEB, AE lock using the button on the back of the camera, depth-of-field preview, clear all camera settings, Custom Function and Clear All Custom Functions, and sensor cleaning.

✦ **Built-in flash settings:** Flash on/off, FE lock, flash exposure compensation.

✦ **Image-recording settings:** RAW, RAW+Large JPEG selection, ISO, white balance, custom white balance, white balance correction, WB bracketing, color space, and processing parameter.

Shiftable means that you can change pro-grammed exposure by changing or shifting the shutter speed or aperture. The camera automatically adjusts other settings to main-tain the same or equivalent exposure.

Note *To learn about exposures and maintaining the same, or equiv-alent, exposure, see Chapter 3.*

This is a handy option that allows you to con-trol depth of field and shutter speed with a minimum of adjustment. Say that the camera sets the aperture at f/8, but you want to soften background using a wide aperture. You can turn the Main dial to shift the pro-grammed exposure settings. For example, you can turn the Main dial to change to a wider aperture and the camera automatically adjusts the shutter speed to maintain the same overall exposure. The camera automat-ically adjusts shutter speed and other set-tings to maintain the same exposure value.

On the EOS 300D in Program AE mode, you can set the ISO, white balance, drive mode (single or continuous), and flash mode. The camera automatically sets the focus to AI to automatically switch between one-shot and AI Servo to track moving subjects. The cam-era also automatically sets the metering mode to Evaluative. It switches to Partial metering if you use AE (auto-exposure) lock.

On the Rebel XT in Program AE mode, you can select all set-tings.

If 30 and the maximum lens aperture, or 4000 and the minimum lens aperture blink in the viewfinder, it indicates an underexpo-sure and overexposure, respectively. In these instances, you can increase or decrease the ISO accordingly.

Note *To learn about ISO settings, see Chapter 3.*

To switch to Program AE (P) mode, follow these steps.

1. **Turn the Mode dial to P.** The Digital Rebel sets the aperture and shutter speed.

2. **To change the exposure, turn the Main dial until the aperture or shutter speed you want is displayed in the viewfinder.** You cannot shift the program if you're using the flash.

A-DEP mode

A-DEP, or Automatic Depth-of-Field, mode automatically calculates the optimum depth of field between near and far subjects. This is a handy mode for group photos when subjects are at staggered distances — one subject is close to the camera and the other subjects are each at farther distances from the camera. A-DEP mode uses seven AF points to detect near and far subject dis-tances and provide a wide depth of field to keep all subjects in sharp focus.

On the EOS 300D in A-DEP mode, you can select the ISO, white balance, drive mode (one shot at a time or continuous), flash mode. The camera automatically sets the autofocus to one-shot with auto-focus point selection, and the metering mode (Evaluative metering). Partial metering is used if AE lock is set.

On the Rebel XT in A-DEP mode, you can select all settings except auto-focus, which is automatically set to autofocus to one-shot with auto-focus point selection.

Cross-Reference *You can learn more about depth of field in Chapter 3.*

To change to Aperture-priority AE mode, fol-low these steps.

1. **Ensure that the lens is set to AF (autofocus).** The focus switch is located on the side of the lens.

2. **Turn the Mode dial to A-DEP.**

3. **Focus on the subject.** In the viewfinder, the focus points flash in red to show the subjects that are covered.

Av Aperture-Priority AE mode

Aperture-Priority AE mode, shown on the camera Mode dial as Av, allows you to set the aperture (f-stop) to control depth of field while the camera automatically chooses the appropriate shutter speed. Depth of field determines how much of the image is in reasonably sharp focus and is most often controlled by the aperture setting. A wide aperture such as f/4 provides a narrow depth of field that softly blurs the background. A narrow aperture, such as f/11 provides an extensive depth of field showing both foreground and background elements reasonably sharp.

 Note *To learn about aperture, see Chapter 3.*

For most day-to-day shooting, you'll care most about your ability to control the depth of field by quickly changing the aperture or f-stop. Aperture-priority AE mode gives you this control.

On the EOS 300D in Aperture-priority AE mode, you can control all settings except the auto-focus mode. The camera automatically sets the autofocus to AI to automatically switch between one-shot autofocus and AI Servo that tracks a moving subject but you can select the autofocus point. The camera also automatically sets the metering mode to Evaluative. If you use auto-exposure (AE) lock the camera switches to Partial metering.

 On the Rebel XT in Aperture-priority AE mode, you can set all settings.

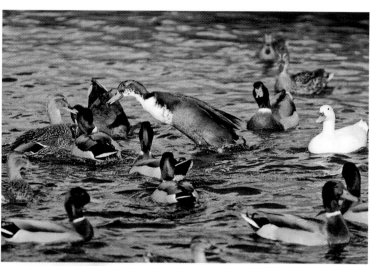

1.11 Using aperture-priority mode allowed me to both freeze the ducks arguing over food and blur the surrounding ducks and background to isolate the subjects. The exposure for this image was ISO 100 at f/4.0, 1/2000 second.

Tip *You can preview the depth of field for an image by pressing the depth-of-field preview button on the front of the camera. When you press the button, the lens diaphragm closes to the aperture you've set so you can see the range of acceptable focus.*

Tip *If you choose to use this mode, just remember to check the shutter speed in the viewfinder, and if it is 1/30 second or slower, or if you're using a telephoto lens, be sure to use a tripod.*

To change to Aperture-priority AE mode, follow these steps.

1. **Turn the Mode dial to Av.**

2. **Turn the Main dial to the aperture you want.** Aperture values are displayed in the viewfinder and LCD in 1/3-stop increments such as 5.6, 6.3, 7.1, and so on. The higher the f-number, the smaller the aperture, and the greater the depth of field will be. The smaller the f-number, the larger the aperture and the less the depth of field.

3. **Press the shutter halfway down to focus on the subject.** The Digital Rebel sets the shutter speed automatically. Then take the picture.

Tv Shutter-Priority AE mode

Shutter-Priority AE mode, shown as Tv on the Mode dial, allows you to set the shutter speed and control whether subject motion is frozen or shown as a blur. In this mode, you set the shutter speed and the camera automatically chooses an appropriate aperture. Setting a fast shutter speed freezes motion while setting a slow shutter speed shows motion blur.

The shutter speeds you can choose from depend on the light in the scene. In low-light

scenes without a flash, you may not be able to get a fast enough shutter speed to freeze the action.

Note *To learn about shutter speeds, see Chapter 3.*

This is also a good mode to use in low-light scenes when you want to ensure that the shutter speed is fast enough to hand-hold the camera and still prevent blur from camera shake.

On the EOS 300D in Shutter-priority AE mode, you can control all settings except the auto-focus mode. The camera sets the auto-focus to AI to automatically switch between one-shot autofocus and AI Servo that tracks a moving subject but you can select the autofocus point. The camera also automatically sets the metering mode to Evaluative. If you use auto-exposure (AE) lock, the camera switches to Partial metering.

XT *On the Rebel XT in aperture-priority AE mode, you can set all settings.*

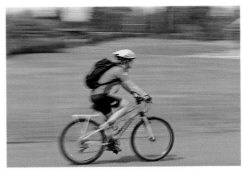

1.12 Using shutter priority set at 1/30 second blurs the motion of the biker in this image. The exposure was ISO 100 at f/22. In most situations you would use shutter-priority to freeze action in progress, but this image helps to illustrate that exposure modes are tools you can experiment with creatively.

For sports and other action scenes, Shutter-priority AE mode allows you to quickly change the shutter speed while the camera automatically chooses the aperture.

To change to Shutter-priority AE mode, follow these steps.

1. **Turn the Mode dial to TV.**

2. **Turn the Main dial to the shutter speed you want.** Aperture values are displayed in the viewfinder and LCD in 1/3-stop increments such as 125 that indicates 1/125 second or "0"6" that indicates 0.6 second. If the f-stop blinks, it means that a suitable aperture is not available at that shutter speed under the prevailing light conditions. You can switch to a higher ISO or a slower shutter speed.

3. **Press the shutter halfway down to focus on the subject.** The Digital Rebel sets the shutter speed automatically. Then take the picture.

Manual mode

Manual mode, as the name implies, allows you to set both the aperture and the shutter speed based on the light meter reading. However, because it takes more time to set all the exposure settings yourself, many people prefer to use semiautomatic modes such as Aperture-priority AE and Shutter-priority AE modes.

However, Manual mode is helpful in difficult lighting situations when you want to override the automatic settings the camera sets in either Av Aperture-Priority AE or Tv Shutter-Priority AE modes and in situations where you want consistent exposures across a series of photos such as for a panoramic series.

On the EOS 300D in Manual mode, you can set all settings except the auto-focus and metering modes. The camera automatically sets the autofocus to AI to automatically switch between one-shot autofocus and AI Servo that tracks a moving subject, but you can select the autofocus point. The camera also automatically sets the metering mode to Center-weighted Average metering but switches to Partial metering if auto-exposure (AE) lock is set.

 On the Rebel XT, you can set all settings.

To change to Manual mode, follow these steps.

1. **Turn the Mode dial to M.**

2. **Turn the Main dial to the shutter speed you want.**

3. **Press and hold the Aperture value (Av) button on the back of the camera, and then turn the Main dial to set the aperture you want.**

4. **Press the shutter halfway down to focus on the subject.** The Digital Rebel displays the exposure level icon in the viewfinder to show how far the exposure is from the standard exposure.

5. **Turn the Main dial to adjust the exposure to the standard level shown at the center mark on the meter scale, or to set the exposure above (to overexpose) or below (to underexpose) the standard exposure, and then take the picture.**

Metering Modes

To make a good exposure, the camera has to know the amount of light that illuminates the subject or scene. To determine this, the

camera's light meter measures the amount of light in the scene, and, based on the ISO, the camera calculates the aperture and shutter speed combinations required to make the exposure.

Most cameras, including the Digital Rebel, use a meter that measures light reflected from the subject back to the camera. Reflective light meters assume that all scenes have an average distribution of light, medium, and dark tones. When calculating exposure, the meter also assumes that the average of all tones in the scene will be medium or 18 percent gray. And, in average scenes, the meter is correct and produces a nicely exposed image.

But in non-average scenes, such as those with predominately light or dark tones, the meter continues to average tones to medium gray. In a snow scene, the result is gray snow. Conversely, in a scene with a large expanse of dark water, the camera produces gray water. In all scenes, the camera averages tone to medium gray.

In addition, you will care more about correctly exposing the subject than the background. For example, if you're making a portrait in bright light or in backlighting, you want the subject's skin tones properly exposed, and you don't care as much about the background. That's when a meter reading on a small part of the scene, such as the subject's face, provides the most accurate reading for exposure. In traditional photography, a spot meter, a meter that reads from a very small area of the subject, is the best tool for this job. On the Digital Rebel, the equivalent of a spot meter is the Partial metering mode.

On the EOS 300D, Partial metering is available in all Creative Zone modes with auto-exposure (AE) Lock, discussed later in this chapter.

The Rebel offers three metering modes that are differentiated by the size of viewfinder area that the meter uses to take the reading. While you cannot manually switch among metering modes, it's helpful to know which metering mode the camera selects with each exposure mode. For example, if you want to use Center-weighted Average metering mode, you can switch to Manual mode. With any Creative Zone mode you can engage partial metering by setting the AE Lock, discussed later in this chapter, in any of the Creative Zone modes.

Evaluative metering

Evaluative metering, the default metering mode on the Digital Rebel, analyzes light from virtually the entire viewfinder area. Canon's 35-zone Evaluative metering system is linked to the autofocus system. The meter analyzes the point of focus and automatically applies compensation if surrounding areas are much lighter or darker than the point of focus. To determine exposure, the camera analyzes subject position, brightness, background, front- and backlighting, and camera orientation.

On the EOS 300D, Evaluative metering mode is the default for all Basic and Creative Zone modes except Manual which uses Center-weighted Average metering.

 On the Rebel XT, you can select Evaluative, Partial, or Center-weighted Average metering in all Creative Zone modes.

Evaluative metering produces excellent exposures in average scenes that include a distribution of light, medium, and dark tones. In scenes where there is a large expanse of predominately light or dark areas, the metering will average the tones to middle gray thereby rendering snow scenes and large expanses of dark water as gray. In these situations, it's

good to use exposure compensation to increase or decrease exposure by one to two stops for scenes with predominately light or dark tones respectively.

Center-weighted Average metering

Center-weighted Average metering gives more weight to the area of the scene within the center five AF points in the viewfinder. Then the camera averages the reading for the entire scene. This is the default metering mode in Manual mode on the EOS 300D.

1.13 Because this image was taken in Manual mode, the Digital Rebel chose Center-weighted Average metering. The lighting for this scene was mixed daylight and fluorescent. Using a 50mm lens, the exposure was ISO 100, f/5.6, at 1/15 second.

Center-weighted Average metering is selectable on the Rebel XT.

Partial metering

Partial metering meters from the center-most nine percent of the screen. The EOS 300D automatically switches to Partial metering in Creative Zone modes when you use AE lock.

On the Rebel XT, you can select Partial metering in any of the Creative Zone modes.

Partial metering is especially handy in back-lit or side lit scenes where you want to ensure that the main subject is properly exposed. For example, if you take a portrait of a person who is backlit, you can use Partial metering mode together with AE lock to ensure that the person's face is properly exposed.

Note

The Digital Rebel's exposure meter is sensitive to stray light that can enter through the viewfinder. If you're using the self-timer or you set the camera on a tripod in bright light but you don't keep your eye pressed against the viewfinder, then stray light entering the viewfinder can result in under-exposed images. When you don't have your eye firmly against the eyecup, be sure to use the viewfinder cover attached to the camera strap or cover the viewfinder with your hand.

On the Rebel XT, you can select Partial metering by pressing the Metering mode (left arrow) key on the back of the camera, use the up or down arrow keys to select the mode you want, and then press the Set button.

Exposure Compensation

Knowing that non-average scenes can fool the camera's meter, you can use exposure compensation to override the camera's default exposure in scenes that have large expanses of predominately light and dark tones, such as snow scapes and ocean or lake scenes. Exposure compensation resets the camera's standard exposure setting by the amount of compensation (in partial or whole f-stops) that you choose.

For example, if you're taking a picture of a snow scene, setting positive exposure compensation adds light to produce white snow instead of gray. In this situation, a positive compensation of +1 to +2 f-stops will do the trick.

Conversely in scenes with predominately dark tones, you can set a negative exposure compensation of -1 to -2 to get true dark tones.

On the EOS 300D, exposure compensation is set in 1/3-stop increments up to +/-2 stops.

On the Rebel XT, exposure compensation is set in 1/3- or 1/2-stop increments up to +/- 2 stops.

You can set exposure compensation by following these steps:

1. **Switch to any Creative Zone mode except Manual, and then press the Shutter button halfway down.** Holding the shutter half pressed is optional. If you release it and the exposure compensation indicator disappears, tap the shutter button to restore it.

2. **While looking in the viewfinder, press the Exposure compensation button on the back of the camera.**

3. **At the bottom of the viewfinder, watch the scale as you turn the Main dial.** To set a positive (right of the center mark) compensation, turn the Main Dial to the right. To set a negative (left of the center mark) compensation, turn the Main Dial to the left.

Exposure compensation remains in effect until you reset it back to the center mark in Step 3.

Auto Exposure Bracketing

Auto Exposure Bracketing (AEB), a favorite technique of photographers for years, is a way to ensure that at least one exposure in a series of three images is acceptable. With AEB turned on, you can take three pictures at three different exposures: one picture at the standard exposure, one picture at an increased (lighter) exposure, and another picture at a decreased (darker) exposure.

On the EOS 300D you can set AEB in 1/3-stop increments up to +/- 2 stops.

The Rebel XT also allows you to set AEB in 1/3-stop increments up to +/- 2 stops.

Auto Exposure Bracketing is extremely useful for getting the best exposure in tricky lighting. Figures 1-14, 1-15, and 1-16 show three bracketed exposures.

While bracketing isn't necessary in all scenes, it's a good technique to use in scenes that are difficult to set up or can't be reproduced, and in scenes with tricky lighting such as a landscape with a dark foreground and much lighter sky area. AEB can't be used with the flash or when the shutter is set to Bulb, a setting where the shutter remains open until you release the shutter button.

1.16 The third exposure-bracketed picture in the sequence increases exposure from the default meter reading. Here the Digital Rebel used ISO 100, f/5.6, at 1/100 second.

1.14 The first of three pictures showing an exposure-bracketed sequence beginning with the metered exposure from the camera. The picture was taken at ISO 100, f/5.6, 1/160 second.

Get Creative

AEB is handy because it produces three different exposures that you can combine in an image-editing program. For example, if a scene has wide differences in light and dark areas, the bracketed exposures help get better exposure of both extremes. In an image-editing program, you start with the standard exposure, layer the darker bracketed exposure to add detail in the highlights that may be missing in the standard image, and then layer the lighter bracketed exposure to reveal detail in shadow areas.

It's worthwhile to learn how AEB works in the different drive modes.

✦ In Continuous and Self-Timer modes, pressing the Shutter button once automatically takes three bracketed exposures.

✦ In Single Drive mode, you have to press the shutter three separate times to get the three bracketed exposures.

1.15 The second exposure-bracketed picture in the sequence decreases the exposure. Here the Digital Rebel used ISO 100, f/5.6, 1/250 second.

In either case, the camera takes the standard exposure first, the decreased exposure second, and then the increased exposure.

You can use AEB in concert with exposure compensation, an option where you set the camera to overexpose or underexpose from the metered exposure. However, AEB settings are temporary. If you change lenses, replace the CF card or battery, or turn off the camera, the AEB settings are cancelled.

Table 1.1 shows examples of AEB. Bracketing is set in 1-stop increments up for a total range of 2 stops.

On the EOS 300D, you can set AEB by following these steps:

1. **Press the Menu button on the back of the camera.** The Shooting tab menu is displayed.

2. **On the Shooting tab, press the down-arrow key, and select AEB.**

3. **Press the Set button.** The bracketing scale is activated.

4. **Rotate the Main dial or use the left/right arrow keys to select the bracketing amount in 1/3rd-stop increments.** Markers showing increased and decreased exposure settings are displayed on the scale.

5. **Press the Set button, and then press the Shutter button to begin shooting.** AEB is now set until you turn off the camera or change lenses or memory cards.

 To set AEB on the Rebel XT, follow the previous set of steps with these minor changes: In Step 2, you press the Shooting 2 tab. In Step 4, press the left or right arrow key to select the bracketing amount in 1/3rd-stop increments. Markers showing increased and decreased exposure settings are displayed on the scale.

You can turn off AEB by turning the camera off.

AE Lock

With the Digital Rebel, the exposure and the focus are locked simultaneously by pressing the Shutter button halfway down. However, there are times when you don't want to meter on the same area where you set the focus. For example, if a subject is lit by a spotlight, the brightest light may fall on the subject's forehead. Metering and setting the exposure for the brightest area will maintain detail in the brightest area, but that isn't where you want the focus. You want to focus on the subject's eyes. In short, you want to de-couple the focusing from the metering, and you can do this by using auto-exposure (AE) lock.

Table 1.1
Auto Exposure Bracketing

	f-stop	Shutter Speed
Standard exposure	f/5.6	1/125 second
Decreased exposure	f/5.6	1/250 second
Increased exposure	f/5.6	1/60 second

On the EOS 300D, AE lock can be used in Creative Zone modes. The camera then automatically switches to Partial metering.

 On the Rebel XT, AE lock can be used in Creative Zone modes, and you can select Evaluative, Partial, or Center-weighted Average metering.

On both the EOS 300D, you can set AE lock by following these steps.

1. **Focus on the part of the scene that you want exposed correctly, and then press the Shutter button halfway down.**

2. **Continue to hold the Shutter button halfway down as you press and hold the AE Lock button on the back of the camera.** An asterisk icon displayed in the viewfinder indicates that AE Lock is activated.

3. **Move the camera to recompose the shot and take the picture.** As long as you continue holding down the AE lock button, you can take additional pictures using the locked exposure.

 The previous set of steps also works to set the AE lock on the Rebel XT.

Evaluating Exposure

Getting an accurate exposure is critical to getting a good image, but you may be wondering how you can judge whether an image is accurately exposed at the time you take the picture. On the Digital Rebel, you can evaluate the exposure immediately after you take the picture by looking at the image histogram.

1.17 The histogram inset in this picture shows pixels crowded against the left side of the graph. This indicates that the image is underexposed in the shadow areas. Particularly with digital captures, underexposure obliterates shadow detail, increasing the chance of digital noise in the shadow areas.

1.18 In the histogram inset in this picture, pixels are crowded against the right side of the graph, which indicates that the image is overexposed. In this case, detail in the highlight areas is likely lost. And, as with film images, if the detail wasn't captured, it is gone forever.

1.19 In the histogram inset in this picture, pixels fill the tonal range, and the image maintains good detail in both the shadow and highlight areas.

If you're new to digital photography, the concept of a histogram may also be new. A histogram is a bar graph that shows grayscale brightness values in the image from black (level 0) to white (level 255) along the bottom. The vertical axis displays the number of pixels at each location.

Naturally, some scenes will cause a distribution of values that are weighted more toward one side of the scale or the other, specifically in scenes that have predominately light or dark tones. But in average scenes, the goal of good exposure is to have the values, or tones, with a fairly even distribution across the entire graph and, in most cases, to avoid having pixels crowded against the left or right side of the graph.

It is important to know that most of the tonal information or values in an image are contained in the brightest image tones, specifically the first and second f-stop of bright tones. As Michael Reichmann, publisher of Luminous Landscape, www. luminous-landscape.com, has reported, in an image with a five-stop dynamic range, the first two f-stops contain 2,152 values while the remaining three f-stops combined contain only 556 values.

This means that with RAW images, it's important to expose toward the right side of the histogram while still avoiding overexposure. In other words, check the histogram to ensure that the exposure maintains highlight detail (pixels should not be slammed against the left side of the graph), but also ensure that there is no empty space between the right edge of the histogram and where the pixels begin.

Make it a habit to press the Info button on the back of the Digital Rebel after you take a picture. This Info screen allows you to review the histogram, but it also has a high-light alert that flashes to show areas of the image that are overexposed (or areas that have no detail in the highlights). Based on this display, you can immediately evaluate the exposure and retake the picture if the highlights are blown or shadow areas are solid black (the pixels are pushed against the left side of the scale).

Focus and Autofocus Modes

In addition to achieving good exposure, the success of a picture also depends on getting crisp focus. In turn, provided that you keep the camera steady when you take the picture, getting tack-sharp focus depends on three factors: the resolving power of the lens (its ability to render fine details sharply), the resolution of the image sensor, and, if you print the image, the resolution of the printer.

And autofocus speed figures into the final image sharpness as well, especially for fleeting moments such as a child's expression or a sighting of an eagle. Autofocus speed depends on factors including the size of the lens and the speed of the lens focusing motor, the speed of the autofocus sensor in the camera, and how easy or difficult the subject is to focus on.

For most shooting situations, the Digital Rebel's wide-area AI (artificial intelligence) autofocus (AF) system—a system that is tied closely to the camera's drive modes—is fast and reliable. The EOS 300D automatically chooses one of three focusing modes: One-Shot AF, AI Servo AF, and AI Focus AF.

On the Rebel XT in Creative Zone modes, you can select the autofocus mode.

Although you cannot manually select a focus mode, knowing the modes the camera uses helps you understand what the camera is doing as you shoot. Table 1.2 shows which mode is selected in each drive and exposure mode.

 When the subject is moving and you are just taking single shots, AI Servo AF is a good mode to select on the Rebel XT. With predictive AF, the camera tracks the subject and predicts the focusing distance just before the picture is taken. If the auto-focus point is automatically selected, the camera uses the center AF point and tracks the subject as it moves across AF points. If the AF point is manually selected, the camera uses the selected AF point to track the subject. In this *mode during continuous shooting, it operates the same way while taking three fps.*

However, when set to One-Shot AF during continuous shooting, three frames per second (fps) is not executed.

 On the Rebel XT, you can set one of three AF modes in Creative Zone modes: one-shot AF for still subjects, AI Servo AF for moving subjects, or AI Focus AF that switches from One-shot AF to AI Servo AF automatically if subject movement is detected. With the lens set to auto-focus, press the AF (right arrow key button) on the back of the camera, and then press the up or down arrow key to change the AF mode. Then press the Set button.

Table 1.2
Autofocus and Drive Modes

Drive Mode	Focus Mode		
	One-Shot AF	**AI Servo AF**	**AI Focus AF**
Single shooting	In One-Shot AF mode, the camera must confirm accurate focus before you can take the picture. Once focus is achieved, it is locked as long as shutter is halfway pressed. Exposure is locked as well. This is the best mode for still subjects	In AI Servo AF, focus tracks a moving subject, and exposure is set when the picture is taken. This mode is used in the Sports Basic Zone mode.	The camera automatically switches between One-Shot AF and AI Servo AF based on the subject movement or lack of movement.
Continuous shooting	Same as single shooting during continuous shooting.	Same as single shooting with autofocus continuing during continuous shooting at 2.5fps on the EOS 300.	

Understanding Auto-Focus Point Selection

The EOS Digital Rebel uses a wide-area artificial intelligence (AI) Auto Focus (AF) system with seven auto-focus (AF) points. An AF point determines the area of the subject that will be in sharpest focus.

In Basic Zone modes, the camera automatically selects the appropriate AF point. You can select the AF point in all Creative Zone modes, except A-DEP mode.

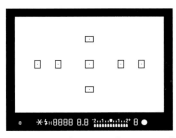

1-20 Seven AF points are shown on the focusing screen.

When no focus point is selected, the camera automatically determines the focus point by analyzing the scene and determining which AF point is over the closest part of the subject. The camera shows the selected AF point in the viewfinder.

While the autofocus system is reliable, it can fail if subjects are in low light, are low in contrast or monotone in color, or when other objects overlap the main subject. For this reason, be sure to confirm in the LCD that the camera selected the best autofocus point. If you still can't get sharp focus,

remember that you can quickly switch the lens to manual focus (MF) and turn the focusing ring manually to focus on low-contrast, dim, or monotone subjects.

In One-Shot AF, you cannot release the shutter until focus is established. In AI Servo AF, you can release the shutter whether or not the subject is in focus because the focus subsequently catches up with the subject's movement.

You can manually select the AF point, by following these steps:

1. **Set the Mode dial to any Creative Zone mode except A-DEP.**

2. **Press the AF Point Selector button on the back of the camera.** The currently selected AF point is displayed in the viewfinder and on the LCD panel.

3. **With the camera to you eye, turn the Main Dial until the AF point you want is highlighted in the viewfinder.** The camera moves through the AF points left, up, down, and to the right as you rotate the Main dial.

4. **Press the Shutter button halfway down to focus on the subject and lock the focus.**

5. **If necessary, continue to hold the Shutter button halfway down, and then move the camera to recompose the shot.**

 On the Rebel XT in Creative Zone modes, you can follow the same steps except in Step 3 you can also use the arrow keys to select the AF point.

Tip *In close focusing situations, and at times when the subject can't be reliably focused on with the auto-focus system, you can switch to MF by sliding the switch on the side of the lens to the MF position. Then you can focus by turning the lens focus ring.*

Set the Drive Mode

Drive modes determine how many shots the camera takes at a time. The Digital Rebel has three drive modes that are appropriate in different shooting situations: Single, Continuous, and Self-timer/Remote control.

In the Basic Zone, the Digital Rebel automatically chooses the drive modes.

You can select the drive mode in all Creative Zone modes.

Single-Shot mode

As the name implies, Single-Shot means that the Digital Rebel takes one picture each time you press the shutter-release button. In this mode on the EOS 300, you can take 2.5 frames per second (fps) (depending on shutter speed).

 On the Rebel XT, the camera's frame rate is 3 fps.

Setting a Custom Function on the Rebel XT

On the Rebel XT, Custom Functions provide the ability to set your favorite preferences and use them when you're shooting in Creative Zone modes. For example, in Custom Function 1 (C.Fn-1) you can choose to change the function of the Set button and arrow keys so they display the Image quality menu, display the Parameters menu, playback images, or allow you to set the AF point without pressing the AF point selection button. Other handy functions allow you to set long exposure with noise reduction, determine exposure compensation increments, set shutter curtain sync, and enable mirror lock up.

To set a Custom Function on the Rebel XT, follow these steps.

1. **Press the Menu button on the back of the camera.** The Shooting 1 menu appears.

2. **Press the right arrow key to select the Set-up 2 tab.** The Set-up 2 menu appears.

3. **Press the down arrow key to select Custom Functions (C.Fn), and then press the Set button.** The Custom Function screen appears.

4. **Press the up or down arrow key to select Custom Function No., and then press the Set button.** The Custom Function options are activated.

5. **Press the up or down arrow key to select the setting number that you want, and then press the Set button.** Repeat Steps 3 and 4 to set other Custom Functions.

6. **Press the Menu button to return to the menu.**

When you choose Single-Shot mode in one of the Creative Zone exposure modes, the camera automatically uses Single-Shot AF mode. When you choose Continuous mode, the camera automatically uses One-shot AF mode at 2.5 fps on the EOS 300D.

 On the Rebel XT, the camera uses One-shot AF mode and 3 fps.

Continuous mode

This mode allows continuous shooting of four sequential images on the EOS 300D and four images at a time.

Thanks to Canon's smart buffering capability, you don't have to wait for the buffer to empty all images to the media card before you can continue shooting. After a continuous burst sequence, the camera begins offloading pictures from the buffer to the card. As offloading progresses, you can take additional pictures.

To see the number of pictures that you can take during the buffer-offloading process, press the Shutter button halfway down and look for the number in the viewfinder.

Viewing and Playing Back Images

The ability to see the picture immediately after you take it is one of the crowning jewels of digital photography. On the Digital Rebel, you can not only view images after you take them, but you can also magnify images to verify that the focus is sharp, display multiple images stored on the memory card, display the image with a histogram showing the tonal distribution, display images as a slideshow, and display the image along with the exposure settings.

The following sections cover viewing options and suggestions on using each option.

Single-image playback

This is the default option that shows the image on the LCD briefly after you take the picture. Canon sets the initial display time to two seconds, hardly enough time to move the camera from your eye in time to catch the image preview. The display time is intentionally set to a short amount of time to maximize battery life, but given the excellent performance of the battery, a longer display time of four to eight seconds is more useful. You can also opt to set the Hold option to display the image until you dismiss it.

To turn on image review, press the Playback button on the back of the camera. If you have multiple pictures on the CF card, you can use the left and right arrow keys, or the Main Dial to move forward and back through the images.

If you want to change the amount of time images are displayed on the LCD, follow these steps:

1. **Press the Menu button on the back of the camera.** The Shooting menu is displayed.

2. **Press the right arrow key to select the Playback tab, and then press the down arrow key and select Review time.**

3. **Press the Set button.** The Review time options are activated.

4. **Press the down arrow key to select 2, 4, 8, or Hold.** The numbers indicate seconds that the image is displayed. Hold displays the image until you dismiss it by pressing the Shutter button.

Because image display tends to be a power-hungry task, use the Hold option cautiously.

5. **Press the Set button to confirm your settings, and then press the Shutter button to return to shooting.**

Index Display

The Index Display is an electronic version of a traditional contact sheet. Index Display shows tiny thumbnails of all images on the CF card. This display is handy when you need to ensure that you have a picture of everyone at a party or event, and it's handy as a way to quickly select a particular image on the media card when the card is full of images.

Tip *Anytime you want to see images on the LCD, just look for the buttons with blue icons or text on the back of the camera. These buttons display images or enable you to move among or magnify images.*

To turn on the Index Display, follow these steps:

1. **Press the Playback button on the back of the camera.**

2. **Press the AE/FE lock button on the back of the camera.**

3. **Press the arrow keys to move among the images.** The selected image has a green border.

4. **Press the Playback button to see a larger view of the selected image, or press the Enlarge button to magnify the image.** A rectangular cursor is displayed in this view. You can move the cursor using the arrow keys to view different areas of the magnified image.

Tip *You can press the JUMP button and the arrow keys to move forward or back nine images in the Index display. In full image display, you can press the JUMP button and the left or right arrow key to move to the first or last image on the card respectively.*

5. **Press the Shutter button to cancel the display.**

Auto playback

When you want to sit back and enjoy all the pictures on the CF card, the Auto Playback option plays a slide show of images on the card, displaying each one for three seconds. This is a cool option to use when you want to share pictures with the people you're photographing, or as a review to verify that you've taken all the shots you intended to take during a shooting session.

You can turn on Auto Playback by following these steps:

1. **Press the Menu button on the back of the camera, and then press the right arrow button to select the Playback tab.**

2. **Press the down arrow key to select Auto play.**

3. **Press the Set button.** Images are shown sequentially and in a continuous loop until you press the Shutter button to stop the slide show.

XT *On the Rebel XT, when you press the Set button, the Autoplay screen appears with a Loading Image message. When the images are loaded, Auto play begins. You can pause the display by pressing the Set button. Press the Set button again to resume Auto play.*

The Info button

During image playback, one of the most helpful features available is the Info button. Whether you're in Single-image, Index, or Auto play modes, you can press the Info button to display all of the exposure settings and see the image's histogram. As you learn to evaluate histograms, you'll appreciate this feature, and it will likely become an often-used playback option.

> **Note**
> *In these playback displays, you can use the JUMP button to move forward and back among images. A bar at the bottom of the LCD indicates the position of the image relative to all images on the CF card. When you use the Jump button combined with the left and right arrow keys, the display jumps nine images either way.*

The Info button is a toggle. Press it once to display the shooting information, and then press it again to return to the original playback display in all but Index display. You can use the arrow keys to move forward and back through pictures in this display as well.

Another especially useful playback option is the ability to magnify an image. Given the small size of the LCD display, magnification goes a long way in helping verify everything from focus to signs of digital noise.

To magnify an image in Single-image or Index playback displays, press the Enlarge button on the back of the camera. You can magnify from 1.5x to 10x, and use the arrow keys to scroll to different parts of the image.

To reduce the magnification, press the Reduce button. Or use the Main dial to scroll to the next image while maintaining the same image position and magnification level.

Erasing Images

Erasing images is a fine advantage only when you know without a doubt that you don't want the image you're deleting. From experience, however, I know that some images that appear to be mediocre on the LCD can very often be salvaged with some judicious image editing on the computer. For that reason, erase images with caution.

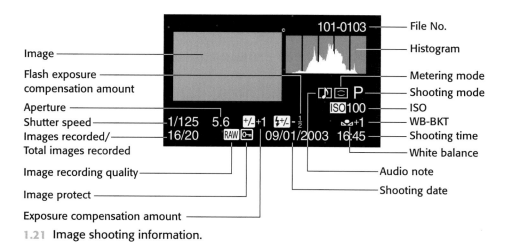

1.21 Image shooting information.

If you want to delete an image, follow these steps:

1. **Press the Playback button on the back of the camera and press the left and right arrow keys to select the picture you want to delete.**

2. **Press the Erase button, and then use the left and right arrow keys to select Erase (only the displayed image), All (all images on the CF card), or Cancel.**

3. **Press the Set button to erase the image or images.** When the access lamp stops blinking, lightly press the Shutter button to continue shooting.

Protecting Images

On the other end of the spectrum from erasing images is the ability to ensure that images that you want to keep do not get accidentally deleted. When you have that perfect or once-in-a-lifetime shot, apply protection to it so you can be sure it doesn't get erased.

Setting protection means that no one can erase the image when using the Erase or Erase All options.

 Caution *Even protected images are erased if you or someone else formats the CF card.*

You can protect an image by following these steps:

1. **Press the Playback button on the back of the camera.** The last image taken is displayed on the LCD.

2. **Press the left or right arrow key to move to the image you want to protect.**

3. **Press the Menu button on the back of the camera, and then press the right arrow button to select the Playback tab.**

4. **Press the down arrow key to select Protect, and then press the Set button.** A small key icon appears at the top of protected images. You can use the left and right arrow button to scroll to other images and press the Set button to add protection.

Using a Flash

Some people shy away from using an external or built-in flash because the light emitted by the flash tends to produce harsh, unnatural-looking illumination on the subject — or even worse, dark shadows behind the subject. Others avoid flash because it can often overexpose the subject, or, most commonly, it produces the dreaded red-eye effect in people and pets.

The Digital Rebel's built-in flash or an external Canon EX flash unit helps solve many of the common problems associated with flash photography, plus they both allow greater control over the final results than you may have had with other cameras. Tables in this section describe use of the flash in Creative Zone modes and in Basic Zone exposure modes that automatically activate the flash.

If you routinely use the built-in flash, be sure to know the range and capabilities of the flash. The range depends on the type of lens you use and the ISO. In general, the longer the focal length, the shorter the distance that the flash covers. And the higher the ISO, the farther the distance the flash illumination covers.

Why Flash Sync Speed Matters

Flash sync speed matters because if it isn't set correctly, only part of the image sensor has enough time to receive light while the shutter is open. The result is an unevenly exposed image. The Digital Rebel doesn't allow you to set a shutter speed higher than the 1/200 second flash sync speed, but in some modes, you can set shutter speeds slower than the sync speed as shown in the tables in this section.

And in regard to the dreaded red-eye, the high position of the flash unit combined with the Red-Eye Reduction option helps counteract but not eliminate this effect. Red-Eye Reduction is covered in more detail later in this chapter.

In fast-action scenes, be sure to not shoot faster than the flash can recycle which is approximately two seconds. The built-in flash is sufficient to cover a 28mm field of view, and the closest flash-to-subject distance is one meter or about three feet, three inches. The maximum flash-sync speed on the Digital Rebel is 1/200 second, which the camera sets automatically although in some exposure modes, you can set a slower shutter speed.

To ensure correct subject illumination, Canon has a flash-exposure (FE) lock that's available in Creative Zone exposure modes. The camera calculates and locks the correct exposure for any part of a subject you choose so that the subject's face, for example, isn't overexposed. FE lock is discussed in more detail later in this chapter.

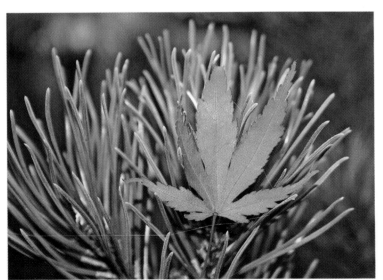

1.22 Using the flash in outdoor photos such as this improves the color and contrast, and it makes the subject stand out from the background.

In addition to the built-in flash, the Digital Rebel has a hot shoe for external Canon EX flash units. While the built-in flash is handy and performs well, an external flash offers creative options including bouncing and feathering the flash to produce flattering, soft lighting effects, fill-flash to reduce harsh shadows caused by bright overhead light, and fill light for areas in shadow.

 With the Rebel XT, the distances for the 18 to 55mm lens are slightly different.

 On the Rebel XT, you can set Custom Function 3 (C. Fn-3), Flash sync. Speed in Av mode to option 1: 1/200 second fixed.

 Tip *When you use the built-in flash, be sure to remove the lens hood first to prevent obstruction of the flash coverage. And if you use a fast, super-telephoto lens, the built-in flash coverage may also be obstructed.*

Tables 1.3 and 1.4 describe the behavior of the flash and the options in various exposure modes, the ranges of the flash, and flash sync speed and aperture settings.

Red-Eye Reduction

Long the bane of photographers of all skill levels, the red-eye effect has ruined many, many pictures. This ghoulish appearance of the eyes occurs when the light from the flash reflects off the back of the retina making the eyes appear red. Red-Eye Reduction fires a preflash that helps to decrease the diameter of the pupil and lessen the effect; however, it will not eliminate it entirely.

Table 1.3
Built-in Flash Range with the EF-S18-55mm Lens

ISO	18mm	55mm
100	*0.7-3.7m (2.3 to 12.1 ft.)	0.7 to 2.3m (2.3 to 7.5 ft.)
200	0.7 to 5.3m (2.3 to 17.4 ft.)	0.7 to 3.3m (2.3 to 10.8 ft.)
400	0.7 to 7.4m (2.3-24.3 ft.)	0.7 to 4.6m (2.3 to 15.1 ft.)
800	0.7 to 10.5m (2.3 to 34.5 ft.)	0.7 to 6.6m (2.3 to 21.6 ft.)
1600	0.7 to 14.9m (2.3 to 48.9 ft.)	0.7 to 9.2m (2.3 to 30.2 ft.)

Table 1.4
Flash Sync Speeds and Aperture Settings

Exposure Mode	Shutter Speed	Aperture
P & A-DEP	Auto (1/60 to 1/200 second)	Auto
Tv	Manual (30 seconds to 1/200 second)	Auto
Av	Auto (30 to 1/200 second)	Manual
M	Manual (Bulb or 30 seconds to 1/200 second)	Manual

You can use Red-Eye Reduction in all exposure modes except Landscape, Sports, and Flash-off modes. To turn on Red-Eye Reduction, follow these steps:

1. **Press the Menu button on the back of the camera.**

2. **On the Shooting menu, press the down arrow key to select Red-eye On/Off.**

3. **Press the Set key, and then press the down arrow key to select On.** Repeat this process to turn off Red-Eye Reduction, otherwise it is retained when the camera is turned off.

Tip *To reduce the appearance of red eyes, ask the subject to look slightly away from the camera and turn on additional lights. If you're using Red-Eye Reduction, ask the subject to look at the preflash lamp on the front of the camera, and then take the picture while the Red-Eye Reduction lamp indicator in the viewfinder is lit.*

FE lock

When you want precise flash exposure for a particular area of the subject, switch to a Creative Zone exposure mode and use FE lock. FE lock can also be used to increase or decrease flash intensity. For example, to

decrease flash intensity, point the camera to a white object or a subject that is closer to the camera. To increase flash intensity, point the camera at a dark or farther-away subject.

To use FE lock, follow these steps:

1. **Set the camera set to a Creative Zone mode, and then press the Flash button to pop up the built-in flash.**

2. **Focus on the subject by pressing the Shutter button halfway down.** Continue to hold the shutter during the next steps.

3. **Position the center of the viewfinder over the area of the subject where you want to lock flash exposure, and then press the FE lock button.** A preflash will fire and the FE lock icon will be displayed in the viewfinder.

4. **Reposition the camera to compose the shot and take the picture.**

Tip *In Manual mode, you can experiment with shutter speeds (1/200 second and slower) to lighten or darken the scene. The shutter speed controls the overall scene exposure and the aperture controls the flash exposure. Try experimenting with one or both settings to get the effect you want.*

Digital Rebel Setup

Setting up the Digital Rebel is the first step in getting pictures that you'll treasure from the camera to print and display for years to come. This chapter offers important pointers on setting up your Digital Rebel, but ultimately the best way to get great pictures from the Digital Rebel is to experiment with settings. Unlike paying for film and prints, the pictures you take with the Digital Rebel are "free." This gives you the freedom to explore different camera settings until you get pictures with the color, saturation, and contrast that's pleasing to your eye and that creates vibrant prints.

Many people are afraid that changing camera settings will "mess up" the pictures they're getting, and that they will forget how to reset the camera if they don't like changes they've made. Canon provides a reset option, which means that you can always revert to the original settings on the Digital Rebel. Once the settings are cleared, you have a fresh start.

 There are two Clear setting options on the Rebel XT.

Chances are that you've already done some of the setup tasks included in this chapter. If you have, you can skim through the chapter watching for tips that you may have missed in your initial setup.

Charging the Battery

Before you can set up the Digital Rebel, be sure that the lithium-ion battery is fully charged. A charging cycle for a fully depleted battery is approximately 90 minutes. For the EOS 300D and it's important to leave the battery in the charger for an hour **after** the red light stops blinking to complete the charging cycle. Unlike NiCad batteries or NiMH batteries, lithium ion batteries should be charged early and often.

How Temperature Affects Battery Life

In normal operating temperatures (68 degrees F), a battery charge will deliver 400 to 600 shots. But in freezing or colder temperatures, battery life decreases to 350 to 450 shots per charge.

When shooting outdoors in cold weather, keep the camera under your coat when you're not shooting. It's a good idea to carry a spare battery in an inside pocket close to your body to keep it warm.

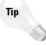

Tip *Lithium-Ion batteries have a two- to three-year life span regardless of use. It's best to buy newly manufactured batteries.*

All About Media Cards

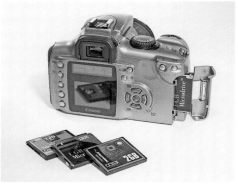

2.1 You can use CompactFlash Type I and Type II cards as well as microdrives in the Digital Rebel. While microdrives are economical, they contain moving mechanisms that can be easily damaged by bumping or dropping the drive.

The Digital Rebel accepts CompactFlash (CF) Type I and Type II media cards as well as microdrives, as shown in figure 2.1. And, because the Rebel supports the FAT32 file system, you can use media cards of 2GB and larger capacities.

Not all media cards are created equal. In particular, the type and speed of media you use affects the Digital Rebel's response times for tasks such as turning the camera on and waking it up, writing images to the media card and the ability to continue shooting during that process, the speed at which images are displayed on the LCD, and how long it takes to zoom images on the LCD.

The type of file format you choose also affects the speed of certain tasks. For example, when writing images to the media card, JPEG image files write to the card faster than with RAW.

Note *JPEG and RAW file formats are discussed in detail later in the chapter.*

Media cards are rated by speed and use various designations such as High Speed, Ultra, Write Acceleration, and numeric speed ratings such as 40x. However, the speed of the card becomes a moot point when it outdistances the camera's speed in delivering data to the card. The moral to this story is that fast cards are good, but there is a point of diminishing returns. You must determine the best card for you based on speed, capacity, and price.

As you take pictures, the LCD panel shows the approximate number of images remaining on the media card — emphasis on approximate. The number is approximate because each image varies slightly depending on the ISO setting, the file format and resolution, the parameters chosen on the camera, and the image (different images compress differently).

Note *For performance results for various media cards and cameras, including the EOS Digital Rebel, visit Rob Galbraith's Web site at* www.robgalbraith.com.

You insert the card into the card slot on the camera with the front of the card facing the back of the camera. When you get a new card, always format it in the camera. Never format a card on your computer. Because

formatting erases images, you should be very careful to off-load all images to the computer before you format the card. Formatting a media card in the camera sets the data structure especially for the Digital Rebel.

To format the card in the camera press the Menu button. Use the right arrow key to select the Set-up 1 tab, and then press the down arrow key to choose Format. Press the Set button, and then press the right arrow key to select the OK button. Wait a few seconds for the card to be formatted.

In general, it's a good idea to format media cards every few weeks to keep them clean. If you've used a media card in another camera, be sure to format it in the Digital Rebel to ensure proper data structure is set and to clean up the card.

Tip *It is possible to take pictures when no memory card is in the camera. The 300D initially displays a message on the LCD that no card is present, but it is possible to overlook the message. Always check that the memory card is present before you begin taking pictures.*

XT *On the Rebel XT, you can choose to allow shooting with or without a memory card in all shooting modes. To choose an option, press the Menu button, press the right arrow key to select the Set-up 1 tab. Press the down arrow key to select Shoot w/o card, press Set, press the arrow key to choose the option you want, and then press Set again.*

Avoid Losing Images

When the camera's red access light is blinking, it means that the camera is recording or erasing image data. When the access light is blinking, do not open the CF card slot cover (it powers down the camera), attempt to remove the media card, or remove the camera battery. Any of these actions can result in loss of images and damage to the media card and camera. What's more, if you open the media door, there is no audible warning to let you know that you've just lost the image being written as well as any in the camera's buffer. In short, don't open the CF card slot cover if the access light is on.

Setting the Date and Time

Setting the date and time on the Digital Rebel ensures that the data that travels with each image file has the correct date and time stamp. This data, commonly referred to as *metadata*, helps you identify when the image was taken and is very helpful when you want to organize your image collection.

Metadata is a collection of all the information about an image, including the filename, date created, size, resolution, color mode, camera make and model, exposure time, ISO, f/stop, shutter speed, lens data, and white balance setting, to name a few. *EXIF*, used interchangeably, is a particular form of metadata.

To set the date and time on your Digital Rebel, follow these steps:

1. **Press the Menu button on the back of the camera.**

2. **Press Jump button or up/down arrows to select the tabs on the top row.**

3. **Press the right-arrow key to select the Set-up 1 tab.**

4. **Press the down arrow key to select Date/Time.**

5. **Press the Set button.**

6. **Press the up- or down-arrow keys to make changes.**

7. **Repeat Steps 5 and 6 for each date and time entry.**

8. **When all options are set, press the Set button.**

9. **To close the menu, press the Menu button.**

 Tip *Reset the hour to adjust for daylight savings or when changing time zones.*

Choosing the File Format and Quality

The file format and quality level used to take your pictures is one of the most important decisions you make. These settings determine not only the number of images you can store on the media card, but also the sizes at which you can later enlarge and print images from the EOS Digital Rebel.

Table 2.1 explains the options that you can choose among.

Table 2.1
File Format and Quality

Image Quality	Approximate Recording and Print Sizes	Image Size (pixels)	Format	Approximate File Size; fine/normal
L	Records images at approximately 6.3 megapixels,	3072 x 2048	JPEG	3.1 MB
L	sufficient for making A4-size prints (12"x8.6").			1.8 MB
M	Records images at approximately 2.8 megapixels	2048 X 1360		1.8 MB
M	sufficient for making A5 (8.5"x6") to A4-size prints.			1.2 MB
S	Records images at			1.4 MB
S	approximately 1.6 megapixels.	1536 x 1024		0.9 MB
RAW + M	Records images at approximately 6.3 megapixels with no image degradation from compression. Sufficient for printing images at A4 size or smaller. RAW images must be processed on the computer and cannot be printed directly from the camera. A medium JPEG image is automatically recorded and embedded within the RAW image.	3072 x 2048	RAW _ JPEG	7 MB

Because of the high-quality images that the Digital Rebel delivers, you can make lovely enlargements from your images. Even if you think that you'll never want anything larger than a 4 x 5-inch print from an image, something can happen to make the image important enough to print at a larger size. For this reason, and certainly to take advantage of the Digital Rebel's fine image detail, it pays to choose a high-quality setting.

JPEG format

JPEG, which stands for Joint Photographic Experts Group, is a lossy file format that discards some image data during the process of compressing image data stored on the media card. Because JPEG images are compressed, you can store more images on the media card. However, as the compression ratio increases, more of the original image data is discarded, and image quality subtly degrades.

Other important things to know about choosing JPEG formats are that, unlike RAW images that allow you to change many settings after the picture is taken, JPEG images are processed by Canon's internal software before being stored on the media card.

2.2 At the Large/Fine JPEG or RAW settings, photos show excellent detail and very few, if any, JPEG compression artifacts.

2.3 At the Medium and Small settings, especially with high compression, image detail and quality begin to deteriorate and pixelation becomes evident.

JPEG images can be opened in any image-editing program and can be printed directly from the computer.

If you choose the JPEG format, then you can choose among different image sizes and among compression ratios ranging from low (Fine settings) and high (Normal settings).

RAW format

RAW stores data directly from the image sensor on the card with no preprocessing in the camera. Because RAW is a lossless format (no loss of image data), you can store fewer RAW images on the media card than JPEG images, but image quality is not degraded.

However, unlike JPEG images that can be viewed in any image-editing program, RAW files must be viewed using the Canon File Viewer Utility software and converted using Canon's Digital Photo Professional program or Adobe's Camera Raw plug-in. When you shoot RAW images, Canon embeds a medium-size JPEG image in the RAW file. You can view the embedded JPEG using the Canon processing program that comes with the Digital Rebel.

On the Rebel XT you can choose to between RAW and RAW+JPEG. These options allow you to control file size. Shooting RAW provides a smaller file size which allows you to get more shots on the memory card. Shooting RAW+JPEG provides the convenience of having a RAW and a JPEG (Large Fine) file, but the tradeoff is a somewhat larger file size than RAW.

RAW data gives you the ultimate flexibility— you can change camera settings *after* the picture is taken. For example, if you didn't set the correct white balance or exposure, you can change it in a RAW conversion program on the computer. This gives you a second chance to correct underexposed or overexposed images, and correct the color balance after you take the picture.

Table 2.2
JPEG versus RAW

	Digital Rebel: 128 MB Card		Digital Rebel XT: 512 MB Card	
	Approximate File Size MB	**Number of Pictures**	**Approximate File Size MB**	**Number of Pictures**
Large JPEG; Fine or Normal	3.1 / 1.8	65 / 38	3.3 / 1.7	145 / 279
Medium JPEG; Fine or Normal	1.8 / 1.2	66 / 101	2.0 / 1.0	245 / 466
Small JPEG; Fine or Normal	1.4 / 0.9	88 / 132	1.2 / 0.6	419 / 790
RAW [not possible without M JPG]	7	16	8.3	58
RAW + M	7		7	41

Table 2.2 shows the file size and approximate number of images that can be stored on 128MB and 512MB media cards for the Digital Rebel and the Digital Rebel XT.

To set the image quality of your pictures, follow these steps:

1. **Press the Menu button on the back of the camera.**

2. **On the Shooting tab, press the down arrow key to select Quality.**

3. **Press the Set button.** The image quality options are displayed.

4. **Press the down-arrow key to select the size and quality you want.**

5. **Press the Set button again.**

6. **To return to shooting, press the shutter button.**

XT

To set the image quality on the Rebel XT, make sure to press the Shooting 1 tab in Step 2 of the previous set of steps. When you press the Set button in Step 3, the recording quality screen appears.

Choosing a White-Balance Option

The human eye sees white as white regardless whether a white object is viewed in household light that has a yellow cast or in shade that has a blue cast. A digital camera, however, cannot make the same adjustments. A white balance setting tells the camera the type of light in a scene so the camera can render white and other colors accurately.

Because the temperature, or color, of light varies by source and time of day, you must tell the camera type of light in which you're taking picture by choosing a white balance option. The Digital Rebel offers eight white-balance settings for a variety of different light temperatures: AWB (Auto White Balance), Daylight, Shade, Cloudy/Twilight/Sunset, Tungsten, White Fluorescent, Flash, and Custom.

 Note *Chapter 4 provides more detail on light and color temperature.*

2.5 This picture was taken in fluorescent light with the white balance set to fluorescent.

2.4 The images shown in this picture and 2.5 show the difference when white balance is set for the correct light. This picture was taken at AWB (auto white balance) in fluorescent light.

Of course, the Digital Rebel, like other digital cameras, includes an automatic white-balance setting (AWB). When you use this option, the camera looks at the colors in the overall scene color and makes a "best guess" on white balance. This strategy works admirably except in scenes dominated by one or two colors and where no white is present. So, you'll get the best image color if you set the camera for the specific type of light in the scene.

Changing the white balance is important to getting pictures with accurate color, and choosing the setting is easy.

To change the white balance on the Digital Rebel, follow these steps:

Adjusting the Color Temperature on the Rebel XT

The Digital Rebel XT takes white balance a step further by allowing you to correct the standard white balance in a way that is much like using color-correction filters in film photography. In film photography, conversion filters allow you to use film in light that it isn't balanced for. For example, with the correct color conversion filter, you can use daylight film (balanced to 5500 degrees K) in tungsten light (balanced to 3200 degrees K). Without the filter, the pictures will have an orange tint. But with a cooling color-conversion filter, certain wavelengths of light are prevented from passing through to the lens thereby shifting colors so they are more natural.

On the Digital Rebel XT you can replicate the effect of a color conversion filter using the WB SHIFT/BKT function to shift the color bias. To adjust the white balance, press the Menu button, move to the Shooting 2 tab, select WB SHIFT/BKT, and then press the Set button. Then use the arrow keys to shift the color balance toward Blue (B), Amber (A), Magenta (M), or Green (G). To cancel a bias correction, move the cursor back to the center, or 0,0 point.

1. **Press the WB (White Balance) button on the back of the camera.** The white balance menu appears.

2. **As you watch the LCD, turn the main dial until the setting you want is displayed.**

3. **To return to shooting, press the shutter button.**

To change the white balance on the Rebel XT, in Step 2, press the arrow keys to choose a setting, and then press the Set button. If you want to see the white balance setting in the LCD panel, press the Shutter button halfway.

Cover your white-balance bases

To ensure that the nuances of color are accurate, you can use white-balance auto bracketing if you're shooting JPEG images. White-balance bracketing captures three images, each with +/-3 one-stop differences in color from the base white-balance setting.

With white-balance auto bracketing, the camera captures one image at the white-balance setting, one image that is slightly cooler, and another that is slightly warmer in tone.

On the Rebel XT, white-balance bracketing can be set up to +/- 3 levels in single-level increments. Images are bracketed based on the white-balance mode's current temperature with a blue/amber or magenta/green bias.

To set a white-balance auto bracketing, follow these steps:

1. **If you have the camera recording set to RAW, reset the image recording to JPEG.**

2. **Press the Menu button on the back of the camera.** The Shooting menu appears.

3. **Press the down button to select WB-BKT.**

4. **Press Set.**

5. **Press the left and right buttons to select the amount in full stops to bracket the color setting.** The mark for the selected white-balance level blinks.

6. **Press Set.**

7. **Press the shutter or Menu button to return to shooting.**

You can cancel white-balance bracketing by turning the camera off.

XT

To set a white-balance auto bracketing on the Digital Rebel XT, press the Menu button, and then select the Shooting 2 menu. Press the down arrow button to select WB SHIFT/BKT, and then press the Set button. On the WB correction/WB bracketing screen, turn the Main dial to the left to set Magenta/Green bracketing, or to the right to set a Blue/Amber bracketing in plus/minus 3 single-level increments. Then press the Set button. The bracketed sequence begins with normal white balance, then blue and amber bias images, or magenta and green bias.

Mixed light? No problem

Mixed light scenes, such as tungsten and daylight, used to drive photographers crazy. Shooting film in these scenes meant that you had to hold your breath and hope for the best. But, digital photography changed everything. With the Digital Rebel, you can set a custom white balance to get accurate color in mixed light, as well as in other less-than-perfect lighting situations. Setting a custom white balance saves time you'd otherwise spend color correcting images on the computer.

To set a custom white balance, follow these steps:

1. **Position the camera so a sheet of white paper fills the center of the viewfinder, and take a picture.** If the camera cannot focus, switch the lens to MF (Manual Focusing), and focus on the paper. Also ensure that the exposure is neither underexposed nor overexposed.

2. **Press the Menu button.**

3. **On the Shooting menu, press the down button and select Custom WB.**

4. **Press the Set button.** The camera displays the most recent image. If the image of the white paper is not selected, use the arrow keys to select it.

5. **Press the Set button to have the Digital Rebel import the white balance data from the selected image.**

6. **Press the Menu button.**

7. **Press the WB button on the back of the camera.**

8. **As you watch the LCD panel, turn the Main dial until the custom WB icon is selected.**

XT

To set a custom white balance on the Rebel XT, be sure the camera is not set to B/W processing. Take a picture of a gray or white card. Press the Menu button, and then select the Shooting 2 tab. Press the down arrow key to select Custom WB, and then press the Set button. If the image of the gray or white card is not selected, press the arrow keys to select it, and then press the Set button. A caution screen appears. Select the Shooting 2 tab, press the down arrow key to select White Balance, and then press the Set button. On the White Balance screen, select the custom white balance option, and then press the Set button.

Set a Processing Parameter

Processing parameters are a set of camera instructions that determine the color, contrast, and saturation levels of images. The Digital Rebel has several processing parameters that you can choose among to change how images appear. Images from the EOS Digital Rebel have excellent color, contrast, and saturation right out of the box. The default "parameter" for the Digital Rebel delivers this vivid contrast and saturation. However, sometimes a less vivid image may be preferable and you can get it by choosing a different processing parameter.

Regardless of your tastes or workflow, the Digital Rebel offers enough processing parameters to satisfy most people's preferences.

2.7 This picture was taken with the camera set to Adobe RGB.

The Digital Rebel offers the following processing parameters:

✦ **Parameter 1.** This default parameter produces images with vivid color and slightly higher sharpness — a good choice if you regularly print images directly from the camera.

✦ **Parameter 2.** This parameter offers less saturation, contrast, and slightly less sharpness, and, therefore, it gives you more editing headroom later as you edit images on the computer.

✦ **Adobe RGB.** This is the third parameter, and it offers the widest color range. It is the choice for advanced and professional photographers who edit their images for

2.6 This picture was taken with the camera set to Parameter 2.

custom or commercial printing. Images taken with this parameter have much more subdued color, saturation, and sharpness than images taken with Parameter 1.

The Rebel XT offers the Parameter 1 and 2 as well as a B/W parameter for black-and-white photos. Note that Adobe RGB is a processing parameter on the Digital Rebel and a color space option from the Shooting 2 menu on the Rebel XT.

On both cameras, you can create and save up to three sets of adjustments for your preferred contrast, sharpness, saturation, and color tone settings. The cameras offer Set 1, Set 2, and Set 3 as custom options.

To adjust a processing parameter and save your own custom adjustments, follow these steps:

1. **Press the Menu button.** The Shooting menu appears.

2. **Press the down-arrow key to select Parameters.**

3. **Press Set to open a menu of preset parameters**.

4. **Press the down-arrow key to select the parameter you want.**

5. **To change a user-specified parameter, press the down-arrow key to select Set up.**

6. **Press Set.**

7. **Press the up/down arrow to select the Set (1, 2, or 3) whose contrast, sharpness, saturation, and color settings you want to change.**

8. **Press the Set button.**

9. **To change contrast, press the Set button, and then press the**

left- and right-arrow keys to increase or decrease the contrast.

10. **Press the Set button.**

11. **Press the down-arrow key to select each of the next items you want to adjust, and repeat steps 9 and 10.**

12. **To return to the Parameters menu, press the Menu button twice.**

To set a processing parameter on the Digital Rebel XT, press the Menu button, and then select the Shooting 2 tab. Press the down arrow key to select Parameters, and then press the Set button. On the Processing parameter screen, press the Set button to move to the Parameter option numbers. Press the up or down arrow key to select the parameter you want, and then press the Set button. Follow Steps 9 to 11 to change individual parameter settings. When you finish, press the Set button.

To save a custom processing parameter, follow these steps:

1. **Press the Menu button.**

2. **Press the right arrow key to select the Shooting 2 menu.**

3. **Press the down-arrow key to select Parameters, and then press the Set button. The Processing parameter screen appears.**

4. **Press the Set button.**

5. **Press the arrow keys to select the set you want, Set 1, Set 2, or Set 3, and then press the Set button.**

Changing Color Space with the Rebel XT

A color space defines the range of colors that can be reproduced. Some color spaces contain more colors than others, while some are better for printing, and still others are better for pictures displayed on the Web.

The Digital Rebel XT offers two color spaces: Adobe RGB and sRGB. The color space with the widest color range is Adobe RGB (with Design rule for Camera File System 2.0, or Exif 2.21). It is the choice for advanced and professional photographers who edit their images for custom or commercial printing. Images taken with this parameter have much more subdued color, saturation, and sharpness than images taken with sRGB.

The second color space is sRGB. Although the range of colors is not as wide, colors appear brighter and more saturated than with Adobe RGB. This is a good color space to use for images you display on the Web or send in e-mail.

To change the color space on the EOS 350D, follow these steps.

1. **Press the Menu button.**

2. **Press the right arrow key to select the Shooting 2 tab.**

3. **Press the down arrow key to select Color space, and then press the Set button.**

4. **Press the arrow keys to select sRGB or Adobe RGB, and then press the Set button.** If you select Adobe RGB, image filenames begin with _MG_.

5. **Press the shutter button to return to shooting.**

6. **Press the arrow keys to select the setting you want to change such as Contrast, Sharpness, Saturation, or Color tone.**

7. **Press the Set button.**

8. **Press the right arrow key to increase the setting or the left arrow key to decrease the setting. Increasing Color tone produces more yellow skin tones. Decreasing Color tone produces more reddish skin tones.**

9. **Press the Set button.**

10. **Repeat steps 7 through 9 for each additional setting you want to adjust.**

11. **Press the shutter button to return to shooting.**

Change File Numbering

With the Digital Rebel, you can have the camera number images sequentially, or you can restart numbering each time you change the media card.

With Continuous numbering, images are numbered sequentially using a unique four-digit number from 0001 to 9999. With unique filenames, managing and organizing images on the computer is easy because

there is no chance that images will have duplicate filenames. This option is also useful to track the total number of images, or actuations, on the camera. The Digital Rebel's default setting is Continuous file numbering.

Alternately, you can reset the frame numbering so that it restarts each time you change the media card. If you like to organize images by media card, this can be a useful option. If you use this option, be aware that multiple images will have the same number or filename. That means that you should create separate folders for each offload and otherwise follow scrupulous folder organization to avoid filename conflicts and potential overwriting of images.

To change the file numbering method on your Digital Rebel, follow these steps:

1. **Press the Menu button on the back of the camera.**

2. **Press the right-arrow key to select the Set-up 1 tab.**

3. **Press the down-arrow key to select File numbering.**

4. **Press the Set button.**

5. **Select Continuous or Auto reset.** Auto reset will begin the numbering again with each session.

6. **Press the Set button.**

7. **Press the Menu or shutter button to return to shooting.**

Creating Great Photos with the Digital Rebel

✦ ✦ ✦ ✦

✦ ✦ ✦ ✦

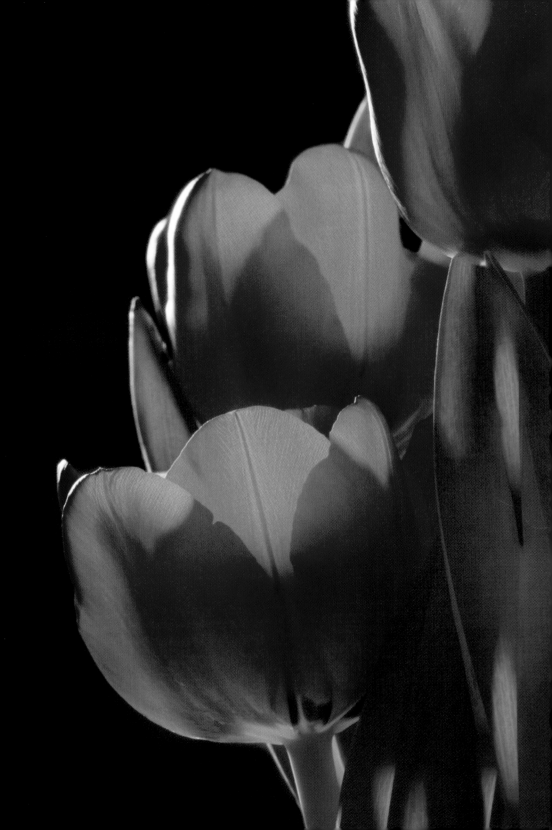

Photography Basics

Maybe you purchased the Digital Rebel to gain more creative flexibility than is offered by other cameras. And maybe you're still stuck in the Basic Zone exposure modes, but you're anxious to move into the Creative Zone modes to take advantage of the camera's creative options. This chapter offers you a good start in understanding basic photographic concepts — concepts that are the foundation for using the Digital Rebel's creative potential.

If you've used a film SLR, this chapter may be a refresher for you. If you haven't used an SLR, this chapter will help you build a foundation from which you can expand your skills. Either way, you'll learn quickly with the Digital Rebel because you can see the results immediately. Instant feedback from the camera lets you determine whether you're on target or need to make adjustments.

And whether you use the Basic or the Creative Zone, you'll get better pictures with the Digital Rebel when you understand the basics of exposure.

As you read the chapter, don't worry about remembering everything at once. Take your time and enjoy the process of learning.

3.1 Whether you're shooting outdoors or indoors, understanding and adjusting exposure will give you creative control. The exposure for this image was ISO 100, f/8, at 1/160 second.

The Four Elements of Exposure

Think of exposure as a precise combination of four elements — all of which are related to light. Each element depends on the others to create a successful result. If the amount of one element changes, then the other elements must be increased or decreased proportionally to get a successful result.

Here are the four elements:

✦ **Scene light:** The starting point of exposure is the amount of light that's available in the scene to make a picture.

✦ **Sensitivity:** Sensitivity refers to the amount of light that the image sensor needs to make an exposure – or the sensor's sensitive to light: Does the sensor need a lot of light or a little light to make the exposure? In digital photography, choosing an ISO setting determines how sensitive the image sensor is to light.

✦ **Intensity:** Intensity refers to strength or amount of light that reaches the image sensor. Intensity is controlled by the aperture, or f-stop, an adjustable opening on the lens that allows more or less light to reach the sensor.

✦ **Time:** Time refers to the length of time that light is allowed to reach the sensor. Time is controlled by the shutter speed.

In many cases, the amount of available light can't easily be changed. So, for now, consider the amount of light in the scene as fixed as you look at the remaining three exposure elements in more detail.

Sensitivity: The role of ISO

ISO (International Organization for Standardization) sets the image sensor's sensitivity to light. The higher the ISO number, the more sensitive the sensor is to light and the less light that's needed to make a picture.

In digital photography, the ISO sequence usually encompasses ISO100, 125, 160, 200,

250, 320, 400, 800, and up to 1600. The lower the ISO number, the more light the sensor requires, and the higher the number, the less light the sensor needs for the exposure. Photographers refer to ISO as being slow (under ISO 200), fast (ISO 400 to 800), and very fast (over ISO 800 and faster).

Low ISO settings provide high-quality images with good sharpness, saturation, and contrast. On the other hand, because the image sensor is less sensitive to light, a longer shutter speed is needed. Longer shutter speeds limit your ability to handhold the camera and still get a sharp picture.

In low-light scenes, you can switch to a fast (high) ISO setting. This allows faster shutter speeds that help reduce the risk of blur if the subject moves or from camera movement as you press the shutter. During a short exposure time, blur from movement does not have enough time to register in the image.

On the downside, however, using a high ISO increases the risk of introducing digital noise, the equivalent of film grain, in the image. Digital noise shows up in images as unwanted and/or colorful pixels scattered about mainly in the shadow areas of the image. Digital noise degrades overall image quality. To avoid digital noise, it's a good idea to set the ISO as low as you can and still get the picture.

3.2 In reasonably bright light, you can set a low ISO such as 100 to get excellent image quality. This image was taken in bright sunlight at ISO 100, f/14, at 1/320 second.

Note *You can use noise reduction programs to reduce digital noise, but reducing noise also tends to reduce image detail. That's another good reason to avoid ISO settings higher than 400.*

On the Digital Rebel XT, you can also enable a Custom Function (C.Fn-2: Long exposure noise reduction) to reduce digital noise in bulb exposures of 30 seconds or longer at ISO 100 to 800 and at 1 second or longer at ISO 1600.

Tip *An easy way to think about ISO is that each ISO setting is twice as sensitive to light as the previous setting. For example, ISO 800 is twice as sensitive to light as ISO 400. As a result, the sensor needs half as much light to make an exposure at ISO 800 as it does at ISO 400.*

In addition to the potential for digital noise, high ISO settings can also reduce sharpness, detail, color saturation, and increase file size.

3.3 Selecting a higher ISO, such as 400, means that you can use faster shutter speeds in low-light scenes and still handhold the camera to get sharp results. This image was taken at ISO 400 in household (tungsten) light at f/5.6, at a shutter speed of 1/7 second. Even with a fast ISO, the light was too low to handhold the camera, so I used a tripod.

On the Digital Rebel, ISO settings are 100, 200, 400, 800, and 1600. In the Basic Zone modes, the camera automatically sets the ISO at either 100 or 400. The camera chooses the ISO based on whether you use the built-in flash or a Canon Speedlite, which is an external flash that you can buy separately.

In the Creative Zone modes, you can choose ISO 100, 200, 400, 800, or 1600.

To change the ISO, follow these steps:

1. **Choose a mode in the Creative Zone.**

2. **Press the ISO button.**

3. **Turn the Main dial and watch the LCD to select the ISO.**

To change the ISO on the Rebel XT, follow Step 1 and 2 from the previous set of steps. Then, in Step 3, press the down or up arrow key to select the ISO from the ISO speed menu. Press the Set button.

Intensity: The role of the aperture

The lens aperture (the size of the lens opening) determines the amount, or intensity, of light that strikes the image sensor. Aperture is shown as f-stop numbers, such as f/2.8, f/4, f/5.6, f/8, and so on.

Checking for Digital Noise

If you choose a high ISO setting, you can check for digital noise by uploading the pictures to the computer and zooming the display to 100 percent. Look for flecks of color in the shadow and midtone areas that don't match the other pixels.

If you see colored or other unwanted flecks then it's best to set the ISO to a lower setting. This means that the shutter speeds will be slower, so you should either use a flash or steady the camera on a solid surface when you take pictures in low light.

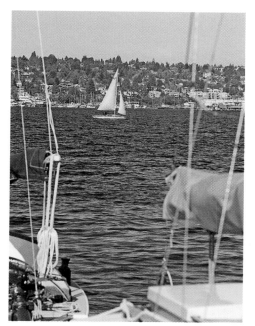

3.4 A narrow aperture of f/14 provides excellent sharpness throughout an image unless you are close to a foreground object as shown with the foreground sailboat here. This image was taken at ISO 100 at a shutter speed of 1/100 second.

Wide aperture

Smaller f-stop numbers, such as f/2.8, set the lens to a large opening that lets more light reach the sensor. A large lens opening is referred to as *wide* aperture. At wide apertures, the amount of time the shutter needs to stay open to let light into the camera is decreased.

Narrow aperture

Larger f-stop numbers, such as f/16, set the lens to a small opening that lets less light reach the sensor. A small lens opening is referred to as a *narrow* aperture. At narrow apertures, the amount of time the shutter needs to stay open to let light into the camera is increased.

Aperture in Basic Zone modes

The Digital Rebel automatically sets the aperture (and ISO and shutter speed) in Basic Zone modes based on available light in the scene and the type of picture you want to take. For example, in Portrait mode, the camera automatically chooses a wide aperture to blur the background. Conversely, in Landscape mode, the camera chooses a narrow aperture to get sharp detail from foreground to background.

3.5 A wide aperture of f/2.8 provides a limited zone of sharpness that focuses attention on the old tractor steering wheel. This image was taken at ISO 100 at a shutter speed of 1/2000 second.

Aperture in Creative Zone modes

In the Creative Zone modes, you can control the aperture by switching to Aperture-priority AE or Manual mode. Just turn the Mode dial to Av or M to change to these modes.

In Aperture-priority AE mode, you set the aperture and the camera automatically sets the correct shutter speed. In Manual mode, you set both the aperture and the shutter speed based on the reading from the camera's light meter. The light meter shows a scale in both the viewfinder and the LCD panel that indicates over-, under-, and correct exposure based on the aperture and shutter speed combination.

Cross-Reference *You can learn more about exposure and exposure modes in Chapter 1.*

Choosing an Aperture

Your choice of aperture depends on several factors. If you want to avoid blur from camera shake or subject motion in lower light, choose a wide aperture (smaller f-number) so that you get the faster shutter speeds.

If you're using a telephoto (long) lens, and you want to handhold the camera, choosing a wide aperture such as f/2.8 or f/4.0 will help achieve the fast shutter speed you'll need to prevent blur in lower light scenes.

Another important consideration in choosing an aperture is controlling the depth of field in your pictures. Depth of field is discussed in detail in the next section.

To set the aperture on the Digital Rebel, follow these steps:

1. **Turn the Mode dial to Av (Aperture-priority AE) or M (Manual mode).**

2. **In Av mode turn the Main dial until the f-stop you want appears on the LCD panel or in the viewfinder. In Manual mode press the Av button on the back of the camera while turning the Main dial.** The aperture values displayed differ depending on the lens you're using. In Aperture-Priority AE mode, the camera automatically sets the correct shutter speed. In Manual mode, use the Main dial to set the correct shutter speed based on the exposure scale shown in the viewfinder.

Note *If "30" blinks in the viewfinder, turn the Main dial to select a wider aperture (lower f-number) to avoid underexposure. If "4000" blinks in the viewfinder, turn the Main dial and select a narrow aperture (larger f-number) to avoid overexposure.*

What is Depth of Field?

Depth of field is the zone of acceptably sharp focus in front of and behind a subject. Aperture is the main factor that affects depth of field, although camera-to-subject distance and focal length affect depth of field as well.

Shallow depth of field

Pictures where the background is a soft blur and only the subject is in sharp focus have a shallow depth of field. To get a shallow depth of field, choose a wide aperture such as f/2.8, f/4, or f/5.6. The subject will be sharp, and the background will be soft and non-distracting. A shallow depth of field is a great choice for portraits.

Extensive depth of field

Pictures with reasonably sharp focus from front to back have extensive depth of field. To get extensive depth of field, choose a narrow aperture, such as f/8 or f/11 or narrower. For images such as landscapes and photos of large groups of people, extensive depth is a good choice.

3.6 Good foreground-to-background sharpness in this picture of a pumpkin patch resulted from using a narrow aperture of f/18. This image was taken at ISO 100 at a shutter speed of 1/125 second.

If it's difficult to remember which f/stop to choose, just remember that large numbers enlarge the depth of field and small f-numbers shrink depth of field. In other words, large f-numbers, such as f/22, enlarge the range of acceptably sharp focus. Small f-numbers, such as f/4, shrink the range of acceptably sharp focus.

When you choose a narrow aperture such as f/16, a longer shutter speed is required to ensure that enough light reaches the sensor for a correct exposure. With slower shutter speeds, be sure to use a tripod, or switch to a faster (higher) ISO setting to get a faster shutter speed.

While aperture is the most important factor that affects the range of acceptably sharp focus in a picture, other factors also affect depth of field including:

✦ **Camera-to-subject distance.** At any aperture, the farther you are from a subject, the greater the depth of field will be. If you take a scenic photo of a distant mountain, the foreground, midground, and background will be acceptably sharp. If you take a portrait and the camera is close to the subject, only the subject will be acceptably sharp.

✦ **Focal length.** Focal length, or angle of view, is how much of a scene the lens "sees." From the same shooting position, a wide-angle lens takes in more of the scene than a telephoto lens and produces more extensive depth of field. A wide-angle lens may have a 110-degree angle of view while a telephoto lens may have only a 12-degree (narrow) view of the scene.

 Cross-Reference *For more information on focal length, see Chapter 5.*

3.7 Using a wide aperture of f/3.4 blurred the computer in the background for this portrait. This image was taken at ISO 100 at a shutter speed of 1/80 second.

Time: The Role of Shutter Speed

Shutter speed controls how long the curtain in the camera stays open to let light from the lens strike the image sensor. The longer the shutter stays open, the more light reaches the sensor (at the aperture you set). Shutter speed affects your ability to get a sharp image in low light while handholding the camera and the ability to freeze motion or show it as blurred in a picture.

Shutter speeds are shown in fractions of a full second. Common shutter speeds (from slow to fast) are: Bulb (the shutter stays open until you close it by releasing the shutter button), 1 second, 1/2, 1/4, 1/8, 1/15, 1/30, 1/60, 1/125, 1/500, 1/1000, and so on.

When you increase or decrease the shutter speed by one full setting, it doubles or halves the exposure. For example, twice as much light reaches the image sensor at 1/30 second as at 1/60 second.

Shutter speed determines whether you can freeze a moving subject or allow it to be blurred in the picture. For example, you can adjust shutter speed to freeze a basketball player in midair, or adjust it to show the motion of water cascading over a waterfall. As a rule of thumb, to stop motion set the shutter speed to 1/60 second or faster. To show motion as a blur, try 1/30 second or slower, and use a tripod.

If you shoot in Basic Zone modes, the camera automatically sets the shutter speed, which gives you less creative control in showing or freezing motion.

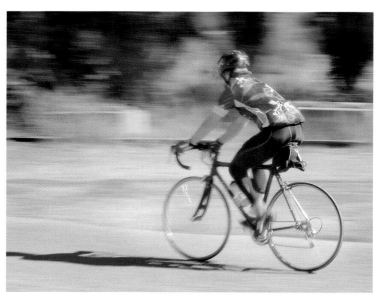

3.8 To show motion as a blur in this image of a biker, the shutter speed was set to 1/30 second. This image was taken at ISO 100 at f/22.

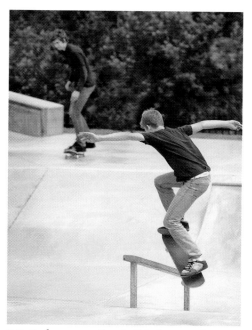

3.9 To freeze motion in this image of a young skateboarder, the shutter speed was set to 1/800 second. This image was taken at ISO 100 at f/5.6.

If you shoot in Creative Zone modes using Shutter Priority or Manual mode, you can set the shutter speed. In Manual mode, you set both the shutter speed and the aperture.

To set the shutter speed when shooting in the Creative Zone, follow these steps:

1. **Turn the Mode dial to Tv (Shutter-Priority AE) or M (Manual).**

2. **In Tv or Manual mode turn the Main dial until the shutter speed you want appears on the LCD panel or in the viewfinder.** In Shutter-Priority AE mode, the camera automatically sets the aperture based on the shutter speed you choose. In Manual

mode, use the Main dial to set the correct shutter speed based on the exposure scale shown in the viewfinder.

Tip *As a guideline, never handhold a camera at a shutter speed slower than the inverse of the focal length of the lens. For example, with a 100mm lens, don't handhold the camera at shutter speeds slower than 1/100 second. And, with long telephoto lenses, it's a good idea to always use a monopod or tripod.*

Equivalent Exposures

Cameras require a very specific amount of light to make a good exposure. As you have seen, after the ISO is set, two factors determine the amount of light that makes the exposure: the size of the lens opening (aperture or f-stop) and the shutter speed. Set a wide aperture, and you can use a fast shutter speed. But switch to a small aperture (f-stop), and you must use a slower shutter speed.

Many combinations of aperture (f-stop) and shutter speed produce exactly the same exposure; in other words, the same amount of light will expose the image. For example, an exposure setting of f/22 at 1/4 second is equivalent to f/16 at 1/8 second, f/11 at 1/15, f/8 at 1/30, and so on. The exposures are the same because you decrease the amount of exposure time as you change to the next larger aperture.

The camera's light meter measures the amount of light reflected from the subject. The meter uses this information to calculate

the necessary exposure depending on the ISO, aperture size, and the shutter speed. If you change the aperture, the camera recalculates the amount of time needed for the exposure. Change the shutter speed, and the camera's meter determines what aperture is required for a correct exposure.

> **Tip** *Shoot in a semiautomatic mode such as Aperture-priority mode. This mode gives you creative control over depth of field and eliminates the need to constantly make manual adjustments to the shutter speed. And, if you want to control the shutter speed for freezing or blurring motion, you can use Shutter-priority (Tv) mode instead.*

Putting It All Together

ISO, aperture, shutter speed, and the amount of light in a scene are the essential elements of photographic exposure. On a bright, sunny day you can select from many different f-stops and still get fast shutter speeds to prevent image blur. There is little need to switch to a high ISO for fast shutter speeds at small apertures.

As it begins to get dark, your choice of f-stops becomes limited at ISO 100 or 200. You'll need to use wide apertures, such as f/4 or wider, to get a fast shutter speed. Otherwise, your images will show some blur from camera shake or subject movement. Switch to ISO 400 or 800, however, and your options increase and you can select narrow apertures, such as f/8 or f/11, for greater depth of field. The higher ISO allows you to shoot at faster shutter speeds to reduce the risk of blurred images, but it increases the chance of digital noise.

While the basic elements of exposure and using them together may seem like a lot to digest, you may find it easier to choose one aspect — aperture, for example — and experiment by changing the f-stop to achieve different effects. Keep a photo journal to see how changing the aperture affects the final image. Then move on and experiment with different shutter speeds. The Digital Rebel is the greatest single tool you can have to learn photography quickly and inexpensively.

3.10 You can practice using aperture, shutter speed, and ISO combinations to get both classic results as well as creative effects. Exposure settings for this picture of a rustic barn in heavy fog were ISO 100, f/8 at 1/60 second.

Let There Be Light

Who hasn't taken photos in which friends and family look like they have a strange illness — what else could explain that jaundiced or sometimes feverish skin tones? And you probably have pictures in which the subject has dark raccoon-like shadows under the eyes, nose, and chin.

The common thread in these situations is light — its color, direction, quality, and intensity. To solve these kinds of problems, you need to understand the basic characteristics of light and how you can use light to your advantage. The more you learn about light, the more able you'll be to transform your pictures from mundane snapshots into showstoppers.

It helps to think of light as a painter thinks about a color palette. You can use the qualities of light to set the mood; control the viewer's emotional response to the subject; reveal or subdue the subject's shape, form, texture, and detail; and render scene colors as vibrant or subdued.

Color Hues

Few people think of light as having color until the color becomes obvious, such as at sunrise and sunset when the sun's low angle causes light to pass through more of the earth's atmosphere creating visible and often dramatic color. But regardless of the time of day, natural light has color, and each color of sunlight renders subjects differently. Likewise, household bulbs, candlelight, flashlight, and electronic flash have distinctive colors.

The human eye automatically adjusts to the changing colors of light so that white appears white regardless of the type of light we view it in. Digital image sensors are not, however, as adaptable as the human eye. When the Digital Rebel is set to

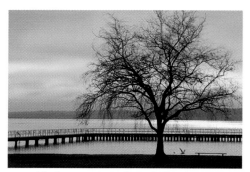

4.1 This image was taken during late afternoon as the sun created a golden glow across the sky.

When learning about color temperatures, keep in mind this general principle: the higher the color temperature, the cooler (or more blue) the light; the lower the color temperature, the warmer (or more yellow/red) the light.

Table 4.1 shows Kelvin scale ranges for a sunny, cloudless day. These are, of course, general measures. The color temperature of natural light is affected by atmospheric conditions such as pollution and clouds. An overcast day shifts the color of light toward the cool end of the scale, measuring between 6,000 and 7,000 degrees K.

Daylight, it renders color in a scene most accurately in the light at noon on a sunny, cloudless day. At the same setting, it does not render color as accurately at sunset or sunrise because the temperature of light has changed.

Different times of day and light sources have different temperatures. Light temperature is measured on the Kelvin scale and is expressed in degrees K. So for the Digital Rebel to render color accurately, the white balance setting has to match the specific light in the scene.

 XT

Due to the warmer setting for sunset on the EOS Digital Rebel XT, you may want to use AWB for sunset photos, or you can use WB SHIFT/BKT and shift toward magenta.

 Cross-Reference

If you use RAW capture, you can adjust the color temperature precisely using Canon's Digital Photo Professional RAW conversion program. See Chapter 7 for details on using this program.

Color Temperature isn't Atmospheric Temperature

Unlike air temperature that is measured by degrees Fahrenheit (or Celsius), light temperature is based on the spectrum of colors that is radiated when a black body is heated. Visualize heating an iron bar. As the bar is heated, it glows red. As the heat intensifies, the metal changes to yellow, and, with even more heat, it glows blue-white. In this spectrum of light, color moves from red to blue as the temperature increases.

This becomes confusing because we think of "red hot" as being significantly warmer than someone who has turned "blue" by being exposed to cold temperatures. But in the world of color temperature, blue is, in fact, a much higher temperature than red. That also means that the color temperature at Noon on a clear day is warmer (bluer) than the color temperature during a fiery red sunset. And the reason that you care about this is because it affects the color accuracy of your pictures.

Table 4.1
Selected Light Color Temperatures

Time of Day	Range in Degrees Kelvin	Digital Rebel Setting and Approximate Corresponding Temperature
Sunrise	3,100-4,300	Auto (AWB): 3,000 to 7,000
Midday	5,000-7,000	Daylight: 5,200
Overcast or cloudy sky	6,000 & 8,000	Cloudy, twilight, sunset: 6,000
Sunset	2,500-3,100	AWB or Cloudy, twilight, sunset: 6,000

On the Digital Rebel, setting the white-balances tells the camera the general range of color temperature of the light so that it can render white as white in the final image. The more faithful you are in setting the correct white-balance setting, the less color correction you'll have to do on the computer.

The "Color" of Light

Like an artist's palette, the color temperature of natural light changes throughout the day. By knowing the predominant color temperature shifts throughout the day, you can adjust settings (or use WB SHIFT/BKT on the Digital Rebel XT) to ensure accurate color, to enhance the predominant color, and, of course, to use color creatively to create striking photos.

Sunrise

In predawn hours, the cobalt and purple hues of the night sky predominate. But as the sun inches over the horizon, the landscape begins to reflect the warm gold and red hues of the low-angled sunlight. During this time of day, the green color of grass, tree leaves, and other foliage colors are enhanced, while earth tones take on a cool hue. Landscape, fashion, and portrait photographers often use the light available during and immediately after sunrise.

AWB is a good general white-balance setting to use. If you are shooting RAW images, you can also adjust the color temperature precisely in Canon's Digital Photo Professional RAW conversion program. See Chapter 7 for details on using this program. This is also a great time to use Auto Exposure Bracketing (AEB) set to 1/2 or a full stop.

Midday

During midday hours, the warm and cool colors of light equalize to create a light the human eye sees as white or neutral. On a cloudless day, midday light is often considered too harsh and contrasty for many types of photography, such as portraiture. However, midday light is effective for photographing images of graphic shadow patterns, flower petals and plant leaves made translucent against the sun, and for images of natural and man-made structures.

For midday pictures, use the Daylight white-balance setting on the Digital Rebel. If you take portraits during this time of day, it's a good idea to use the built-in flash or an

4.2 A chilly fall morning shows the warm color beginning to emerge over the mountaintops at sunrise.

accessory flash to fill dark shadows. With the Digital Rebel XT, you can set Flash Exposure Compensation in 1/3- or 1/2-stop increments to get just the right amount of fill light using either the built-in or an accessory Speedlite.

Sunset

During the time just before, during, and just following sunset, the warmest and most intense color of natural light occurs. The predominantly red, yellow, and gold light creates vibrant colors, while the low angle of the sun creates soft contrasts that define and enhance textures and shapes. Sunset colors create rich landscape, cityscape, and wildlife photographs.

For sunset pictures, AWB is a good general white-balance setting to use on the Digital Rebel. If you are shooting RAW images, you can also adjust the color temperature precisely in Canon's Digital Photo Professional RAW conversion program.

 See Chapter 7 for details on using Digital Photo Professional program.

Diffused light

On overcast or foggy days, the light is diffused and tends toward the cool side of the color temperature scale. Diffusion spreads light over a larger area making it softer, and it usually reduces or eliminates shadows. Light can be diffused by clouds; an overcast sky; atmospheric conditions including fog, mist, dust, pollution, and haze; or objects such as awnings or shade from trees or vegetation.

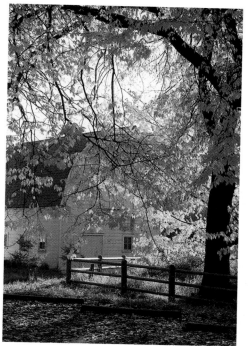

4.3 Low-angled sunlight provided beautiful backlighting for this fall farm scene.

Even in bright light, you can create a diffuse light by using a *scrim*, which is a panel of cloth, such as thin muslin or other fabric, stretched tightly across a frame. The scrim is held between the light source (the sun or a studio or household light) and the subject to diffuse the light.

Diffused light creates saturated color, highlights that are more subdued than in open light, and shadows that are softer. Diffuse light is excellent light for portraits.

Because overcast and cloudy conditions commonly are between 6,000 and 8,000 degrees K, the Cloudy, twilight, sunset white-balance setting on the Digital Rebel is a good choice for overcast conditions. For cloudy conditions, AWB is a good choice.

Electronic flash

Most on-camera electronic flashes are balanced for the neutral color of midday light, or 5,500 to 6,000 degrees K. Because the light from an electronic flash is neutral, in the correct intensities it reproduces colors accurately.

Flash is obviously useful in low-light situations, but it is also handy outdoors where fill-flash eliminates shadow areas caused by strong top lighting and provides detail in shadow areas for backlit subjects.

On the Digital Rebel, the Flash white-balance setting, which is set to 6,000 K, is the best option, and it reproduces colors with high accuracy.

Tungsten light

Tungsten is the light commonly found in household lights and lamps. This light is warmer than daylight and produces a yellow/orange cast in photos that, in some cases, is valued for the warm feeling it lends to images.

Setting the Digital Rebel to the Tungsten white-balance setting retains a hint of the warmth of tungsten light while rendering colors which have high accuracy. If you want to retain a hint of the warmth of tungsten light, use white-balance bracketing on either camera.

Fluorescent and other light

Commonly found in office and public places, fluorescent light ranges from a yellow to a blue-green hue. Fluorescent light produces a green cast in photos when the white-balance is set to Daylight or Auto.

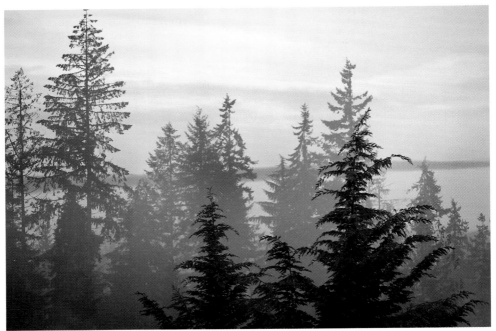

4.4 A combination of sunshine and fog creates a sense of depth in this image.

Other types of lighting include mercury-vapor and sodium-vapor lights found in public arenas and auditoriums that have a green/yellow cast in unfiltered/uncorrected photos. It's a good idea to set a custom white-balance on the Digital Rebel in this type of light.

Under fluorescent light, set the camera to the White fluorescent light setting (approximately 4,000K). In stadiums, parking lots and other colors, you may want to set a custom white balance or use AWB.

Light from fire and candles creates a red/orange/yellow cast. In most cases, the color cast is warm and inviting and can be modified to suit your taste on the computer.

Metering Light

Your camera's reflective light meter sees only gray. Objects that you see as "neutral" gray, an even mix of black and white, reflect 18 percent of the light falling on them and absorb the rest of the light. In a black-and-white world, objects that you see as white reflect 72 to 90 percent of the light and absorb the remainder. Objects that you see as black absorb virtually all of the light. All other colors map to a percentage or shade, of gray. Intermediate percentages between black and white reflect and absorb different amounts of light.

In color scenes, the light and dark values of color correspond to the swatches of gray on the grayscale. A shade of red, for example, has a corresponding shade of gray on a grayscale. The lighter the shade, the more light it reflects.

The Digital Rebel's reflective light meter (which measures light that is reflected back to the camera from the subject) assumes that everything is 18 percent gray. The meter expects to see an average scene, one that contains a balance of dark and light tones. In average scenes, the camera's meter produces an accurate rendition of what the human eye sees. However, in scenes with large expanses of snow, white sand, and black objects you often get pictures with gray snow or gray graduation gowns that should have been black.

Colored surfaces reflect some color onto nearby objects. For example, if you photograph a person sitting in the grass, green is reflected into the subject. The closer the subject is to the grass, the more green will be reflected in the subject's face. Similarly, photographing a subject under an awning or near a colored wall also results in that color reflecting onto the subject. The amount of reflectance depends on the proximity of the subject to the color and the intensity of the color.

So, you must be aware not only of the color of the primary light, but also of surrounding structures that reflect onto the subject. Reflected color, of course, can make it difficult to get correct color in the image. To avoid or minimize corrections, it's best to move the subject away from the surface that is reflecting onto the subject.

What Is the Best Light?

Photographers often describe light as harsh or soft. Harsh light creates shadows with well-defined edges. Soft light creates shadows with soft edges. There are traditional uses for each type of light. Understanding the

4.5 Hard light illuminated the transparent petals of the tulips emphasizing their rich color.

effect of each type of light before you begin shooting is the key to using both types of light, and variations in between, effectively.

Hard/harsh light

Hard light is created when a distant light source produces a concentrated spotlight effect — for example, light from the sun in a cloudless sky at midday, an electronic flash, or a bare light bulb. Hard light creates dark, sharp-edged shadows as well as a loss of detail in highlights and shadows.

For example, portraits taken in harsh overhead light create dark, unattractive shadows under the eyes, nose, and chin. This type light is also called contrasty light. Contrast is measured by the difference in exposure

readings (f-stops) between highlight and shadow areas. The greater the difference, the higher the contrast. Because hard light is contrasty, it produces well-defined textures and bright colors. Hard light is best suited for subjects with simple shapes and bold colors.

To soften hard light, you can add or modify light on the subject by using a fill flash or a reflector to bounce more light into shadow areas. In addition, you can move the subject to a shady area, or place a scrim (diffusion panel) between the light and the subject. For landscape photos, you can use a graduated neutral density filter to help compensate for the difference in contrast between the darker foreground and brighter sky.

Soft light

Soft light is created when clouds or other atmospheric conditions diffuse a light source, such as the sun. Diffusion not only reduces the intensity (quantity) of light, but

4.6 Diffused light created pleasing soft light for this portrait.

it also spreads the light over a larger area (quality). In soft light, shadow edges soften and transition gradually, texture definition is less distinct, colors are less vibrant than in harsh light, detail is apparent in both highlights and shadow areas of the picture, and overall contrast is reduced.

When working in soft light, consider using a telephoto lens and/or a flash to help create separation between the subject and the background. While soft light is usually well suited for portraits and macro shots, it is less than ideal for travel and landscape photography. In these cases, look for strong, details and bold colors, and avoid including an overcast sky in the photo.

Directional light

Whether natural or artificial, the direction of light can determine the shadows in the scene. Dark shadows on a subject's face under the eyes, nose, and chin result from hard, top light. You can use both the type and direction of light to reveal or hide detail, add or reduce texture and volume, and help create the mood of the image.

Front lighting

Front lighting is light that strikes the subject straight on. This lighting approach produces a flat effect with little texture detail, and with shadows behind the subject, as seen in many snapshots taken with an on-camera flash.

Side lighting

Side lighting places the main light to the side of and at the same height as the subject. One side of the subject is brightly lit, and the other side in medium or deep shadow, depending on the lighting setup. While this technique is often effective for portraits of men, it is usually considered unflattering for portraits of women.

4.7 Dappled backlighting creates interesting patterns in this image.

However, a variation of side lighting is *high-side lighting*, a classic portrait lighting technique where a light is placed to the side and higher than the subject.

Top lighting

Top lighting, as the term implies, is light illuminating the subject from the top, such as you'd find at midday on a sunny, cloudless day. This lighting produces strong, deep shadows. While this lighting direction is suitable for some subjects, it is usually not appropriate for portraits unless fill light is added using a flash or reflector.

However, a variation on top lighting is *butterfly lighting*, a technique popularized by classic Hollywood starlet portraits. Butterfly lighting uses high, front, top light to create a symmetrical, butterfly-like shadow under the nose.

Backlighting

Backlighting is light that is positioned behind the subject. This technique creates a classic silhouette, and depending on the angle, can also create a thin halo of light that outlines the subject's form. While a silhouette can be dramatic, the contrast obliterates details in both the background and subject unless a fill flash is used.

In addition, backlighting often produces lens flare displayed as bright, repeating spots, or shapes in the image. Flare can also show up in the image as a dull haze or unwanted rainbow-like colors. To avoid lens flare, use a lens hood to help prevent stray light from striking the lens, or change your shooting position.

Tip *While you may not be able to control the light, especially natural outdoor light, consider these items that may improve your shot:*

- *Move the subject*
- *Change your position*
- *Use a reflector or scrim*
- *Use a filter or change white-balance settings to balance color for or enhance the light*
- *Wait for better light or a light color that enhances the subject or message of the picture*

The Art and Science of Lenses

One of the biggest advantages to owning the Canon Digital Rebel is the ability to use EF and EF-S-mount interchangeable lenses. Simply by changing lenses, you can transform a boring scene into a compelling and interesting composition.

Because the lens is the "eye" of the camera, the importance of quality lenses can't be underestimated. With a high-quality lens, pictures will have stunning detail, high resolution, and snappy contrast. Conversely, low-quality optics produce marginal picture quality.

Lens Choices

Lenses range in focal lengths, or the amount of the scene included in the frame, from fisheye to super telephoto, and lenses are generally grouped into three main categories: wide angle, normal, and telephoto along with macro lenses that serve double-duty as either normal or telephoto lenses as well as offering macro capability.

Wide angle

Wide-angle lenses offer a wide view of a scene. Lenses shorter than 50mm are commonly considered wide angle. For example, 16mm and 24mm lenses are wide angle. A wide-angle lens also offers sharp detail from foreground to background especially at narrow apertures such as f/22. The amount of reasonably sharp focus front to back in an image is referred to as *depth of field*.

5.1 A wide-angle lens captures an extensive view of a scene. This image was taken with a 35mm lens, which is equivalent to 56mm on the Rebel. As a result of the focal length factor on the Digital Rebel, less of the scene is included than would be on a full-frame camera.

 Cross-Reference *Depth of field is discussed in more detail in Chapter 3.*

Normal

Normal lenses offer a "normal" angle of view and perspective very much as your eyes see the scene. On full-35mm-frame cameras, 50mm to 55mm lenses are considered normal lenses. Normal lenses provide excellent depth of field (particularly at narrow apertures), are compact, and versatile.

Telephoto

Telephoto lenses offer a narrow angle of view enabling close-up views of distant scenes. On full-35mm-frame cameras, lenses whose focal lengths are longer than 50mm are considered telephoto lenses. For example, 80mm and 200mm lens are telephoto lenses. Telephoto lenses offer shallow depth of field providing a softly blurred background, particularly at wide apertures.

Understanding Zoom and Single-Focal-Length Lenses

In addition to these basic lens categories, you can also choose between zoom and single-focal-length lenses, also called "prime" lenses. As you think about adding lenses to your system, knowing the advantages and disadvantages of each type of lens helps you choose the type of lens you'll use most often for the situations you photograph most often.

Zoom lens advantages

The obvious advantage of a zoom lens is the ability to quickly change focal lengths without changing lenses. In addition, only two or three zoom lenses are needed to encompass the focal range you'll use most often for everyday shooting.

Most mid-priced and more expensive zoom lenses offer high-quality optics that produce sharp images with excellent contrast.

Zoom lens disadvantages

While zoom lenses allow you to schlep around fewer lenses, zoom lenses tend to be heavier than their single-focal-length counterparts. Mid-priced, fixed-aperture zoom lenses tend to be "slow," meaning that with maximum apertures of only f/4.5 or f/5.6, they call for slower shutter speeds that limit your ability to get sharp images when hand-holding the camera.

Some zoom lenses have variable apertures. If a variable-aperture f/4.5 to f/5.6 lens at the widest focal length has an aperture of

5.2 A normal lens captures the size relationships of various items in the scene much as your eyes see them. This picture was taken with a 50mm lens.

Macro

Macro lenses are designed to provide a closer lens-to-subject focusing distance than non-macro lenses. Depending on the lens, the magnification ranges from half-life size (0.5x) to 5x magnification. Thus, objects as small as a penny or a postage stamp can fill the frame, revealing breathtaking details that are commonly overlooked or not visible to the human eye. By contrast, non-macro lenses typically allow maximum magnifications of about one tenth life size (0.1x). Macro lenses are single focal-length lenses that come in normal and telephoto focal lengths.

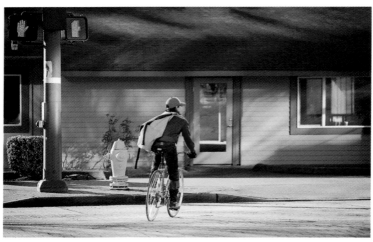

5.3 A focal length of 153mm offered a closer view of this boy riding his bike. This picture was taken at ISO 100, f/2.8 with a shutter speed of 1/350 second.

5.4 A macro lens captures extreme close-ups such as this picture that was taken with a Canon EF180mm f/3.5L Macro USM lens.

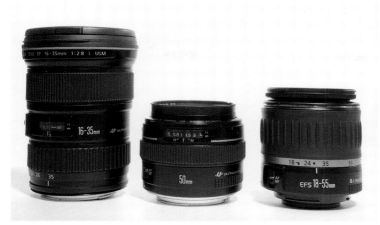

5.5 While zoom lenses are versatile, a single-focal-length lens, such as the 50mm lens shown in the center, is often smaller and lighter.

f/4.5, at the telephoto end it has an aperture of f/5.6. Unless you use a tripod or your subject is stone still, your ability to get a crisp picture in lower light at f/5.6 will be questionable.

> **Cross-Reference** *For a complete discussion on aperture, see Chapter 3.*

More expensive zoom lenses offer a fixed and fast maximum aperture, meaning that with maximum apertures of f/2.8, they allow faster shutter speeds that enhance your ability to get sharp images when hand-holding the camera. But the lens speed comes at a price: the faster the lens, the higher the price.

Single-focal-length lens advantages

Unlike zoom lenses, single-focal length, or prime, lenses tend to be fast with maximum apertures of f/4.5 or wider. Wide apertures allow fast shutter speeds, and that combination allows you to hand hold the camera in lower light and still get a sharp image. Compared to zoom lenses, single-focal-length lenses are lighter and smaller.

In addition, many photographers believe that single-focal length-lenses are sharper and provide overall better image quality than zoom lenses.

Single-focal-length lens disadvantages

While most prime lenses are lightweight, you need more of them to cover the r ange of focal lengths needed for everyday photography, although some famous photographers used only one prime lens. Single-focal-length lenses also limit the options for on-the-fly composition changes that are possible with zoom lenses.

Understanding the Focal-Length Multiplication Factor

The Digital Rebel image sensor is 1.6 times smaller than a traditional 35mm film frame. It is important to know the sensor size because it not only determines the size of the image, but it also affects the angle of view of the lenses you use. A lens's angle of view is how much of the scene, side-to-side and top-to-bottom, that the lens includes in the image.

5.6 This image shows the approximate difference in image size between a 35mm film frame and the Canon Digital Rebel. The smaller image size represents the Digital Rebel's image size.

The angle of view for all lenses you use on the Canon Rebel is narrowed by a factor of 1.6 times at any given focal length giving an image equal to that of a lens with 1.6 times the focal length. That means that a 100mm lens on a 35mm film camera becomes the equivalent to a 160mm on the Digital Rebel. Likewise, a 50mm normal lens becomes the equivalent of an 80mm lens, which is equivalent to a short telephoto lens on a full-35mm-frame size. And, the EF-S 18-55mm f/3.5-5.6 lens that comes with the Digital Rebel kit produces an equivalent angle of view of 28.8 to 88mm, which is a very useful focal range for out-and-about shooting.

Note *The EF-S 18-55mm lens is usable only on the Digital Rebel due to a redesigned rear element that protrudes back into the camera body.*

This focal-length multiplication factor works to your advantage with a telephoto lens because it effectively increases the lens's focal length. And because telephoto lenses tend to be more expensive than other lenses, you can buy a shorter and less expensive telephoto lens and get 1.6 times more magnification at no extra cost.

The focal-length multiplication factor works to your disadvantage with a wide-angle lens because the sensor sees less of the scene when the focal length is magnified by 1.6. But, because wide-angle lenses tend to be less expensive than telephoto lenses, you can buy an ultra-wide 14mm lens to get the equivalent of an angle of view of 22mm.

Because telephoto lenses provide a shallow depth of field, it seems reasonable to assume that the conversion factor would produce the same depth of field results on the Digital Rebel that a longer lens gives. That isn't the case, however. While an 85mm lens on a full-35mm-frame camera is equivalent to a 136mm lens on the Digital Rebel, the depth of field on the Digital Rebel will match the 85mm lens, not the 136mm lens.

This depth-of-field principle holds true for enlargements. The depth of field in the print is shallower for the longer lens on a full-frame camera than it is for the Digital Rebel.

Using Wide-Angle Lenses

A wide-angle lens is great for capturing scenes ranging from large groups of people to sweeping landscapes, as well as for taking pictures in places where space is cramped.

When you shoot with a wide-angle lens, it pays to keep these lens characteristics in mind:

✦ **Extensive depth of field.** Particularly at small apertures such as f/8 or f/11, the entire scene, front to back, will be in reasonably sharp focus. This characteristic gives you slightly more latitude for less-than-perfectly focused pictures.

✦ **Narrow, fast apertures.** Wide-angle lenses tend to be faster (meaning they have wide apertures) than telephoto lenses. These lenses are good candidates for everyday shooting even when the lighting conditions are not optimal.

✦ **Distortion.** Wide-angle lenses can distort lines and objects in a scene, especially if you tilt the camera up or down when shooting. For example, if you tilt the camera up to photograph a group of skyscrapers, the lines of the buildings tend to converge and the buildings appear to fall backward (also called keystoning). You can use this wide-angle lens characteristic to creatively enhance a composition, or you can avoid it by moving back from the subject and keeping the camera parallel to the main subject;. Some wide-angle lenses can also produce images that tend to be soft along the edges.

 Tip To avoid keystoning, you can insert a small bubble level on the hot shoe to ensure that the camera is level. Keystoning and other lens distortions can often be repaired during photo editing; however, it is always better to avoid problems when shooting than fixing problems afterward.

✦ **Perspective.** Wide-angle lenses make objects close to the camera appear disproportionately large. You can use this characteristic to move the closest object farther forward in the image or you can move back from the closest object to reduce the effect. Wide-angle lenses are not suitable for close-up portraits because they exaggerate the size of facial features closest to the lens.

Tip If you're shopping for a wide-angle lens, look for aspherical lenses. These lenses include a non-spherical element that helps reduce or eliminate optical flaws to produce better edge-to-edge sharpness and reduce distortions.

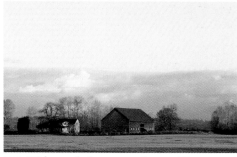

5.7 Wide-angle lenses such as a 22mm, provide excellent front-to-back sharpness especially at narrow apertures, such as f/11 used for this picture.

Using Telephoto Lenses

Choose a telephoto lens to take portraits, and to capture distant subjects such as birds, buildings and wildlife, and distant landscapes. Telephoto lenses such as 85mm and 100mm are perfect for portraits, while longer lenses (300 to 800mm) allow you to keep a safe distance while photographing wildlife. When you use a telephoto lens with a wide aperture such as f/4.0, the shallow depth of field can make grasses or cage bars at the zoo much less obvious, or, at times, seem to disappear.

When you shoot with a telephoto lens, keep these lens characteristics in mind:

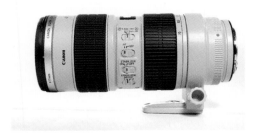

5.8 Telephoto lenses are larger and heavier than other lenses, but a good telephoto zoom lens is indispensable for photographers. This 70-200mm lens also features Image Stabilization (a Canon trademark) that helps counteract slight movement when handholding the camera.

✦ **Shallow depth of field.** Telephoto lenses magnify subjects and provide a very limited range of sharp focus. At wide apertures, such as f/4, you can reduce the background to a soft blur. Because of the extremely shallow depth of field, pay attention to careful focus. Many Canon lenses include full-time manual focusing which you can use to fine-tune the camera's autofocus.

✦ **Narrow coverage of a scene.** Because the angle of view is narrow with a telephoto lens, much less of the scene is included in the image. You can use this characteristic to exclude distracting scene elements from the image.

✦ **Slow lenses.** Mid-priced telephoto lenses tend to be slow; the widest aperture is often f/4.5 of f/5.6 and that limits the ability to get sharp images without a tripod in all but the brightest light. And because of the magnification factor, even the

slightest movement is exaggerated. Invest in a good tripod to ensure razor-sharp images.

✦ **Perspective.** Telephoto lenses tend to compress perspective making objects in the scene appear stacked together.

If you're shopping for a telephoto lens, look for those with low-dispersion lens elements that help reduce distortion and improve sharpness. Image Stabilization further counteracts blur caused by handholding the camera.

Using Normal Lenses

A normal lens is a great lens to keep on the Digital Rebel for everyday shooting. On a 35mm film camera it is 50mm, but on the Digital Rebel, a 35mm lens is closer to normal when the focal-length conversion factor is considered.

5.9 A normal lens is small and light. It provides an angle of view similar to that of the human eye.

Normal lenses are lightweight, offer fast apertures. In addition, normal lenses seldom have issues with optical distortion, and they produce pictures with a pleasing, "normal" perspective. Normal lenses are reasonably priced and offer sharp images with excellent contrast.

Using Macro Lenses

Macro lenses open a new world of photographic possibilities by offering an extreme level of magnification. In addition, the reduced focusing distance allows beautiful, moderate close-ups as well as extreme close-ups of flowers and plants, animals, raindrops, and everyday objects.

Normal and telephoto lenses offer macro capability. Because these lenses can be used both at their normal focal length as well as for macro photography, they do double-duty.

Canon offers macro lenses in the following focal lengths:

✦ 50mm, f/2.5 Compact Macro (0.5x magnification). A Life-Size Converter EF is also available for the EF 50mm Compact Macro lens.

✦ EF-S 60mm f/2.8 Macro USM lens (1:1 magnification).

✦ 100mm f/2.8 Macro USM and 180mm f/3.5L Macro USM (1:1 magnification).

✦ MP-E 65mm f/2.8 Macro Photo (1x-5x magnification).

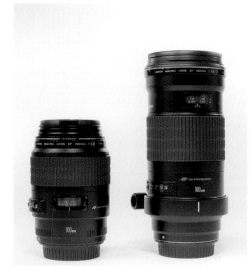

5.10 Canon offers several macro lenses including the EF 100mm f/2.8 Macro USM and EF180MM f/3.5L Macro USM that offer 1x (life-size) magnification and a minimum focusing distance of 0.48m/1.6 ft. This focusing distance is great for small objects such as insects where a longer working distance is desirable.

When you shoot with a macro lens, keep these characteristics in mind:

✦ **Extremely shallow depth of field.** At 1:1 magnification, the depth of field is less than 1mm at maximum aperture. The shallow depth of field makes focusing critical; even the slightest change to the focusing ring can throw the picture out of focus.

✦ **High magnification.** With extremely high magnification, any movement causes blur. It's best to always use a tripod and cable release or remote to release the shutter.

If you're buying a macro lens, you can choose lenses by focal length or by magnification. If you want to photograph moving subjects such as insects, choose a telephoto lens with macro capability. Moving subjects require special techniques and much practice.

 Cross-Reference *For ideas on using macro lenses, see Chapter 6.*

Based on focal length and magnification, choose the lens that best suits the kinds of subjects you want to photograph.

Extending the Range of Any Lens

For relatively little cost, you can increase the focal length of any lens by using an *extender*. An extender is a lens set in a small ring mounted between the camera body and a regular lens. Canon offers two extenders, a 1.4x and 2x. Extenders can also be combined to get even greater magnification.

5.11 Extenders, such as this Canon EF1.4 II mounted between the camera body and the lens, extend the range of your lenses. They increase the focal length by a factor of 1.4x, in addition to the 1.6x focal-length conversion factor inherent in the camera.

For example, using the Canon EF2xII extender with a 600mm lens doubles the lens's focal length to 1200mm before applying 1.6x. Using the Canon EF1.4II extender increases a 600mm lens to 840mm.

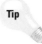 **Tip** *At longer focal lengths, it is critical to stabilize the camera on a tripod.*

Extenders do not change camera operation in any way, but they do reduce the light reaching the sensor. The EF1.4xII extender decreases the light by one f-stop, and the EF2xII extender decreases the light by two f-stops. And, in addition to being fairly lightweight, the obvious advantage of extenders is that they can reduce the number of telephoto lenses you carry.

Techniques for Great Photos

Now is a good time to do some serious shooting with your Digital Rebel. In this section of the book, you can brush up on composition basics and explore a wide variety of photography specialty areas and subjects.

There is no right way to use this chapter. You can skip around and try only the photography subjects that appeal to you, or you can try all of them. In some sections, several techniques are presented, all of which are suitable for the subject. Feel free to experiment creatively with these techniques to create your own unique effects. You'll know that the approach was successful when that one special picture seems to jump off the screen or leaves you with a feeling of deep satisfaction and pride.

While most of these techniques are straightforward and easy, some may take practice to perfect. And the pictures you take for photo subjects will, of course, vary depending on the scene and subject that you are shooting. Use the information in the book as a starting point, and as you shoot your pictures, think about how the scene you're capturing differs from the sample photo. Then use what you've learned in other sections of this book to modify and make adjustments as necessary. Creative problem solving is part of the fun of photography, and it helps you integrate all the elements of photography into your own shooting.

Remember, the best way to get great pictures is to take a lot of pictures.

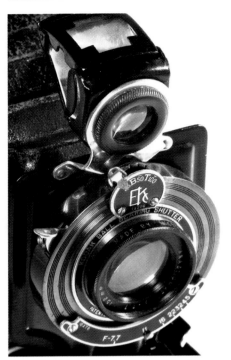

6.1 Whether you enjoy nature and landscape photography, macro photography, still life photography, or portraits, this chapter has something for everyone.

Tip *A great additional resource is the Canon Digital Learning Center at* www.Photoworkshop.com *where you'll find extensive online tutorials on both Digital Rebels, using Canon's accessory flash units, and using Canon's Digital Photo Professional software*

Composition Basics

Composition is the aspect of photography that many photographers strive to master first. Mastering composition, however, remains a lifelong goal for most photographers. While composition principles can help you design an image, ultimately, your

personal aesthetic sense is the final judge. After all, for every rule of composition, there are galleries filled with successful pictures that break the rules.

As a photographer, your eyes, your logic, your instinct, and your heart reveal and interpret each scene for the viewer. Your job is to combine your visual and emotional perceptions of a scene with the objective viewpoint of the camera. To begin, stand back and evaluate all of the elements in the scene. Gradually narrow your view and look for scenes within the scene. This exercise will help you learn to see isolated vignettes within the scene. Continue the exercise by looking closely within the vignette to identify dominant elements, colors, patterns, and textures, and think about how you can use them to organize the visual information in the picture.

Before you begin shooting, ask yourself these questions:

✦ Why am I taking this picture?

✦ What do I want to convey to the viewer with this picture, or what's the story?

If you don't consider these questions, you run the risk of taking a picture that lacks a clear message and is visually difficult to "read." Distilling the image to a single message is the first and most important step in creating a well-composed image.

When you know the message of the image, you can use traditional composition guidelines detailed here to help you refine the composition.

✦ **Is symmetry good or bad?**
Perfectly symmetrical compositions — images that are balanced from side to side or top to bottom — create a

6.2 Your perception of the scene, the lenses you use, the depth of field you choose, and the position from which you choose to photograph all affect the final composition of the image.

sense of balance and stability, but they are also often visually boring. The human eye seeks symmetry and balance, and once it finds it, the interest in the composition diminishes. Further, symmetrical compositions usually offer less visual impact than asymmetrical photos.

✦ **Create a sense of balance.** Balance is a sense of "rightness" in a photo. A balanced photo doesn't appear to be too heavy (lopsided) nor too off-center. To create balance, you should evaluate the visual "weight" of colors and tones (dark is heavier than light), objects (large objects appear heavier than light objects), and placement (objects placed toward an edge appear heavier than objects placed at the center of the frame) in the scene. Then arrange the elements to create a visual balance.

6.3 The diagonal angle of the main grass blade and the counterbalance of the background blade create a sense of balance in this image.

✦ **What do lines convey?** Because lines have symbolic significance, you can use them to bolster communication, to direct focus, and to organize visual elements. For example, you can place a subject's arms in a way that directs attention

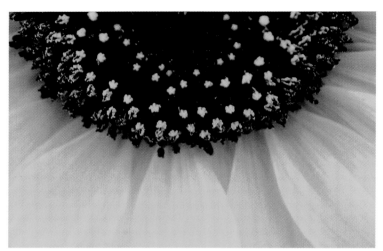

6.4 Big, bold images that fill the frame command immediate attention and closer inspection from viewers.

to the face. You can use a gently winding river to guide the viewer's eye through a landscape photo. You can use a strong diagonal beam in an architecture shot to bolster the sense of the building's strength.

Lines traditionally convey these meanings:

- Horizontal lines imply stability and peacefulness.

- Diagonal lines create strength and dynamic tension.

- Vertical lines imply motion and strength.

- Curved lines symbolize grace.

- Zigzag lines convey a sense of action.

- Wavy lines indicate peaceful movement.

- Jagged lines create tension.

✦ **Fill the frame.** Just as an artist would not leave part of a canvas blank or filled with extraneous details, you should try to fill the frame with elements that support the message. If you ask the questions suggested earlier, the answers will help you decide how much of the scene you want to include in the frame. Every element that you include should support and reveal more about the subject.

✦ **Check the background.** While this is related to the previous item, it merits separate discussion. In any picture, the elements behind and around the subject become as much a part of the photograph as the subject, and occasionally more so because the lens tends to compress visual elements. As you compose the picture, check all areas in the viewfinder for background and surrounding objects that, in the final image, seem to merge with the subject, or that compete with or distract from the subject.

The classic example of failing to use this technique is the picture of a person who appears to have a telephone pole or tree growing out of the back of his or her head. To avoid this type of background distraction, try moving the subject or changing your position.

✦ **Use the Rule of Thirds.** A standard composition technique in photography is the Rule of Thirds. Imagine that a tic-tac-toe grid is superimposed on the viewfinder. The grid divides the scene into thirds using horizontal and vertical lines. Interesting compositions are those that place the subject at one of the points of intersection or along one of the lines on the grid.

If you're taking a portrait, you might place a subject's eyes at the upper-left intersection point. In an outdoor photo, you can place the horizon along the top line to emphasize the foreground detail, or along the bottom line to emphasize a dramatic cloud formation. Using this type grid also helps create a sense of dynamic imbalance and visual interest in the picture.

In practice, you can use the following tips when composing different images:

- If your main point of interest is a static spot, try placing the main point of interest at any one of the intersecting grid lines.

- If the main point of interest is horizontal, or it is a horizon, try placing it along one of the horizontal grid lines.

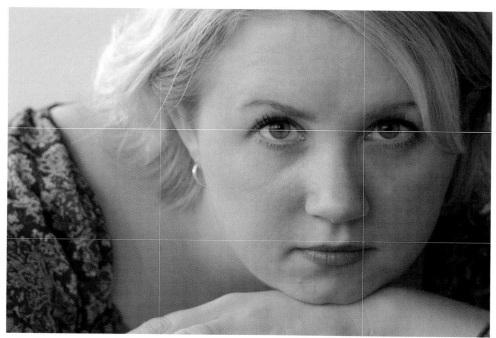

6.5 This image roughly shows the grid described by the rule of thirds.

- If the main point of interest is vertical, try placing it along one of the vertical grid lines.

✦ **Compose with color.** Depending on how colors are used in a photo, they can create a sense of harmony and balance, or they can make bold, stimulating visual statements. To use colors in composition, remember that complementary colors are colors opposite each other on a color wheel, such as green and red, and blue and yellow. Harmonizing colors are adjacent to each other on the color wheel, such as green and yellow, yellow and orange, and so on.

6.6 Bold colors create the interest in this image.

- If you want a picture with strong visual punch, use complementary colors of approximately equal intensity in the composition. If you want a picture that conveys peace and tranquility, use harmonizing colors.

- The more that the color of an object contrasts with its surroundings, the more likely that object will become the main point of interest. Conversely, the more uniform the overall color of the image, the more likely that color will dictate the overall mood of the image.

- The type and intensity of light can also affect the intensity of colors and, consequently, the composition. Weather conditions, such as a haze, mist, and fog, reduce the vibrancy of colors. These conditions are ideal for creating pictures with harmonizing, subdued colors. On a bright, sunny day, however, color is intensified and is ideal for composing pictures with bold color contrasts.

✦ **Frame the subject.** Photographers often borrow a technique from painters — putting a subject within a naturally occurring frame, such as a tree framed by a barn door or a distant building framed by an archway in the foreground. The frame may or may not be in focus, but to be most effective, it should add context or visual interest to the image.

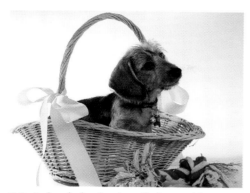

6.7 A simple basket handle is used here to frame the puppy.

✦ **Additional composition techniques.** These can include using strong textures, repeated patterns and geometric shapes, and color repetition or contrasts to compose images. These elements can create a picture themselves, or you can use them to create visual motion that directs the eye or supports the subject.

✦ **Control the focus and depth of field.** Because the human eye is drawn first to the sharpest part of the photo, be sure that the sharpest point of focus is on the subject or the part of the subject you want to emphasize, such as a person's eyes, for example. This establishes the relative importance of the elements within the image.

Differential focusing controls the depth of field or the zone (or area) of the image that is acceptably sharp. In a nutshell, differential focusing works like this: the longer the focal length and the wider the aperture, the less the depth of field (or the softer the background). Conversely, the shorter the focal length and the narrower the aperture, the greater the depth of field.

You can use this principle to control what the viewer focuses on in a picture. For example, in a picture with a shallow depth of field, the subject will stand in sharp focus against a blurred background. The viewer's eyes take in blurred background, but they return quickly to the much sharper area of the subject. With very shallow depth of field, you can virtually eliminate distractions behind the subject.

To control depth of field, you can use the techniques in Table 6.1 separately or in combination.

6.8 A very shallow depth of field focuses attention on the center playing piece in this image.

✦ **Change your point of view.** Instead of routinely photographing subjects at eye-level, try changing the viewpoint. For example, if you photograph a subject from a position lower than slightly below eye-level, the subject seems more powerful while a shooting position above the subject's eye-level creates the opposite effect.

Table 6.1
Depth of Field

To Decrease Depth of Field (Blur the Background)	To Increase the Depth of Field (Sharpen the Appearance of the Background)
Choose a telephoto lens or telephoto setting on a zoom lens.	Choose a wide-angle lens or wide angle setting on a zoom lens.
Choose a wide aperture, for example f/1.4 to f/5.6.	Choose a narrow aperture, for example, f/8 to f/22.
Move closer to the subject.	Move farther away from the subject.

✦ **Use tone and contrast.** Contrast—the difference between light and dark tones in a photograph—can be used to set off your subject. A small white flower appears more distinct against a large, dark wall than it does against a bright, light-colored wall.

✦ **Define space and perspective.** Some ways to control the perception of space in pictures include changing the distance from the camera to the subject, selecting a telephoto or wide-angle focal length, changing the position of the light, and changing the camera position.

For example, camera-to-subject distance creates a sense of perspective and dimension; when the camera is close to a foreground object, background elements in the image appear smaller and farther apart. A wide-angle lens also makes near objects appear proportionally larger than those in the mid-ground and background.

✦ **Leading lines.** Naturally occurring lines in an image can be used to lead the viewer's eyes from the foreground to the background. This is often used in landscape photos where the lines of a railroad track, for example, converge on a distant horizon, or a gracefully curving

river meanders into the distance. But the technique is equally useful in portraits and other types of photography. You can position the subject's arms and hands, for example, so that they lead the viewer's eyes to the subject's face.

6.9 The decorative marble balls form leading lines in this photo.

While knowing the rules provides a good grounding for well-composed pictures, Henri Cartier-Bresson summed it up best in when he said, "Composition must be one of our constant preoccupations, but at the moment of shooting it can stem only from our intuition, for we are out to capture the fugitive moment, and all the interrelationships involved are on the move. In applying the Golden Rule, the

only pair of compasses at the photographer's disposal is his own pair of eyes." (From *The Mind's Eye* [Aperture Publishing].)

Privacy Notes

The majority of this chapter discusses specific photography subjects. Before going further, it's important to add a note about privacy concerns. In general, as a photography enthusiast, you can photograph people and buildings that are in public places freely. But you should always be aware of privacy concerns when taking images of strangers and of commercial property. Some people and many corporate facilities do not want to be photographed or allow photographs of facilities.

Also be aware of whether you are shooting on public and private property. For example, most shopping malls are private property. You should not photograph at private malls,

stores, or on any other private property without the consent of the owner or management company. Also, it is not permissible to enter private property to take a person's picture without the person's permission. Most important, always avoid photographing children even in public places without the consent of the parents. Even if the photo does not identify the child, common courtesy dictates the wisdom of getting parental permission before you make a picture.

 Note *If you sell your photographs, additional considerations apply. I recommend reading* The Law in Plain English for Photographers, *by Leonard D. DuBoff.*

Abstract Photography

Usually when you take pictures, you want the subject to be clearly recognizable, or literal, so that the viewer immediately

6.10 Simple backlit wire creates an intriguing abstract photo.

6.11 A light display at a science exhibition created this play of light streaks.

recognizes what the subject is. However, in abstract photography, you can leave much more to the viewer's imagination. In fact, subjects in abstract photography are often unrecognizable.

Abstract photography ranges from extreme close-ups and macro photos, to vague and beautifully evocative shapes, colors, and forms that may or may not be identifiable. At the heart of abstract photography is the sensory response that the image evokes for the viewer.

Whether it's a sense of grace and peace from the softly blurred shapes of lilies or the sense of strength and confidence aroused by bold liquid-looking colors reflected in a chrome bumper, the success of abstract images lay in the feelings and imaginings that they suggest.

Unlike literal photos, abstract images invite active participation from the viewer in interpreting the image. And during the process of interpretation, the image may gradually change ownership, becoming as much the viewer's photo as it is the photographer's.

While approaches to abstract photography sidestep many of traditional photography guidelines, it's still important for photographers to provide a visual organization and composition of abstract elements if the image is to be successful.

The Creative Zone modes on the Digital Rebel give you the freedom to create abstract images that challenge your skills and spark the viewer's imagination.

Inspiration

Nature provides a treasure-trove of abstract images. For example, natural abstract images are found in the reflections of trees in the ripples of a lake, the soft pastels in a wash of evening clouds, the graphic pattern of shadows cast on a sidewalk, the graceful rise and fall of sand dunes, a pattern of waves lit by the low angle of the sun, raindrops beaded on a waxy leaf, or the fragile, lacey patterns of frost on a winter window.

In home and urban scenes, look for reflections and shadow patterns cast on mirrored buildings and solid white walls that provide strong graphic patterns. Other potential subjects include objects against window blinds, colorful objects reflected in a chrome fender or tailpipe, softly blurred trees through a rain-soaked window, unique perspectives and framing of musical instruments, or isolated architectural elements such as a louvered awning.

Abstract photography practice

Abstract photography tips

✦ **Keep it abstract.** The more literally you depict a subject, the less abstract the image will be. To get a more abstract interpretation of the subject, move closer to, or move to one side or the other of the subject, or photograph only the reflections or shadows cast by a literal object.

✦ **Trust your eye and your instincts.** The best abstract images are those that catch your eye — if something catches your eye, chances are good that it will catch the eye of viewers as well.

6.12 This abstract photo captures the undulating image of a building reflected in a gently rippling lake.

Table 6.2
Taking Abstract Pictures

Setup	In the practice photo (see figure 6.12), it was important to find a shooting position where the rippled reflections filled the frame and literal background elements were eliminated.
	When you take abstract images, set up or frame the picture so that it includes only the abstract elements that you want in the final image. Including objects that are easily identifiable typically makes the image less abstract. Shoot from different angles to see how the composition changes.
Lighting	**Practice Picture:** This was taken at mid-afternoon on a gray, cloudy day. The subdued light and the color of the reflections create an appealing monotone look.
	On Your Own: Abstract images are excellent opportunities to experiment with dramatic and directional light as well as with color gels that you can place over the indoor lights, flash units, and inexpensive studio lights.
Lens	**Practice Picture:** Canon EF-S 18-55mm set at 55mm.
	On Your Own: Choose the lens that gives the effect you want. For example, a telephoto lens compresses space between objects while a wide-angle lens creates more visual distance between objects. Or try using a wide-angle lens and get close to make objects seem farther apart. You can use a macro lens to reveal the tiniest details of a subject that appear abstract in the image due to the close focusing distance.
Camera Settings	**Practice Picture:** RAW capture. Aperture-priority AE with white balance set to Cloudy. RAW capture and Aperture-priority AE are my preferred, general shooting modes. Aperture-priority AE mode allows me to change the depth of field quickly, and RAW capture mode allows me to make exposure adjustments after shooting.
	On Your Own: You can experiment with different white-balance settings to add specific hues of color to abstracts. Generally, Aperture-priority AE mode is a good choice because it allows you to control the depth of field by changing the f/stop.
Exposure	**Practice Picture:** ISO 100, f/16, 1/10 second. An alternative would have been to use a wider aperture, say f/5.6 or even f/8. I chose f/16 to ensure front-to-back sharpness in the image My personal preference is to shoot at low ISO settings. You can, of course, choose to use a higher ISO setting to get a faster shutter speed.
	On Your Own: Depending on the subject, it may be preferable to maintain extensive depth of field with abstracts by using a narrow aperture. However, your image may be more intriguing with a shallow depth of field. Experiment with different f/stops and see which gives the results you want. You can also try techniques in other sections of this chapter such as motion blur and panning to create abstract images.
Accessories	The slow shutter speed made using a tripod a necessity.

✦ **Use leading lines.** Scenes that have leading lines or imply a sense of continuity are good candidates for abstract photography. A series of two or more doorways that recede into the distance is an example.

✦ **Experiment with focus.** To enhance the abstractness of the subject, soften the focus or add a soft blur filter later in an image-editing program.

✦ **Try high- or low-key images.** High-key images, which have predominately light tones, and low-key images, which have predominately dark tones, can add intrigue to abstract images. For example, for a high-key abstract effect you could photograph a graceful white lily against a white background lit with bright sunlight.

Architectural Photography

Architecture mirrors the culture and sensibilities of each generation. New architecture reflects the hopeful aspirations of the times while older structures are often valued for the nostalgic memories they evoke. For photographers, both new and old architecture provides rich photo opportunities.

Architectural photography is about capturing the spirit of the times, and it is about capturing the spirit of the structure. In short, architectural photography is photographing a sense of place and space.

Get Creative

When foreground elements mirror the architecture, be sure to use them in the composition to lead the eye. For example, if a nearby metal sculpture echoes the glass and steel design of the building, include all or part of the sculpture for foreground interest.

Whether or not architecture is your primary interest, a brief foray into architectural photography will help hone your eye for how lines, masses, and spaces work together to create a definable presence.

If you're new to architectural shooting, choose a building and spend time studying how light at different times of the day transforms the character of the building. Look for structural details and visual spaces that create interesting shadow plays, reflections, and patterns as they interact with other subsections of the structure.

6.13 In this image, the buildings seem to be a single unit, although they are not. A telephoto lens compressed the visual distance between the two office buildings.

About Wide-Angle Distortion

Both wide-angle and telephoto lenses are staple lenses in architectural photography. When you use a wide-angle lens at close shooting ranges, and especially when the camera is tilted upward, the vertical lines of buildings converge toward the top of the frame. You can correct the distortion in an image-editing program, or you can use a tilt-and-shift lens, such as the Canon TS-E24mm f/3.5L, that corrects perspective distortion and controls focusing range. Shifting raises the lens parallel to its optical axis to correct the wide-angle distortion that causes the converging lines. Tilting the lens allows greater depth of focus by changing the normally perpendicular relationship between the lens's optical axis and the camera's sensor.

To use a tilt-and-shift lens, you set the camera so that the focal plane is parallel to the surface of the building wall. As the lens is shifted upward, it causes the image of the wall's surface to rise vertically thus keeping the building shape rectangular.

Most buildings are built for people, and people contribute to the character of the building. In a compositional sense, people provide a sense of scale in architectural photography, but more important, they imbue the building with a sense of life, motion, energy, and emotion.

The umbrella of architectural photography includes interior photography of both commercial and private buildings and homes. Just as it does when you photograph a building's exterior, light plays a crucial role in creating compelling interior images. As you thumb through a few pages of *Architectural Digest* magazine or similar publications, it is clear that well-planned lighting makes or breaks the shot. Chances are that you don't have studio lights, but you can use an accessory flash or multiple wireless flash units to supplement interior lighting. It's also entirely possible to get lovely interior shots by using ordinary room lighting judiciously.

Inspiration

Be sure to go inside buildings and look for interior design elements that echo the exterior design. Then create a series of pictures that explain the sense of place and space.

6.14 An office complex patio provides a view to the neighboring office building and allows one to play off the other visually.

Find old and new buildings that were designed for the same purposes—courthouses, barns, cafes and restaurants, libraries, or train stations, for example. Create a photo story that shows how design and use has changed over time. As you shoot, study how the building interacts with surrounding structures. See if you can use juxtapositions for visual comparisons and contrasts.

As you consider buildings and interiors, always try to verbalize what makes the space distinctive. When you can talk about the space, you can begin to think about ways that will translate your verbal description into visual terms.

For interior practice, try photographing your home or office using a wide-angle lens. Look for distinctive and meaningful details that would help a stranger get a sense of place from your images.

Architectural photography practice

Architectural photography tips

✦ **Emphasize color.** If the building you're photographing features strong, vivid colors, you can emphasize the colors by shooting in bright midday sunlight.

✦ **Use surrounding elements to underscore the sense of place and space.** For example, a university building's design that incorporates gentle arches might be photographed through an archway leading up to the entrance. Or if the area is known for something such as an abundance of dogwood trees, try including a graceful branch of blossoms at the top and side of the image to partially frame the structure. And consider using the same supporting element, say dogwood blossoms, in a series of images on a single building or several buildings in that area. The dogwood blossoms can be a thematic element that unites a sequence of images.

6.15 The roofline of an older low-rise building in the foreground sets off the imposing new high-rise apartment complex.

Table 6.3
Taking Architectural Pictures

Setup	**Practice Picture:** For this image (shown in figure 6.15), I wanted an angle that gave strong lines for the foreground low-rise building so that it contrasted with the imposing height of the new high-rise apartments. I could have filled the frame with the building, but I chose to include some sky area to contrast to the similar colors of the two buildings. **On Your Own:** Study the building looking for the best details. Will details be best pictured straight on or from the side? Can you isolate repeating patterns that define the style? Consider contrasting ultra-modern buildings with older, nearby buildings. Frame architectural images carefully to include only the detail or structures that matter in the image.
Lighting	**Practice Picture:** Front lighting at midday on a cloudy day gave the structure an overall flat look, almost as if the foreground and background buildings are a single unit. **On Your Own:** Older buildings often look especially good photographed in golden late-afternoon light or take advantage of sunny weather to show off the bold details and angular design of modern buildings. For mirrored buildings, reflections cast by nearby sculptures, passing clouds, and passing people can sometimes add interest.
Lens	**Practice Picture:** Canon EF-S 18-55mm lens at 31mm. As an alternative, it would be interesting to use a medium telephoto lens to further flatten the visual space between the two buildings. **On Your Own:** Zoom lenses are very helpful in isolating only the architectural details that you want while excluding extraneous objects such as street signs. If you use a wide-angle lens and want to avoid distortion, keep the camera on a level plane with the building — avoid tilting the camera up or down.
Camera Settings	**Practice Picture:** RAW capture. Aperture-priority AE with white balance set to Daylight. **On Your Own:** Aperture-priority AE mode allows you to control the depth of field, which is important in architectural photos. In most cases, choose a narrow aperture ranging from f/8 to f/16 to ensure sharpness throughout the image.
Exposure	**Practice Picture:** ISO 100, f/20, 1/40 second. A narrow aperture of f/20 provides good sharpness throughout the image. **On Your Own:** Always meter for the most important area of the image. If the image is of a building and there is a statue nearby, meter for the building, not the statue. Bracket exposures to help ensure that highlight detail is maintained. In most cases, choose a narrow aperture ranging from f/8 to f/16 to ensure sharpness throughout the image.
Accessories	While I did not use one for this particular shot, very often, a polarizing filter is an excellent way to reduce or eliminate glare from glass and mirrored building surfaces. In addition, it also enhances color contrast. Architectural photos are expected to be very sharp and show extensive depth of field. Use a tripod unless there is a very good reason not to.

✦ **Try A-DEP mode.** If your photograph shows a succession of buildings from an angle that puts them in a stair-stepped arrangement, use A-DEP mode to get the best depth of field. The camera analyzes the scene and automatically calculates the best aperture for maximum depth of field.

✦ **Deal with interior lighting.** For interior photographs, the most challenging aspect can be uneven lighting as well as extremes between highlight and shadow areas. Switch to Aperture-priority AE mode and take meter readings on light and dark areas. If there is a one-stop difference between areas set your exposure halfway between the two or take an exposure reading off an area between the two in brightness. If greater than one stop difference, set exposure bracketing in steps wide enough to cover the range.

This ensures that you get three exposures that you can composite in an image-editing program to create a single image with nicely exposed light, midtone, and shadow areas. If you use this technique, be sure to use a tripod and keep the camera in exactly the same position throughout the bracketed shots. Otherwise the three images will not register when you combine them in your image-editing program.

Action and Sports Photography

Action and sports shots offer cool creative opportunities for adding great images to your collection. They are your chance to capture the thrill and emotion of the action.

From a technical point of view, there are two approaches to taking action and sports photos. The first and most traditional approach with sports photography is to freeze action showing the action mid-motion. Freezing action is the technique that top sports photographers use to get shots of athletes in seemingly impossible positions and with the emotion that shows that their heart and soul go into every play.

The second and more artistic approach to action and sports photography is to show the motion as a blur. While freezing action captures emotion and physical feats in mid-progress, the images can sometimes make it appear as if the subject is standing still. This static depiction fails to convey the thrill and energy that makes the scene exciting. With slow shutter speeds and employing techniques such as panning, you can convey a sense of speed and artistry.

The images in 6.16 and 6.17 show both approaches.

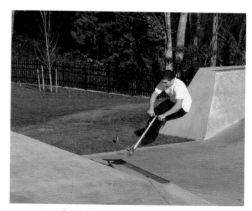

6.16 For this shot, I used a fast shutter speed to freeze the action.

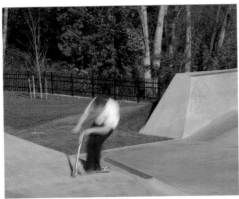

6.17 On the other hand, for this shot, I used a slow shutter speed to show blurred motion.

Inspiration

Sports photography encompasses the entire range of sports activities from volleyball and skiing to car racing. Action subjects cover a broader range; everything from children playing to puppies romping in the yard to people walking on the street.

As you take sports and action photos, it's important to not only master the techniques of freezing or blurring motion, but also to capture the emotion and sense of being "in the moment." And if you photograph sports that you play or are interested in, your passion or enthusiasm for the sport is often conveyed in your images.

The difference in technique is primarily a result of shutter speed. Fast shutter speeds freeze motion and slow shutter speeds show motion as a blur. In addition, with a slow shutter speed, if you move the camera to follow the subject, you can blur background elements while keeping part of the subject in reasonably good focus. This is called *panning* (described later in this chapter). The Digital Rebel is more than capable of either freezing action or showing it as a blur.

Stop-motion practice

Whether you're shooting a child playing in a youth league game or athletes in a professional event, the traditional approach to sports photography is to freeze the subject in mid-motion.

This is a good time to make use of the Rebel's continuous drive mode in one of the

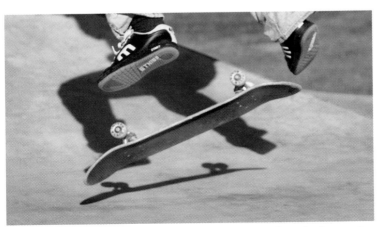

6.18 Not every photo needs the full figure to complete the image. In this image, the skateboarder is "completed" by his shadow.

Creative Zone modes to get a series of pictures. Then you can choose the best of the series. Of course, you can also switch to Sports mode and get great shots. The camera automatically tracks the subject until you press the Shutter button. If the light is dim or overcast, set the ISO to 200 or 400 to ensure a fast shutter speed to freeze subject motion.

When you shoot action shots with the Digital Rebel, either make sure the camera stays on continuously or be sure to wake up the camera well before the action occurs. Otherwise, while you wait for the camera to power-on, you'll miss one or more shots. Or set the Auto power off option to a longer period of time. On the Setup menu, select Auto power off, and then select a longer time period, such as 15 or 30 minutes before the camera powers off.

Lighting determines many of the options you have or don't have in shooting sports shots, including the ability to successfully hand-hold the camera, the ability to freeze the action, and the final quality of images. Be sure to arrive at the venue early and take test shots. If the light is too low to freeze action, switch to the fastest lens you own, preferably an f/2.8 lens, and open up to f/2.8 for shooting.

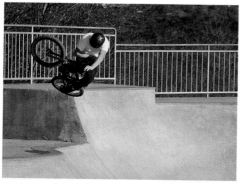

6.19 Catching the contortions and nuances of athletes in action go to the heart of sports and action photography.

Alternately, increase the ISO up to 400. If you switch from ISO 100 to 200, half as much light is needed to make the exposure. And half as much light is needed if you move from ISO 200 to 400. Be aware that ISO settings faster than 400 will generate noticeable digital noise in the images. While you can decrease the noise in an image-editing program, most noise-reduction processes also resulted in decreased image detail. If you are within range of the built-in flash, you can try using the built-in or an accessory flash. Flash photos taken from typical grandstand distances, however, simply are not effective because the flash is too far away from the subject.

Several variables figure into exposure for freezing action including the speed at which the subject is moving, the angle of subject movement, the type of lens you use, and the depth of field that you want. For example, to free the motion of a person running in a race requires a slower shutter speed than that needed for a car racing on a track. In addition, the subject will be in the frame longer with a wide-angle lens than with a telephoto lens. Here are some helpful guidelines.

✦ The closer the subject is to you, the faster the shutter speed you need. With a 100mm lens and the subject 25 feet away and moving toward or away from the camera at approximately 10 mph, use 1/250 second. If the subject is 25 feet away and moving parallel to the camera, use 1/1000 second; and if the subject is moving at a 90-degree angle to the camera, use 1/500 second.

✦ If the camera-to-subject distance halves, double the shutter speed.

✦ If the camera-to-subject distance doubles, halve the shutter speed.

✦ At any angle, as the subject speed increases from 5 to 10, 10 to 30, and 40 to 60 mph, double the shutter speed.

For sports photography in particular, a telephoto lens is indispensable if you want close-up action from a grandstand shooting position. Canon offers a variety of affordable telephoto zoom lenses that gain a boost from the 1.6x focal length factor. Combine a telephoto lens with an extender, and you can get very close to the action.

> **Tip**
>
> *For the fastest shooting prefocus manually on an object that is the same distance away that the subject will be. For example, an object beside the race track, a post, or a flag on the track. Then with the focus set, wait for the action to come into the focused space.*

Blur-motion practice

At the other end of the spectrum is showing all or part of the action as a blur. Not only does this technique lend a creative touch to images, it is also a good way to show speed in fast action scenes, or to show a sense of movement and change in non-action photos. Blurring motion is the technique street photographers often use to impart the sense of speed or movement by showing a blur of people walking across a busy street. It is also effective to show the unusual action of a music concert or to slow the motion of water running over a waterfall to a silky blur.

In contrast to freezing action, showing motion as a blur is achieved by using slower shutter speeds that allow the subject motion to be recorded on the image sensor.

Table 6.4
Taking Stop-Action Pictures

Setup	**Practice Picture:** In figure 6.19 I took a shooting position where I would not disturb other athletes but could still get a clean foreground and reasonably clean background.
	On Your Own: Use height to your advantage in sports shooting. For example, take a position in the bleachers that offers a higher vantage point. Watch the background for distractions including billboards and signs, and either choose a place on the field for the shot that offers fewer background distractions, or use a wide aperture to blur them.
Lighting	**Practice Picture:** This picture was taken in bright, mid-afternoon sunlight.
	On Your Own: Lighting for sports events covers the gamut. Arrive early enough to find areas on the field that have good, consistent light and concentrate on shooting in that area. At grandstand distance, and even at sideline distances, the built-in flash will be ineffective.

Lens

Practice Picture: For this image, I used a Canon 70-200mm, f/2.8L IS USM lens.

On Your Own: Unless you are along the sidelines, a telephoto lens is your best friend at sports events. You can consider using an extender to bring the action even closer, but it will cost one to two stops of light if you use it. The Canon 70-200mm, f/2.8L IS USM lens is a great choice because it offers a good focal range and is a fast lens.

While a wide-angle lens will provide an overall view of the field, the players' faces will likely be unidentifiable, and unless you are on the sidelines, the figures will be so small that they become insignificant. In addition to bringing the action closer, a telephoto lens creates a shallow depth of field that makes background elements such as fences, billboards, and sponsorship signs less distracting. If you don't have a telephoto lens, you can get acceptable shots with a normal or wide-angle lens. If the subject isn't close enough in the final image, you can crop the image in any image-editing program.

Camera Settings

Practice Picture: Sports mode with the white balance set to Daylight. You can also use Shutter-priority AE mode and set a shutter speed of 1/60 second or faster to freeze the action. In low-light scenes, you can increase the ISO to 200 or 400 to enable a fast-enough shutter speed to freeze the action.

On Your Own: Sports mode is a good choice because it offers focus tracking. In low-light sports venues, you may want to switch to Shutter-priority AE mode to ensure that the shutter speed is sufficient to handhold the camera and freeze action. I recommend setting the shutter to 1/60 second, and not below 1/30 second in lower light venues. Even at 1/30 second, you may not be able to freeze the action.

Exposure

Practice Picture: ISO 400, f/10, 1/800 second.

On Your Own: Exposure options depend on the light available. In bright light, you can set the ISO at 100 and get shutter speed fast enough to freeze action. In low light, try ISO 200, 360, or 400. See previous notes under Camera Settings for shutter speed recommendations.

Accessories

In most cases, with a telephoto zoom lens, you'll be shooting at the longest focal length, which means that a tripod, or at the very least, a monopod is a necessity. Another handy accessory is a Canon Extender such as the EF1.4x II (1.4x magnification) or the EF2x II (2.0x). The advantage of using an extender is the increase in focal length. The downside is that these extenders reduce light by one (EF1.4x II) or two (EF2x II) stops.

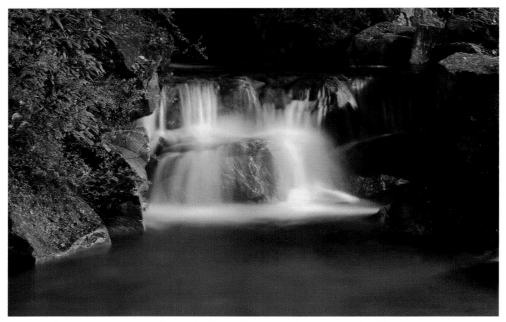

6.20 A slow shutter speed allows the flow of water to be rendered a silky blur.

With slow shutter speeds, you can render the entire scene as a blur creating an impressionistic sense of speed or motion. Or, with faster shutter speeds, you can show part of a subject using only subtle motion blur, such as a runner coming off the blocks in sharp focus while the runner's feet show a slight motion blur.

> **Tip** *In low light scenes, try combining a flash with slow shutter speeds of 1/15 second or slightly slower. The burst of flash freezes the subject at one point in the scene and the longer shutter time shows the motion as a blur.*

Showing motion as a blur depends on existing light to achieve the effect you want. Showing motion in bright daylight requires some experimentation to balance slow shutter speeds against the depth of field that you want. For example, in bright daylight, a very narrow aperture of f/22 or f/32 may be required to get a slow enough shutter speed to show motion blur at 1/30 or 1/20 second. When you want a less distracting background, you can pan with the subject to blur the background. Panning is discussed later in this chapter.

Action and sports photography tips

✦ **Capture the thrill.** Regardless of the technique you choose to shoot action photos, set a goal of showing the emotion, thrill, speed, or excitement of the scene in your pictures. As veteran sports photographer, David Bergman says, you want the kind of picture where people look at it and say "Wow, man, look at this!"

Table 6.5
Taking Blur-Action Pictures

Setup	**Practice Picture:** The image in figure 6.20 was taken at a local business complex. The company had colored the water green for a special event.
	On Your Own: Find a good shooting position with a nice background. If you are shooting athletes, set up the camera and pre-focus on a spot where they will pass. Then as the athletes enter the frame, press the shutter button.
Lighting	**Practice Picture:** This was taken well past sunset, but streetlights and lighting on the waterfall aided in making the exposure.
	On Your Own: Moderate light is ideal for showing action blur, although the technique can be used in bright light with very narrow apertures.
Lens	**Practice Picture:** Canon EF 70-200mm f/2.8L IS USM lens set to 70mm.
	On Your Own: The lens you choose depends on the subject you're shooting. If a wide-angle lens is appropriate for the shot, it offers the additional advantage of having the subject in the frame longer to show more of the motion effect.
Camera Settings	**Practice Picture:** Shutter-priority AE mode with the white balance set to AWB.
	On Your Own: To control shutter speeds, use Shutter-priority AE mode and set it to 1/30 second or slower. In mixed light situations, I recommend using AWB white balance or setting a custom white balance.
Exposure	**Practice Picture:** ISO 100, f/5.6, 1/2 second.
	On Your Own: You may need to experiment to get the shutter speed that shows motion blur and the f/stop that gives you the depth of field you want, you can generally show motion blur at 1/30 second and slower shutter speeds.
Accessories	Because you're shooting at slower shutter speeds, use a tripod to ensure that background elements are sharp.

✦ **Take a high shooting position.** Instead of choosing a front-row seat at a sports event, move back to the fourth or fifth row and use the additional height to your advantage. Be sure to stake out room enough for your monopod or tripod, and if you have a lens extender, take a few test shots with and without the extender to see whether the loss in light is worth the extended focal length. For example, using a 2x extension tube costs you two f-stops. If this loss of

light means that you can't get a fast enough shutter speed to freeze motion, then you may want to opt out of using the extender.

✦ **When shooting sports events, know the rules of the game.** This allows you to anticipate the next play or action and move the camera into position to capture it.

✦ **Find a well-lit spot and wait.** If lighting varies dramatically across the sports field and you find it difficult to continually change the exposure or white balance, find the best-lit spot on the playing field or court, set the exposure for that lighting, and then wait for the action to move into that area.

✦ **Experiment with shutter speeds.** To obtain a variety of action pictures, vary the shutter speed between 1/30 and 1/1000 second. At slower shutter speeds, part of the subject will show motion, such as a player's arm swinging or a slight blur of water as a diver enters a pool.

✦ **Practice first.** Practice your action photography between events by photographing children and pets in motion. As you practice, develop your eye for quick composition, as well as honing your reflexes.

✦ **Shoot locally.** If you can't always make it a major sporting event, consider high school and local amateur events. These are good places to practice shooting sports. And, usually you will be under fewer restrictions and able to get closer to the athletes, as well as have fewer fans to contend with.

Business Photography

Given a choice between reading business correspondence that is a solid block of text or reading correspondence that includes illustrative photos, most people would gleefully choose the correspondence with photos, and with good reason. Well-placed photos not only illustrate and explain the text, but they lend credibility and interest to many types of business documents.

6.21 I used this image of a vintage camera to add interest to my business card.

Photos that represent a company's branding or that are used in advertising are best made by a professional photographer. But routine business correspondence benefits from the addition of clean, well-lit images.

Inspiration

At the office, photograph new employees; employee milestone events such as anniversaries and retirements; informal company parties; product or project photos for internal or external newsletters; and, new business or internal project proposals. You can also use pictures to illustrate-employee training materials.

"The true portrait... reflects the personality."

Henri-Cartier Bresson

Photography by: Charlotte Lowrie
Available for Corporate, Editorial, & Stock Assignments
Editorial, nature, people, & still-life stock photos available.
Portfolio: http://wordsandphotos.org/Portfolio_Main.htm
555.788.0667 | charlotte@wordsandphotos.org

6.22 Images can be used effectively for all types of business documents such as this self-promotion piece for a mailing.

If you are in sales, you can use a camera to photograph customers with a product they purchased, and then use the image in thank-you promotion pieces such as calendars or cards. Small businesses can use and reuse product images for print and Web promotions, as well as for documenting processes such as product manufacturing.

The most important aspect of business photography is to get a clean, uncluttered shot that shows the subject, whether it is a person or a product, in the best light and with true-to-life color. For small object backgrounds, you can buy folding poster boards at a craft store and set them up on a desk or conference table. For images of people and large objects, find a neutral-color wall with enough space to move the subject 5 to 6 feet away from the wall. This helps lessen dark background shadows if you use the built-in flash.

Business photography practice

6.23 Simple setups such as this are easy and quick to create, and with them you can create clean images of products for promotions on a Web site.

Business photography tips

✦ **Compensate for shadows.** If you're doing a head-and-shoulders shot of a person, such as a new employee, ask the subject to hold a silver reflector at waist level and tilted upward slightly to fill in shadows created by overhead lighting. Ask the subject to adjust the reflector position slightly, and watch for the position that best fills shadow areas under the person's eyes, nose, and chin.

Table 6.6
Taking Business Pictures

Setup	**Practice Picture:** I used a simple sheer curtain as the background for this image of soaps in figure 6.23 that a friend makes and sells. **On Your Own:** Simple setups and compositions are the best place to start with business images. You can't go wrong with white, black, or gray poster board backgrounds for small objects. For composition ideas, look at magazine ads that show attractive compositions, and then modify them to suit your needs.
Lighting	**Practice Picture:** I draped sheer curtains over a stand and onto the table to create a soft background and base for the candle and soaps. I used a simple tungsten light on the left and a silver reflector on the right to reflect light back into the setup. I also used a tungsten light to the camera left to flood the front of the setup with light. **On Your Own:** To avoid harsh shadows, avoid using a flash that doesn't have a modifier on it such as a diffuser or soft-box type attachment. It's relatively easy to use small office lamps to light small setups. Use one or two lights to light the background and another to light the subject. You can use a reflector to one side to fill in shadow areas.
Lens	**Practice Picture:** Canon EF 24-70mm f/2.8L USM lens set to 46mm. For small objects such as this, a normal lens or zoom lens such as the EFS 18-55mm lens set to 35mm is ideal because there is no lens distortion to contend with. **On Your Own:** Your lens choice depends on the subject. For small objects, a normal lens is a good choice such as the EF-S 60mm f/2.8 Macro USM. If you want to blur the background, choose a telephoto lens, and for large displays, use a wide-angle lens. If you photograph a group of objects, or a production process, consider a medium wide-angle lens. For portraits, a short telephoto lens such as 50mm (equivalent to 80mm on the Digital Rebel) or 70mm (equivalent to 112mm on the Digital Rebel) will give you a nice head-and-shoulders shot.
Camera Settings	**Practice Picture:** RAW capture. Aperture-priority AE with a custom white balance. **On Your Own:** You'll want to control the depth of field, so choose Aperture-priority AE mode and set the white balance to the type light in the scene.
Exposure	**Practice Picture:** ISO 100, f/11, 1/8 second. **On Your Own:** To ensure front-to-back sharpness, set a narrow aperture such as f/8 or f/16. If the background is distracting, use a wider aperture such as f/5.6 or f/4.0. Set the ISO to 100 or 200, depending on the amount of light available.
Accessories	Silver reflectors are invaluable, especially when you have limited options for controlling existing light. Affordable silver reflectors come in a variety of sizes. When you finish using them, they twist up to fit inside small nylon carrying cases.

✦ **Adjust the set up for the photograph based on its intended use.** For example, if you're taking photos to use on a Web site, keep the composition and the background simple to create a photo that is easy to read at the small image sizes used on the Web. It's also helpful to brighten small-size images just slightly for use on the Web.

✦ **Maintain the same perspective in a series.** In a series of photos, be sure to keep the perspective the same throughout. For example, if you are photographing several new food dishes, set up the dishes on a long table and use the same lens and shooting position for each shot. Also be sure to keep lighting consistent though the succession of shots.

✦ **Look at the colors as a group.** As you set up a photo, consider all of the colors in the image. If they do not work well together, change backgrounds or locations to find a better background color scheme for the subject, or, failing that, use a neutral-color background such as a white wall or a poster board.

✦ **Turn off the flash.** If you're photographing small objects, turn off the flash. It is very difficult to maintain highlight detail at close working ranges using a flash. You can supplement light on the object with a desk lamp, if necessary.

Candid Photography

Few photographers can resist the urge to capture pictures of people just as they are — unposed and acting natural. Good candid pictures often become the prize images in your photo collection because, unlike posed portraits, you catch subjects unaware, preoccupied with their private world of thoughts and activities and without their "camera" faces. Capturing candid photos means that you need to fade quietly into the background.

6.24 In this image, Rhinestone Rosie, a member of the National Association for the Self-Employed, is absorbed in a conversation with a customer and is unaware of the camera.
© *National Association for the Self-Employed, photo by Charlotte Lowrie*

To disappear into the surroundings, you need a lens—usually a zoom lens—that allows you to change focal length while maintaining your distance. You also need to be able to shoot quickly to capture the subject's expression or activity as it changes. Therein lies the importance of being prepared and patiently staying with the subject to capture the truest expressions and reactions.

Note *While it may seem that family members are great candidates for candid photography, they are often the ones who are most alert to and aware of your presence. You may have better luck shooting family candid shots when family members are in large groups and are distracted by activity around them.*

6.25 This is a candid shot of a man working through lunch.

Inspiration

Downtown streets filled with people going about their daily routines also offer endless opportunities for candid photography. Other excellent opportunities can be found at concerts, parades, airports, and parks.

Candid photography practice

6.26 This photo illustrates an over-the-shoulder candid approach that didn't interrupt the artist's work or distract his subjects.

Table 6.7
Taking Candid Pictures

Setup	**Practice Picture:** The scene for the shot in figure 6.26 was a private corporate party that included a variety of activities. Because the party was crowded, I tried several different shooting positions and finally staked out a spot next to a concrete post that didn't impede traffic. Then I waited patiently for the artist to become absorbed drawing the caricatures. **On Your Own:** Choose a shooting position that provides a clean background, or shoot using a wide aperture to blur background distractions. If you have to change positions, be quiet to avoid distracting the subject or giving away your candid shooting.
Lighting	**Practice Picture:** Bright side light on the artist's face and deep shadows on his back made this a difficult exposure. In addition, the angle of the artist's easel blocked light making the drawing relatively dark. In the final image, I lightened select areas in Adobe Photoshop CS. **On Your Own:** Lighting for candid can run the gamut. Watch for highlight areas on the subject's face and use Auto-Exposure Lock to ensure that highlights are not blown out. With Auto-Exposure Lock, you can take the meter reading on the brightest area of the subject, lock the exposure to that reading, then move the camera to recompose the picture.
Lens	**Practice Picture:** Canon 70-200mm f/2.8L IS USM at the 128mm setting. **On Your Own:** A zoom lens is indispensable for candid shots. Typically a telephoto zoom offers the focal range necessary for you to remain at a distance yet fill the frame with the subject.
Camera Settings	**Practice Picture:** RAW capture. Aperture-priority AE mode with white balance set to Daylight. I wanted to control the aperture so that I could blur the busy background. Using aperture-priority with AE lock enabled me to lock the exposure on the brightest area, in this case the artist's forehead and temple area, and then recompose and focus on either the artist's eye or on the drawing. On the EOS 300D, AE lock defaults to partial metering, which acts like a spot meter with a telephoto lens. On the EOS 300D and 350D, Evaluative Metering mode is set automatically in Basic Zone modes. In Creative Zone modes, you can switch to Partial Metering mode by pressing the AE lock button (300D) or by pressing the left arrow key, and then selecting Partial Metering from the Metering mode menu (350D). Partial metering in this type of strong side lighting ensures that the bright areas of the face will be properly exposed and maintain detail. The downside is that shadow areas go very dark. In tradeoff situations, choose to properly expose the most important area of the image; in this case, the bright area on the artist's face.

Continued

Table 6.7 (continued)

On Your Own: For quick captures, set the camera to Full Auto mode. Otherwise, you'll likely want to control the depth of field by choosing Aperture-priority AE mode. If the light is low, switch to Shutter-priority AE mode and keep the shutter speed at 1/30 second or faster. Be sure to set the white balance to match the type of light in the scene.

Exposure	**Practice Picture:** ISO 100, f/4.0, 1/4 second. **On Your Own:** In low-light scenes, switch to Shutter-priority AE mode and set the shutter to 1/30 or 1/60 second. At 1/30 second, you may get some blur if the subject moves, which can add interest to the image. In good light, switch to Aperture-priority AE mode, set the ISO at 100, and select a moderate to wide aperture.

Candid photography tips

✦ **Be patient and be prepared to shoot quickly.** Patience is a hallmark of candid photography. And, be sure to set the Auto Power Off delay to a long time period and carry a spare, charged battery with you.

✦ **Change lenses as you watch and wait to survey the overall look of the scene.** Have alternate lenses nearby and easy to grab for quick lens changes.

✦ **Because using a flash gives away your candid shooting, try switching to wide apertures in low-light scenes.** Set the camera to Aperture-priority AE mode, and turn the Main dial to set the aperture at f/3.5 or f/2.8 depending on the speed of the lens you're using.

Child Photography

With faces as fresh as a new canvas waiting for the first brush stroke, photographing children offers opportunities for making priceless images that range from soft and sweet to mischievous and comical. And child photography offers invaluable practice in developing your skill in effective negotiation, cajoling, bribery, and providing comfort during emotional meltdowns.

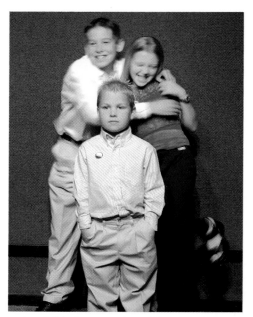

6.27 Child photography with some children is synonymous with "action" photography. If you have active children, an occasional picture that shows their exuberance and motion may be the most descriptive photo you make of them.

The goal of child photography is to capture the essence of the child or children. Young people are incredibly bright: By the end of their first year of life, most babies have perfected a cheesy "camera smile." This likely is not the smile you want. In fact, not all child pictures must depict a child smiling. The better that you are able to connect with the child, the greater your chances are of capturing genuine expressions of happiness, interest, or concentration.

> **Tip** With young children who are walking, many of the tips in the Action and Sports section of this chapter apply. Because they move fast and often sit still only for milliseconds rather than minutes, setting the camera mode to Continuous to capture image sequences is often a necessity.

It's also a good idea to have games and toys that the children enjoy either nearby during shooting or even to use as part of the picture. And because children feel more comfortable in familiar surroundings, it's often possible to photograph them in a playroom, bedroom, living area, or at an outdoor playground. If you're in an area where you can't control background elements, you can use a wide aperture, such as f/4.0 or wider, to reduce distracting background objects to a soft blur.

6.28 Band Aids and toenail polish were the highlight of this young girl's day at the photographer's.

Of the many factors that figure into making successful pictures of children, the single critical factors are the child's mood or state of mind and how good of a rapport you establish with the child early on. A tired, hungry, bored, or out-of-sorts child will not put up with your attempts to pose and re-pose them for long. Encourage parents to bring children when they are well rested, fed, and in a happy frame of mind. Without this, a photo shoot can quickly degrade into a struggle of historic proportions. And if you skip the important first moments of connecting with the child, the images will ultimately mirror the missing emotional connection.

As you shoot, always focus on the child's eyes — otherwise, delightful pictures may be ruined.

Inspiration

Get Creative Try retro photography to re-create poses that were popular in the 1950s and '60s. Alternately, include a toy or game that denotes pop culture of the moment and helps define the child's interests.

Use clothing colors and background to unify the image, particularly if you're taking a more formal portrait of the child. In an outdoor setting with young children, think about giving them a task, such as picking a flower or pulling a wagon, and then shoot a sequence of images that show the reactions and expressions as they complete the task. And don't forget about the family pet. Dogs and cats put children at ease and can make the job of the photographer far easier.

Child photography practice

6.29 Capturing kids in the middle of everyday life creates appealing portraits such as this one by Tony Chor.
© Tony Chor

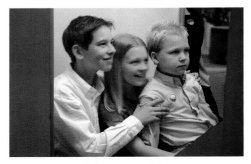

6.30 Use candid opportunities to your advantage. These kids are concentrating on taking an instant photo of themselves, so they aren't paying attention to the fact I'm photographing them.

Child photography tips

✦ **Shooting angle.** For most pictures, shoot from a child's eye level and engage the child by asking questions. For babies, use a toy to capture a baby's attention.

✦ **Keep your expectations age-appropriate for the child.** For example, expecting a one-year-old to sit in the same pose for anymore than a second or two is unrealistic, even with a parent's encouragement.

✦ **Coordinate with the parents.** If you're photographing someone else's children, always check with the parents about what you can and cannot offer the child as an enticement. Before the photo session, ask the parents what snacks the child enjoys and then have those on hand.

✦ **Limit the number of variables that affect exposure and white-balance.** For example, by staying in one location for a series of pictures, you can set the camera exposure and white-balance once

and not worry about it throughout the rest of the session. (Of course, if the light changes, the exposure will need to change as well, but on Aperture-priority mode, the camera takes care of on-the-fly shutter-speed adjustments.) This allows you to concentrate on interacting with the child and composing the images.

✦ **Treat the child as a person.** Avoid using baby talk with young children and talking down to older children.

Table 6.8
Taking Pictures of Children

Setup	**Practice Picture:** The picture shown in figure 6.29 required no special setup, but certainly benefits from the color of the chef's hat. **On Your Own:** Children photographed in their natural surrounding puts them at ease. You can control the background using different apertures.
Lighting	**Practice Picture:** Diffused flash helped add brightness to the child's face. **On Your Own:** Available light or bounced flash are good choices for pictures of children.
Lens	**Practice Picture:** A 24-70mm f/2.8L lens set to 42mm was used for this picture. **On Your Own:** Short telephoto lenses are good choices for child photography. The 18-55mm lens that comes with the Rebel set to 55mm is equivalent to 80mm, which is ideal. A zoom lens increases your options for on-the-fly focal length changes to adjust the composition.
Camera Settings	**Practice Picture:** Aperture-priority AE mode with white balance set to Tungsten. **On Your Own:** Depending on the amount of light in the scene, Aperture-priority AE mode allows you to control sharpness throughout the image. For quick portraits, use Portrait mode on the Digital Rebel.
Exposure	**Practice Picture:** ISO 100, f/4.0, 1/60 second. **On Your Own:** To blur the background, set the aperture to f/5.6 or wider. In good light, choose ISO 100. In lower light scenes, choose ISO 200 or 360 to get faster shutter speeds.
Accessories	A Canon 550 EX Speedlite was used for this image with a Sto-Fen Omnibounce attached to the head of the flash unit to diffuse the light. This flash attachment is inexpensive, small, and extremely easy to use.

Environmental Portrait Photography

An environmental portrait, or a portrait taken of a subject in work or leisure-time surroundings, offers several advantages over traditional portraits. With environmental portraits, the work area adds context that helps to reveal more about the subject than is shown in traditional portraits. In addition, the subject is often more comfortable in familiar surroundings, and the work area also gives ample fodder for conversation during the shooting, both of which help the subject to feel relaxed and comfortable.

Environmental portraits borrow elements from both photojournalism and portraiture. With a successful merger of the two, environmental portraits offer insight into the subject that is often associated with photojournalism and the beauty that is associated with portraits.

6.31 Rhinestone Rosie, a member of the National Association for the Self-Employed, is shown here at her repair desk surrounded by the tools she uses every day.
© National Association for the Self-Employed, photo by Charlotte Lowrie

Note *While environmental portraits may catch a subject working and seemingly unaware of the camera, environmental photography is not synonymous with candid photography. The difference is that the subject is aware of the camera and cooperates with the photographer in environmental portraiture. In candid photography, the subject is typically not aware of the camera.*

Because environmental portraiture offers a refreshing and adaptable approach to portraiture, it is worthwhile to learn the basic techniques. And you can use variations of the techniques for pictures of children, elders, and friends — all within the comfort of their everyday surroundings. You can use either the Portrait mode on the Digital Rebel for quick shots, or switch to a Creative Zone mode such as Aperture-priority AE mode to have more control over the depth of field in the final image.

Tip *In any portrait, be sure the subject's eyes are in sharp focus. On the Digital Rebel, you can ensure this focus by using Auto Focus lock. Position the autofocus point in the viewfinder on the subject's eyes, and then press the Shutter button halfway down. When the camera beeps to confirm focus, continue to hold the Shutter button as you move the camera to recompose the image. Then take the picture.*

Inspiration

Look for environmental portrait opportunities anywhere people are in their work or leisure-time surroundings, whether that's in an office, garage, craft studio, a child's playroom, or engaged in a favorite hobby.

Environmental portrait photography practice

6.32 The background for this photo of a firefighter is the inside metal of a door on the side of an engine.

6.33 The most challenging aspect of environmental portraiture is lighting. In this image of a deputy fire chief, however, the overhead lights at the fire station were sufficient to create even illumination for the portrait.

For example, you might consider making an environmental portrait of your mother or grandmother in the kitchen, a child playing a game, a teenager proudly posing with a first car, a football player leaning against a goal post, or a budding musician with his first instrument.

Table 6.9
Taking Environmental Portraits

Setup	**Practice Picture:** The image in figure 6.33 was taken in a large fire station garage. Fortunately, both ladder and EMT trucks were available. I chose to position the deputy fire chief next to an EMT truck because the truck was smaller and could be more readily identifiable in the final image.

Continued

Table 6.9 *(continued)*

	On Your Own: Get to know the subject to find out what elements play an important role in their work or hobby. Then set up the scene with some of those elements as part of the composition. When framing environmental portraits, use discretion on how much of the scene you include. Ultimately, you want the image to be informative, but also easy to read.
Lighting	**Practice Picture:** The fluorescent overhead light was supplemented with daylight coming through the fire station garage door to the subject's right.
	On Your Own: Light from a nearby window provides soft and flattering light. You can use an accessory flash and bounce the flash off a wall or ceiling to provide more attractive lighting. On the EOS 350D, you can experiment with different levels of flash compensation to get just the right amount of illumination. If you're shooting outdoors, open shade or the light on an overcast day is ideal.
Lens	**Practice Picture:** Canon EF 70-200mm f/2.8L IS USM lens set to 112mm. The Canon EF-S 18-55mm lens would also be a good choice at the 55mm setting.
	On Your Own: Shorter focal lengths, 28 to 35mm, are ideal when you want to include environmental elements in portraits. In addition, they provide good depth of field to make contextual elements visually distinct without competing with the subject. To avoid wide-angle distortion, do not have the subject close to the camera. You can use a normal or short telephoto lens as well. Just step back a little to include environmental elements.
Camera Settings	**Practice Picture:** Aperture-priority AE mode with white balance set to auto (AWB). I chose auto white balance because it generally is accurate, especially in mixed light scenes such as this.
	On Your Own: For quick portraits, use Portrait mode. Otherwise, to control the depth of field, choose Aperture-priority AE mode and set the white balance to the type light in the scene or set a custom white balance.
Exposure	**Practice Picture:** ISO 100, f/3.5, 1/15 second.
	On Your Own: Use as low an ISO setting as possible to avoid introducing digital noise in the image, such as 100 or 200. If the light is low, use an accessory flash and bounce the flash off a wall or ceiling. On the EOS 350D, use flash exposure compensation to get the level of illumination that you want.
Accessories	A tripod is always a good accessory to ensure sharpness when taking portraits.

Environmental portrait photography tips

✦ **Using a shorter focal length.** Normally, a medium telephoto lens is the choice for portraits, but with environmental portraits a shorter focal length allows you to include surroundings that provide context. For example, if you're using the Canon 18-55mm lens, a 24 or 35mm setting is a good choice. If you use a wide-angle lens, be sure that the subject is not close to the camera because facial features can be distorted in very unflattering ways.

✦ **Develop a rapport.** Develop a rapport with your subjects to make them more comfortable. The most important ingredient for any portrait is the connection the photographer establishes with the subject. The photographer's and subject's roles are easier in environmental portraiture, but the photographer still needs to provide direction to the subject to get the best portrait.

✦ **Scout locations that offer flattering light.** Natural light is always a good choice, especially gentle light filtering into the room from a nearby window. You can set up a silver reflector on the opposite side of the subject to reflect light into the shadow areas.

✦ **Check the background.** As with any image, be sure to check the background for distracting elements. You can tidy up the area beforehand, or you can use a wide aperture to help blur distractions. But be careful not to blur away important contextual elements. For example, if you want to leave surrounding elements in reasonably sharp focus, you can use f/5.6 versus f/3.5 or f/2.8.

✦ **Identify poses.** Because people quickly tire of posing, discuss poses with your subject before you begin shooting. Have a list of poses and go over them with the subject so that they feel comfortable and can respond to your direction. If you need ideas, check recent magazines and adapt the poses that you like to fit the subject and environment. Also provide breaks during which the subject can go about their work or play. The distraction of the activity provides countless opportunities for additional shots.

Event Photography

Perhaps no other area presents as many varied photo opportunities as events such as parades, fairs, festivals, and traveling exhibits. Everything from Mardi Gras to a local county fair is a candidate for your photographic prowess. And events add colorful and animated images of groups and individuals to your photo collection.

6.34 Bright and colorful images are plentiful at local events.

Before you go to the event, think about photographing the event as a story that identifies the theme and that provides detailed context to give viewers a true sense of being there. You can include overall shots of the venue to give a sense of the number of visitors as well as close-up shots of visitors in traditional, comical, and poignant situations.

Planning is important. If you're shooting a parade, for example, walk the parade route the day before at the same time of day that the parade will occur. Note areas where you might encounter lighting challenges from the shadows of tall buildings or backlighting.

For festivals, fairs, and other events, it's a good idea to check the sponsor's Web site to get a schedule of events a day or two beforehand. Also get a program or map of the event so that you know where the most interesting booths or exhibits are located, and where and when awards or music events will be held.

If the event is held indoors, check ahead of time to see if there are restrictions on using flash. And, even if the event is outdoors, chances are good that some pictures will be in deep shade that will require slow shutter speeds. Plan ahead whether you will use a flash or need to carry a monopod or tripod, especially for late-day and evening shooting.

Inspiration

In a larger sense, popular public events reflect our culture, the fads and fashions of

6.35 Few enjoy events as much as children. I was taken by the color coordination of these two children at a food fair.

the time. Consider how the series of photos you take at an event can become a record of current culture. In the photos, include popular icons that will eventually reflect the era. Fashion, popular foods and activities, cars, and even cell phones are all possibilities. Be sure to include people in typical situations, such as a child holding onto a parent's leg or crying from exhaustion, or adults catching a short nap on the grass.

To capture the ambience of the event, consider close-up and medium-wide portraits of visitors interacting with performers, with vendors, and with each other. If the event is fast-paced and lively, you can use slow shutter speeds to capture motion as a blur. (See the section "Action and Sports" earlier in this chapter for tips on using this technique.)

Event photography practice

6.36 A sense of quiet but poignant solemnity prevailed when the traveling Viet Nam memorial was set up at a Redmond, Washington, park. People brought their children and pointed out the names of family members or friends inscribed on the wall. They left flowers, cards, and notes at the base of the memorial. This picture reflected the story as well as the tenor of the event.

Event photography tips

✦ **Try to choose multiple location options.** For example, for parades, it is best to locate at least two shooting positions — one that is street-level and the other that is a higher view. Then use the high vantage point to record overall crowd scenes with a wide-angle lens, and use both the wide-angle and a telephoto lens from the street-level shooting position.

✦ **Try creative shooting positions at events.** For example, don't be afraid to kneel down or even lie down and shoot up. This shooting position makes the subject appear more powerful.

✦ **Ask for permission before photographing children.** Always ask permission from a parent or guardian before photographing a child.

✦ **Plan some shots for the best hours of light.** For most outdoor events, this will be late afternoon through sunset. Also stake out a shooting position that allows you to take the best advantage of the golden light.

✦ **Arrive early at popular events.** Because crowds gather quickly, an early arrival allows you to record pictures of people preparing booths or floats. It also allows you to photograph crowds as they begin coming into the event.

Table 6.10
Taking Event Pictures

Setup	**Practice Picture:** The event shown in figure 6.36 was held at a park where there was plenty of space to move around for different shooting positions. By kneeling in front of this display, I was able to record the display as well as the wall and crowd behind it.
	On Your Own: Look for shooting positions that offer the cleanest background possible, or choose a wide aperture to blur the background. Experiment with both high and low shooting positions to offer unique perspectives on the event. Be sure to take overall crowd shots as well as detail shots of the event.
Lighting	**Practice Picture:** This was taken in bright midday sun. This type of light makes colors more vivid, which helped make the red in the American flag and the pink in the flower between the boots more prominent. However, this light is very contrasty with very bright highlights and deep shadows. To reduce the contrast, I lightened some shadow areas and darkened some highlight areas in an image-editing program.
	On Your Own: Lighting for events can obviously run the gamut. In bright, contrasty light, shoot in open shade areas to lessen deep shadows and too-bright highlights. This can be a good time to use fill-flash especially for people shots, to fill in dark shadows under the eyes, nose, and chin.
Lens	**Practice Picture:** Canon 70-200mm, f/2.8L IS USM lens set to 73mm.
	On Your Own: Both wide-angle and telephoto zoom lenses are good choices for event photography. Zoom lenses are indispensable because they allow you to change focal length on the fly.
Camera Settings	**Practice Picture:** Aperture-priority AE mode. The white balance was set to Daylight. By controlling the aperture, I was able to control the depth of field so that the display is in sharp focus and the memorial wall and visitors are slightly blurred.
	On Your Own: You'll want to control the depth of field, so switch to Aperture-priority AE mode and set the white balance to the type light in the scene. If the light is low, switch to Shutter-priority AE mode and set the shutter to 1/30 second or faster.
Exposure	**Practice Picture:** ISO 100, f/8 1/160 second.
	On Your Own: In good light, choose ISO 100. In lower light scenes, choose ISO 200, 360, or 400 to get faster shutter speeds. At music concerts or events in low light, it's often effective to allow blur of the performers to show in the image as well as at other events. Experiment with different shutter speeds to get a variety of shots that reflect the pace and mood of the event.
Accessories	Using a polarizer on the lens helps deepen the colors as well as increasing the saturation of color throughout the image for outdoor events.

Flower and Plant Photography

It's a rare photographer who can resist the temptation to photograph flowers, exotic plants, and gardens. The enticements include the riot of colors, the allure of symmetry and textures, and intricate design variations. Flowers and gardens offer an appeal that transcends cultural and language barriers, making them a truly universally captivating subject. As my friend and renowned landscape and nature photographer Terry Livingstone says, "Flowers are sexy."

Following a few guidelines will help you capture the best images when photographing flowers and gardens. If the garden is a popular attraction for tourists, it is probably designed with several "best" ways to view it with, for example, arbors, topiaries, and fountains or statutes. Get a map at the visitor's center and look for tips on the best vantage points for the main areas of the garden. Take

6.37 Delicate structures, grace, and stunning beauty are only a few of the enticements of photographing flowers and plants.

6.38 The two colors of the top and bottom of the leaves provide a striking contrast.

6.39 Often photographed, close-ups of roses never grow old.

some overall "establishing" shots of the garden from each main vantage point, and then switch to isolating specific areas of the garden as individual compositions.

Of course, flower and garden images are strongest when they factor in the principles of good composition. The image should have a clear subject, and the composition should lead the viewer's eye to the main subject, and then through the rest of the image. Experiment with compositional elements such as color, shape, texture, lines, and selective focus to create the composition.

Employing a little anthropomorphism is helpful as well. In portraiture, the goal is to capture the subject's personality; and the same technique can be used in flower photography to capture the personality of individual blossoms.

Flower photography is a good time to use the Close-up mode on the Digital Rebel. You can use a macro lens and a Creative Zone mode such as Aperture-priority AE to get beautiful macro images.

Inspiration

Take the idea of anthropomorphism a step further by ascribing human characteristics to flowers, and then see where it leads creatively. For example, asking questions such as whether flowers have bad-hair days can help you look at flowers differently. How do flowers handle the problem of overcrowding? Consider the implied hierarchy in the scene or arrangement and see if you can isolate it as the subject. Try using selective lighting to help isolate the hierarchy or order.

Flowers in a bouquet or individual flowers make striking compositions, especially against a vivid background such as a bright blue sky. And given a little patience, you can include bees, butterflies, grasshoppers, and other insects as part of the composition. Isolating individual parts of the flower to create a half-round or stair-stepped sequence of blossoms are only two of hundreds of ways to approach floral photography.

Can you use color to convey your interpretation of the flower or garden as being strong, weak, vibrant, or subdued? What photographic techniques can you use to emphasize the grace, beauty, and tranquility of the garden or flower?

Flower and plant photography practice

6.40 This Bird of Paradise was taken with a macro lens to isolate a section of the flower.

Flower and plant photography tips

✦ **Try a high position.** When photographing large gardens, try shooting from a high position, you can even shoot from a ladder to show the overall scope and color patterns of the garden.

✦ **Ensure precise focus for floral shots.** Anything short of razor-sharp detail detracts from floral images. If necessary, switch to manual focus by moving the switch on the Canon lens to the Manual setting. Then you can tweak the final focus to perfection.

✦ **Enhance color.** In outdoor pictures, use a polarizer to enhance color saturation of the flower colors and the sky.

✦ **Use the sky as a backdrop.** To create striking images, use a low shooting position and tilt the camera up to isolate the flower against a deep blue sky.

✦ **Use lighting to your advantage.** Many flower petals are transparent and with backlighting, the delicate veins of the petals are visible. The same is true for many plant leaves. Watch for backlighting to create compelling and very graphic images of flowers and plants.

Table 6.11
Taking Flower and Plant Pictures

Setup	**Practice Picture:** I took the picture in figure 6.40 at a local nursery that was covered with plastic like a huge greenhouse. I found a blossom that was out of the main traffic area, and then I set up the camera on a tripod. I positioned the camera so that the focal plane was parallel to the plane of the blossom.
	On Your Own: Flowers and plants in outdoor light often offer ready-made setup and lighting. If you don't have a garden, local nurseries and greenhouses offer plentiful subjects. Indoors, a simple single blossom or bouquet makes a good subject as well. You can compose images ranging from large fields of flowers to smaller groupings and single stems. Outdoors, you can take a low shooting position, and then shoot upward to use the blue sky as a beautiful backdrop.
Lighting	**Practice Picture:** The plastic greenhouse covering diffused the moderate sunlight creating an even and soft light.
	On Your Own: Outdoor light ranging from overcast conditions to bright sunshine are suitable for photos. Try using reflectors to direct light toward a small group or blossom. Fill-flash is often helpful to give slightly more color pop.
Lens	**Practice Picture:** Canon 180mm, f/3.5L Macro USM lens.
	On Your Own: For large areas of blossoms or plants or gardens, use a 24 to 35mm lens. For small groupings and single stems, consider a normal focal length or short telephoto lens. Or you can use the EF-S 60mm f/2.8 Macro USM lens. Of course, a long telephoto is useful for isolating small grouping in a large collection of flowers.
Camera Settings	**Practice Picture:** Aperture-priority AE. The white balance was set to Auto.
	On Your Own: Decide what the best depth of field is for the scene you're shooting, and use Aperture-priority AE mode to set the f/stop. To blur the background, start with an f/5.6 aperture. For extensive depth of field, set an f/8 or f/11 aperture.
Exposure	**Practice Picture:** ISO 100, f/6.3, 1/13 second.
	On Your Own: An ISO of 100 or 200 should be useful for most lighting conditions. For large fields of flowers or plants, set a narrow aperture such as f/11 or f/16 to ensure maximum sharpness throughout the image. To isolate details of a single stem, choose a wide aperture such as f/5.6 or f/4.0.
Accessories	A tripod is always a good precaution when you're taking close-up or macro shots and when using a telephoto lens. You can also buy plant holders that do not damage to the plant, but hold it steady against outdoor breezes.

Group Portrait Photography

Group portraits can range from two people to an entire family or all of the employees in an office. Without question, group portraits represent one of the biggest challenges any photographer can undertake. The challenges include coordinating and directing multiple people, artfully posing multiple subjects, getting and keeping the subjects' attention, avoiding reflections from eyeglasses, and ensuring that focus is crisp throughout the group.

Given the challenges, try these planning tips to make your group portrait sessions more successful.

Location and lighting

Choose a location that is large enough to accommodate everyone in the photo. Ideally, the location will have chairs, stairs, or benches so that you can place people in subgroups and at different heights. The location lighting should ensure that no one is in the shadows. You can use reflectors to help light some shadow areas. Flash is seldom effective with very large groups because the flash often cannot cover the group from side to side and back to front. The result is a bright area in the group with other people in the group left in dark areas. A flash, particularly an off-camera flash, is very effective, however, with small groups of two or three persons.

6.41 Two longtime friends were growing tired of posing and took a short break. Their natural position provided a good opportunity for a casual portrait.

Have a plan

Once you know what props will be available at the location, plan the kinds of poses you want. Position the group around a main subject or person, and use strong lines such as diagonals and triangles for posing. In a family portrait, you might have the grandparents as the center attraction with younger family members posed in subgroups around them. Be sure to prepare a list of poses, and stay focused on moving through the list. It is good to have at least a minimum of three different poses to ensure that you get shots that everyone likes. And be sure to take lots of images. The more people in the group, the more pictures you should take to ensure that someone's eyes aren't closed.

Get help

It's incredibly useful if another person coordinates groups of three or four people or more. An extra set of eyes dedicated to making sure that everyone looks great will make the session go much better. The helper can also provide comfort and distract cranky children and adults too.

Hone your directorial skills

Without a director, groups of people are like sheep without a shepherd—they tend to stray. Practice your skills for directing people and for introducing humor as you work with the group. Most important, keep the group engaged in the process so that they don't lose interest.

Posing Tips

The goal of portraiture is to make subjects look the best that they can look. You can use a few techniques to achieve this goal.

✦ Think of posing in terms of the lines the subjects form: diagonal lines, triangles, X shapes, and so on. Posing people along these lines creates more dynamic images than posing them in parallel horizontal rows.

✦ Coach subjects to place their hands in a neutral, non-expressive position. Having a hand placed close to or on the face often places undue emphasis on the hand.

✦ To avoid having the heads on the same vertical plane as the shoulders, ask subjects to stand with their bodies at a slight angle to the camera and to rest their weight on the rear foot.

✦ A subject's eyes should follow the direction of the nose.

✦ In large groups, whenever possible, keep the depth of people in rows shallow. In other words, use an arrangement that is two persons deep rather than three or four persons deep. And use a narrow aperture to keep each person in sharp focus. For example, for a large group, f/11 would provide good depth of field to ensure that each subject is reasonably sharp, provided that you are not standing very close to the group. And if you arrange a small group with one person slightly behind the other in stair-step fashion, try using A-DEP mode. This mode produces excellent depth of field for these type arrangements.

Difficult subjects

If someone in the group is shy or believes that he or she takes a lousy picture, spend time with that person beforehand to provide reassurance and involve that person in the process. This is often enough of a distraction that he or she will feel less self-conscious during the shooting.

Inspiration

Get Creative

If you're photographing friends, families, or co-workers, include props or objects that are meaningful to the group in the portrait. Get creative with locations. If the family gathers in the kitchen, use the kitchen as the location for a casual family portrait.

With family portraits, it is fun to dig back in the family album for very old portraits of great-great grandparents. Try duplicating the original pose for a fun family or couples portrait. It's easy to convert a color image to sepia-tone or black-and-white later on the computer. Alternatively, have a grandparent or parent casually hold the antique image for the new family portrait.

6.42 The sense of motion created by the blur of the young boy in front and the older boy in back adds fun to this image of a father and his two sons.

Group portrait photography practice

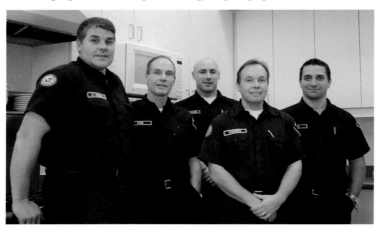

6.43 I arranged this group of firefighters in two diagonal lines to help ensure that all five men could be easily seen in the final image. I didn't tell them on how to pose their hands, but let them assume very natural poses that worked nicely. A slightly lower-than-subject shooting position gives the impression of power that is appropriate for the men's role in the community.

Group portrait photography tips

✦ **Establish a friendly rapport with the group.** Find topics of mutual interest to keep them engaged. If you're photographing a family, steer conversation away from topics that cause strife or tension.

✦ **Always check the lighting situation carefully.** While the diffuse light provided under an awning may seem ideal, be sure that the awning color won't reflect its color hue onto the subjects.

✦ **Monitor where the subjects are looking.** If you place subjects to the far side of the frame, ask them to turn their heads, not just their eyes, to look toward the middle of the scene.

✦ **Give yourself time.** If you choose an outdoor location, arrive early and clean up any litter.

✦ **Flatter older subjects.** Very sharp focus is often less than flattering for older subjects. Soften the focus slightly during the shoot or apply a slight blur during image editing, or use selective sharpening for only the subject's eyes.

✦ **Vary your shooting position.** With older subjects, a low shooting position is unflattering, but a slightly higher-than-eye-level position is more flattering.

Table 6.12
Taking Group Portraits

Setup	**Practice Picture:** Because firefighters are often known for their culinary skills honed during long shifts, I chose to place them in the station kitchen, as shown in figure 6.43. Because it's a common gathering place for these men, it's even more appropriate. **On Your Own:** Choose an area large enough to accommodate the group and that has neutral color walls. Bring a step stool so that you can take some images from a slightly higher camera angle.
Lighting	**Practice Picture:** Mixed lighting, which included moderate sunlight from a window facing the firefighters and overhead fluorescent light. **On Your Own:** Plan for light that's adequate to illuminate everyone, or change the pose by moving people closer so that everyone is well lit. For groups of two or three, an accessory, off-camera flash is helpful, and you can bounce light off a wall or ceiling to supplement existing light. If you shoot outdoors, choose early morning light or late-afternoon light and, if possible, place subjects in open shade.
Lens	**Practice Picture:** Canon EF 24-70mm f/2.8L USM set to 70mm. I used a wide aperture of f/2.8 due to the low light. An aperture of f/5.6 would have provided better sharpness side to side in this image. Another option would have been to increase the ISO to 200 or 400 and shoot at f/5.6. **On Your Own:** A moderate wide-angle lens is good to use for group shots because it helps maintain sharpness for wide scenes. For groups of two or three persons, a normal focal length is an option.
Camera Settings	**Practice Picture:** Aperture-priority AE mode with white balance set to auto (AWB). The Digital Rebel gives good color particularly in mixed light scenes such as this. **On Your Own:** To control the depth of field, choose Aperture-priority AE mode and set the white balance to the type light in the scene. For quick portraits of couples, you can also use Portrait mode.
Exposure	**Practice Picture:** ISO 100, f/2.8, 1/30 second. **On Your Own:** For groups of more than three persons, an aperture of f/8 or f/11 is a good starting point to maintain sharpness side to side and back to front.
Accessories	Use a tripod for all portraits. You'll be busy directing people and checking expressions; having the camera on a tripod frees you to move out from behind the camera often to check details without modifying your shooting position.

Holiday Lights Photography

There is an ageless magic about holiday lights that begs to be immortalized. And if you've spent hours stringing lights around the house and on the tree, taking pictures of them is simply the right thing to do.

6.44 Along with lights on your house or in your neighborhood, commercial displays such as this make great photo opportunities.

An easy way to take pictures of lights is to use the Digital Rebel Flash Off mode with the ISO set to 200, 360, or 400. Mount the camera on a tripod to shoot. And, of course, Night Portrait mode is handy for taking portraits of people with holiday lights in the background. The result will show holiday lights as pinpoints of light.

For more dramatic pictures, use one of the Creative Zone modes. For example, Aperture-priority AE mode gives you control over depth of field while Shutter-priority AE mode lets you control how long the shutter stays open to create pictures with perhaps some motion blur, or, when combined with a higher ISO setting, to get sharp handheld pictures in low light.

Whatever settings you choose, be sure to capture the distinctive spirit of the year's holiday season. For example, if holiday displays include patriotic elements, include them in images. They become markers that set the year's festivities apart from other years.

For the most dramatic images, start shooting at sunset and continue during twilight when a sapphire sky creates a beautiful backdrop for outdoor holiday displays. In addition, holiday lights are great opportunities for taking abstracts, photos with motion blur, and pictures showing light trails.

Inspiration

When shooting either home or commercial holiday displays, be sure to look at both the overall scene and at the details. Very often the details, such as a special ornament set off by a light on the tree or a candle display on the mantel, create beautiful small compositions. At home, experiment by adjusting room lighting to see what creates the best ambience for pictures.

Children typify the delight and wonder of the season. Have your camera handy to capture candid shots of children taking in the beauty of the displays. Take full advantage of the season to add great pictures to your collection.

6.45 Don't forget to take detail shots of holiday decorations.

Holiday lights photography practice

6.46 Having lasting pictures of your holiday handiwork is very satisfying. The couple who own this house spent two days putting up the lights.

Holiday lights photography tips

✦ **Be patient while working out the exposure.** A certain amount of exposure experimentation is inherent in taking pictures of holiday lights. The Digital Rebel's Auto-Exposure Bracketing option is a good choice.

✦ **Use other light to your advantage.** The warmth of tungsten (ordinary household) lighting adds a lovely glow to pictures of holiday lights. Instead of color balancing images to neutral, let the glow of tungsten lighting add to the charm of your photos.

Table 6.13
Taking Holiday Lights Pictures

Setup	**Practice Picture:** To get the entire house with the lights, shown in figure 6.46, I had to include the truck on the right. If possible, be sure that the drives and surrounding areas are free of distractions. To ensure that no vibration marred the image when shooting from my car, I parked across the street and turned off the engine.
	On Your Own: For successful pictures, isolate the parts of the scene that make effective compositions. Including too much in the image creates a confusing jumble of elements.
Lighting	**Practice Picture:** This image was taken at dusk on a rainy evening.
	On Your Own: To capture the ambience of the scene, do not use a flash. For a lovely sapphire backdrop, shoot at twilight at an upward angle to include the sky as a backdrop. If you choose to use a flash, holiday lights will appear as tiny pinpoints of light rather than being rendered with a glow. I recommend existing light to retain the warmth of the holiday lights.
Lens	**Practice Picture:** Canon EF-S 18-55mm, with the lens set to 30mm. This lens provides very sharp images despite the rain that had begun to fall steadily. Rain softens the sharpness of any image.
	On Your Own: Your lens choice depends on the scene and how you want to render the subject. A 35mm to 70mm focal length allows you to isolate single ornaments on the tree. For larger scenes, a 24 to 35mm lens is a good choice. To isolate details in a distant scene, a telephoto zoom lens is handy.
Camera Settings	**Practice Picture:** Aperture-priority AE mode with white balance set to auto (AWB). If I had chosen Shutter-priority mode, I would have had less control over the depth of field, although you may prefer to use Shutter-priority mode for late-day shooting.
	On Your Own: If you use Basic Zone modes, use Flash-off mode. Portrait and Landscape modes are options for small and large scenes respectively. Otherwise, you can use either Shutter- or Aperture-priority AE mode.
Exposure	**Practice Picture:** ISO 100, f/5.6, 1/8 second.
	On Your Own: Holiday-light photography is a good time to use bracketing on the Digital Rebel. Set the bracketing to 1-stop increments and take three frames. You can boost the ISO to 360 or 400 to get faster shutter speeds. Evaluate the pictures on the computer and decide if it would be worthwhile to use a noise-reduction program, such as Noise Ninja.
Accessories	Even rock-steady photographers know that in low light they need to stabilize the camera on a solid surface or by using a tripod. A tripod is your friend.

✦ **Adjust exposure accordingly when photographing by candlelight.** If you want to take portraits by candlelight, move the person close to the light source, and then take a meter reading on a well-lit skin tone. Press the AE-lock button, recompose, and take the picture. The candlelight will be slightly overexposed, but the subject's skin, which is the important aspect of the image, will be accurately exposed.

✦ **Avoid digital noise.** While you may be inclined to use a high ISO setting instead of schlepping around a tripod, you run the risk of introducing digital noise. For the best image quality with the least noise, use settings up to ISO 400.

Landscape and Nature Photography

With breath-taking vistas of forests, mountains, and expanse of sky, Mother Nature's handiwork remains a favorite subject of photographers. From dawn to dusk and sometimes beyond, our environment provides an endless source of inspiration for lovely images. And you don't have to go far. It's possible to choose a single location and return day after day and take entirely different pictures. Seasonal changes to flora and fauna, passing wildlife, rain, sunshine, fog, and snow all contribute to nature's ever-changing canvas.

6.47 Breaks of sunlight give this image of a tree-covered mountainside added dimension.

Photographing landscapes and nature is a wonderful way to develop your skills as a photographer because it requires high levels of both creative and technical skills to create compositions that are dynamic, evocative of the mood of the scene, and that adequately capture the extremes of light and shadow.

Note *Dynamic range is the camera's ability to record detail in light as well as dark areas.*

The image histogram is a great tool for evaluating whether the camera has successfully captured detail in both light and dark areas. If the histogram shows pixels crowded against the left, right, or both sides of the histogram, the camera wasn't able to maintain detail in one or both areas. Filters, such as a graduated neutral-density (NDGrad) filter, can help balance the exposure for bright sky areas and darker foreground areas allowing the sensor can hold detail in both areas.

Cross-Reference *For more information on histograms, see Chapter 1.*

The challenge of outdoor photography is in capturing the essence of a scene without the aid of chirping birds, the smell of clover, and the warm breeze of a late spring day. Compositional techniques including identifying a center of interest, using leading lines, framing, and placing the line of the horizon off-center go a long way in creating interesting nature pictures that help convey the sense of grandeur and beauty you sense when the scene catches your eye.

The quality of light plays a starring role in nature photography. The low angles of the sun at sunrise and sunset create shadows that add a sense of depth to landscapes not to mention the beautifully rich hues these times of day add. Fog adds a sense of mystery, overcast light enriches colors, and rain dapples foliage with fascinating patterns of water droplets.

Without doubt, the Digital Rebel delivers a star performance in nature and landscape photography. You can set the camera on Landscape mode and get consistently outstanding photos. Or you can use a Creative Zone mode to exercise more control over the final image. Either way, you'll be delighted with the results.

6.48 Changing seasons often provide colorful images such as this pumpkin display that was set up shortly before Halloween.

One of the best tools an outdoor photographer can have is a polarizing filter that not only reduces glare and reflections, but also increases color saturation in the sky.

Inspiration

Choose a place that gives you a unique sense of, say, tranquility. Try different positions, focal lengths, and foreground elements to help capture the sense of tranquility. As you take pictures, look both at the overall scene and the components that make it compelling. Isolate subscenes that make independent compositions or that can be used as a center of interest for the overall scene.

As you look around, ask yourself questions such as whether including more or less of the sky will enhance the scene and the composition. Generally, a gray, cloudless sky adds no value to the image; in these conditions, including less of the sky is a better choice. Stormy skies, on the other hand, can add drama as well beautiful color to outdoor images.

Watch for naturally occurring elements such as an old wooden fence, a winding road, or a decaying archway to create classic compositions.

Landscape and nature photography practice

6.49 This late-afternoon scene is set off by the isolated farmhouse sitting in the shadow of the mountains.

Table 6.14
Taking Landscape and Nature Pictures

Setup	**Practice Picture:** The image in figure 6.49 was shot from a road-level view and composed so that the point of the mountains leads to both the tree trunk and the red farmhouse.
	On Your Own: Because such a wide variety of scenes are possible with landscapes and nature, the best advice is to trust your eye to set up and compose images. Try to exclude distracting high-line wires, road signs, and trash within the scene. Shoot from a variety of low, high, and eye-level positions. For sweeping scenes, include a foreground object such as a person, a rock, or a fence to give a sense if scale. As you look through the viewfinder, consider how the elements in the frame will direct the viewer's eye in the final picture.
Lighting	**Practice Picture:** Late-afternoon winter light was ideal for this mountain scene. While the camera maintained detail in the light areas, shadow areas tended to block up, or go too dark to show detail. Although the light exceeded the camera's dynamic range, the image remains successful. An alternative approach is to take two photos from the same shooting position, one exposed for the highlights and the other exposed for the shadows, and then combine or composite them in Adobe Photoshop Elements or Photoshop.
	On Your Own: A wide variety of lighting conditions is inherent in landscape and nature photography. Often the best light is during and just after or before sunrise and dawn when the low angle of the sun creates long shadows and enhances the colors of flora and fauna.
Lens	**Practice Picture:** Canon EF 70-200mm, f/2.8L IS USM set to 200mm.
	On Your Own: Both wide-angle and telephoto zoom lenses are good choices for landscape and nature photography. For distant scenes, a wide-angle lens will render some elements too small in the frame. Use a telephoto lens to bring them closer.
Camera Settings	**Practice Picture:** Aperture-priority AE mode with white balance set to Daylight.
	On Your Own: Aperture-priority AE mode with white balance set to match the light is a favorite choice. Because some landscape images look better with deeper color, you can set Exposure Compensation to – 1/2 or -1/3 stop. Just press the +/– Exposure compensation button on the back of the Digital Rebel, and then dial in the amount of compensation you want.

Exposure

Practice Picture: ISO 100, f/9.5, 1/125 second.

On Your Own: Use the lowest ISO possible to avoid digital noise. In most landscape and nature photos, extensive depth of field is the best choice. Meter for the most important element in the scene and bracket to ensure that at least one frame does not have blown highlights.

Landscape and nature photography tips

✦ **Position yourself to take advantage of sky as a backdrop.** For pictures of foliage, flowers, and colorful seasonal trees, use a low shooting position and shoot upward if you have a deep blue sky as the backdrop for the subject.

✦ **Get extensive depth of field.** To get extensive depth of field, set the Digital Rebel to Aperture-priority AE mode, and choose a narrow aperture such as f/11 or f/16. Then focus the camera one-third of the way into the scene, lock the focus, recompose, and take the picture.

✦ **Try using the Digital Rebel's default parameter settings.** For example, using the Parameter 2 setting subdues colors and helps reduce the high contrast of brightly lit scenes. On an overcast day, use Parameter 1 that provides more vivid colors. Or you can set your own parameters to boost color and sharpness for dismal lighting situations.

✦ **Don't always default to a using a wide-angle lens.** Many people associate landscape photography with wide-angle lenses. However, telephoto lenses are indispensable in all types of outdoor photography, and they are very useful for isolating a center of interest in a wide-ranging vista.

✦ **When you shoot landscapes, include a person or object to help provide scale.** For example, to bring home the massive size of an imposing mountain range, include a hiker in the foreground or midground to give the viewer a scale of reference.

✦ **Look for details that underscore the sense of the place.** A dilapidated fence or a rusted watering trough in a peaceful shot of a prairie helps convey how the land was used.

✦ **Look for interesting light.** For example, when you shoot in a forest or shaded area, look to include streaming shafts of light coming through the trees or illuminating a single plant.

✦ **Use exposure compensation in scenes with large areas of light colors.** Large areas of light or white such as snow scenes or white sandy beaches can fool the camera meter into underexposing the image. To ensure that the snow or sand appears white in the final image, set exposure compensation on the Digital Rebel to +1 or +2.

✦ **Look for different ways to frame the scene.** Try using a tree as a frame along one side of the frame or a break in the foliage that provides a natural window that reveals a longer view of the scene.

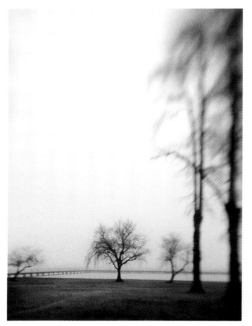

6.50 You can add a touch of creativity to your landscape images with specialty lenses such as the Lensbaby, which I used to make this image of trees in the fog.

Light Trail Photography

Visualize long ribbons of colorful light gracefully curving through the image, or a solid blur of colored light as a Ferris wheel seems to streak across a twilight sky. Light trails make fascinating and fun pictures, and they are easy to take using a slow shutter speed in moderate to low light. By keeping the shutter open, the camera can record the trailing motion of lights creating what is to still photography the equivalent of slow motion in the video world.

Of course, the trick to capturing light trails is to keep everything that isn't moving in sharp focus, which allows the motion of the light to create a dramatic contrast of blurred color streaks. And for variety, you can vary the amount of blur by varying the shutter speed: the faster the shutter, the shorter (or less) the blur and vice versa. Initially, shutter speeds of 1/30 second, to 1/8 second are good to get the effect. Longer shutter speeds can be used as well, but they should be balanced against the risk of introducing digital noise into the image. You can experiment with various shutter speeds to find the best balance between capturing dramatic light trails and maintaining a low level of digital noise.

6.51 A stream of nonstop traffic creates the light trails in this Las Vegas scene.

Add a Pop of Flash

Try adding an accessory flash as you take light-trail shots. A brief burst of flash while the shutter is open lights the subject just long enough to render a subject in good focus while the long shutter speed continues to record the trail of surrounding lights. This is a great technique to use when you want to convey the fun and thrill of a person on a fairground ride or on a passing motorcycle.

Capturing light trails requires some experimentation to get just the right exposure and, of course, solid support for the camera is a must. This is a good time to use the Digital Rebel's exposure bracketing feature.

Inspiration

You can find ample opportunities for taking light-trail pictures at fairgrounds, during fireworks displays, with moving holiday displays, on city streets, and by photographing star trails. Other venues include music concerts and late-day car races.

6.52 Local fairgrounds or amusement parks provide excellent opportunities for you to capture light trails.

Light trail photography practice

6.53 Patience is an essential tool in any nighttime photography. Experiment with exposure to get the effect you want, and wait, as I did here, until the object is moving at full speed to take the image.

Light trail photography tips

✦ **Limit your gear at night.** When shooting at night, take as little camera gear with you as possible and keep a watchful eye on the camera bag. Fairs and city streets and sidewalks at night provide the perfect opportunity for someone to quietly take equipment as you concentrate on shooting.

✦ **Take more pictures than you think you need and use exposure bracketing.** If you have more images, then you can choose from among the best images.

✦ **Exclude peripheral lights.** Be sure that the image framing does not include peripheral floodlights. Bright stationary lights such as streetlights are not only uninteresting, but they can also produce lens flare (that may appear in images as concentric circles of light).

✦ **Vary shooting positions.** Try different shooting positions, such as a

Table 6.15
Taking Pictures of Light Trails

Setup	**Practice Picture:** The image in figure 6.53 was taken at a year-round amusement park. I chose the location because it offered a number of different rides, and, therefore, different shooting opportunities.
	On Your Own: Your creativity is the only limit in taking pictures of light trails. Compose the image so that the trails create a vanishing point, a diagonal or other dynamic direction in the image.
Lighting	**Practice Picture:** It was night, and as a result, only the light from nearby stands provides a glow at the bottom of the frame.
	On Your Own: Twilight and beyond offer appropriate lighting for capturing light trails. Experiment with metering to ensure that very bright lights are not blown out. You can use the flash during long exposures to freeze a split second of the motion.

Lens	**Practice Picture:** Canon EF-S 18-55mm set to 18mm. **On Your Own:** A moderate to ultra wide-angle lens is the best choice for recording light trails. On the Digital Rebel, a focal length of 16 to 24mm is a good choice.
Camera Settings	**Practice Picture:** Shutter-priority AE mode with white balance set to auto (AWB). **On Your Own:** To control the length of the light trails, you have to control the amount of time that the shutter is open. Either Shutter-priority AE mode or Bulb mode where the shutter stays open as long as you keep your finger on the shutter button, are good options. Generally auto white balance, AWB, produces accurate color in these types of scenes.
Exposure	**Practice Picture:** ISO 200, f/8, Bulb mode. I could have set the ISO at 400 or 800, but I wanted to control the amount of digital noise, and because I was using a tripod, I chose a moderate ISO setting. I experimented with exposure using Bulb mode and counting seconds, "1000, 1001, 1002" and so on for the exposure. **On Your Own:** The key to taking pictures of light trails is to experiment with settings to get an acceptable exposure.
Accessories	Always use a tripod or set the camera on a rock-solid surface. Using the Self-timer mode also helps ensure crisp focus.

high vantage point for traffic on a busy freeway or closer in to capture the lights of a single passing car or motorcycle.

✦ **Expect that some images will not be keepers.** Low-light exposures require experimentation, and the camera meter can be fooled by the contrasts in light.

Macro Photography

Beyond the range of what people normally see day to day is a world of beauty, detail, and intricacy that constitutes a world unto itself—a world that can be best revealed and appreciated with macro photography. Many lenses are called macro, but only render subjects at one-third or one-fourth of life size.

Unlike close-up lenses that reproduce subjects at one-fourth to one-third life size, macro lenses' magnification is one-half life size to life size, or 0.5x to 1x magnification.

Macro lenses are also distinguished by the lens-to-subject focusing distance. For example, the closest focusing distance for Canon's EF50mm f/2.5 compact macro lens is 0.8 feet with 0.5x magnification. Or the EF-S 60mm f/2.8 Macro USM lens offers 1:1 magnification offers a working distance of 90mm. When you can't or don't want to get that close to a subject, the Canon EF180mm f/3.5L Macro USM lens has a minimum focusing distance of 1.6 feet with life-size (1x) magnification. In addition, Canon's MP-E65mm f/2.8 1-5x Macro Photo lens brings a world that's normally invisible to the human eye to life with its amazing 1x to 5x magnification.

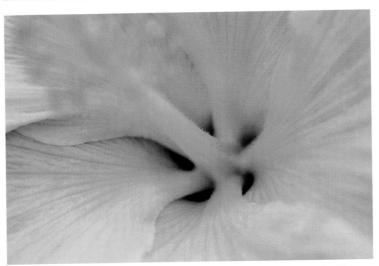

6.54 Delicate structures that are often overlooked are revealed in macro photography.

Note *For the EF 50mm f/2.5 compact macro lens, Canon offers a Life-Size Converter EF that allows magnifications of 0.26x to life-size (1:1). In addition, Canon also offers a ring flash that is ideal for illuminating subjects for macro pictures.*

In macro photography, the depth of field is necessarily very shallow and precise focus is critical. At extremely close focusing distances with high magnification, any camera or subject movement is magnified. This means that using a tripod and the Self-timer mode is the best guarantee for getting a sharp image.

Note *You can buy and use bellows and extension tubes to move the lens away from the image sensor to increase magnification. They require some patience to work with and result in a loss of light, so you need to experiment with exposure somewhat.*

As with all photography techniques, macro photos are best when the photographer clearly identifies a center of interest, works to light the subject with care, and spends time creating a dynamic and interesting composition. While this sounds easy to do, working at close distances and with moving subjects, such as insects, can make macro photography a fun challenge.

Get Creative *For fun and creative pictures, try using the Lensbaby, a moveable lens with bellows-type operation that replicates the effect of the plastic Holga cameras. The lens offers focusing as close as 1 foot when fully extended. You can also purchase an accessory macro lens that allows focusing as close as 1 to 4 inches.*

Inspiration

Macro subjects abound in nature and range from butterflies and ladybugs to the

dazzling design of flower parts and reflections in raindrops on a leaf. You can focus your macro efforts on vegetables, fishing reels, tiny mechanical part of a wristwatch, internal parts of a computer, candles, and even a subject's eye.

Macro photography practice

6.55 With the power of a macro lens, virtually everything becomes a candidate for close inspection, including candles.

6.56 Part of the fun of macro shooting is that you can choose to focus on any part of the subject that you want.

Table 6.16
Taking Macro Pictures

Setup	**Practice Picture:** A nursery constructed as a large greenhouse provided an ideal setting for macro shooting – lots of flowers and plants and nice lighting (see figure 6.56).
	On Your Own: With most macro pictures, the background is provided by surrounding areas of the subject. The most important consideration is to identify a center of interest and compose the image around it. If you want the entire subject in focus, keep the shooting angle so that the subject is as parallel as possible to the camera's focal plane.
Lighting	**Practice Picture:** The plastic covering of the nursery supplied lovely diffuse and even lighting for this picture.
	On Your Own: In many macro scenes, lighting can be enhanced by using a reflector to reflect existing light onto the subject. Many photographers also get good results by adding diffused flash.

Continued

Table 6.16 *(continued)*

Lens	**Practice Picture:** Canon EF 180mm f/3.5L Macro USM.
	On Your Own: Canon offers four macro lenses, a 50mm with optional life-size converter, a 60mm EF-S macro, a 100mm and a 180mm as described earlier in this section. All are excellent lenses and your choice depends on the magnification and working distances you prefer.
Camera Settings	**Practice Picture:** Aperture-priority AE mode with white balance set to auto (AWB).
	On Your Own: In many scenes, you'll want to choose a narrow aperture with a macro lens, which makes Aperture-priority AE mode a good choice. Because macro lenses have a short focusing distance, the depth of field is extremely shallow. For example, one-to-one photography with the 180mm macro lens offers a depth of field less than 1mm at maximum aperture.
Exposure	**Practice Picture:** ISO 100, f/5.6, 1/60 second.
	On Your Own: For the best image quality, choose the lowest ISO possible given the lighting available. The aperture choice is yours, but because of the inherent shallow depth of field, you may want to choose a narrow aperture.
Accessories	The higher the image magnification, the greater the likelihood of not holding the camera steady during exposure, especially with long focal length lenses. For the best macro images, always use a tripod and either the self-timer, or a cable release.

Macro photography tips

✦ **Always use a tripod.** A tripod is your friend.

✦ **Use an alternate focus method.** As you focus a macro lens, the image size becomes larger or smaller, which, in turn, changes the composition. Instead of adjusting focus on the lens, try moving the tripod and camera forward and back to adjust focus.

✦ **Be patient and wait for the best shot.** Unlike other photography specialties, macro photography requires using a deliberate and slow approach for setting up, composing, and focusing. Don't rush the process. Take your time and get the best composition, light, and focus possible.

✦ **Be aware that any movement will ruin a shot.** When shooting outdoor macro photos, the slightest breeze can ruin your careful focusing. Look into making or buying a plant holder that steadies the plant without damaging it.

Night and Evening Photography

If you're ready to challenge your photography skills, shooting low-light and nighttime images are a great way to do it. Evening and

night images not only expand your understanding of exposure, but they also open a new world of creative challenge, enjoyment, and the potential for spectacular results.

6.57 The intrigue of nighttime photography is one that few photographers can resist. The Digital Rebel offers a variety of ISO settings that make nighttime photography easier and more fun for digital photographers.

Sunset and twilight are magical photography times for shooting of subjects such as city skylines, harbors, and downtown buildings. During twilight, the artificial lights in the landscape, such as street and office lights, and the light from the sky reach approximately the same intensity. This crossover lighting time offers a unique opportunity to capture detail in a landscape or city skyline, as well as the sky.

Always meter the scene first, and then bracket exposures. Low-light and night photos are a great chance to use Manual mode on the Digital Rebel. Sample starting metering recommendations are provided in Table 6-17.

Inspiration

Try shooting city skyline shots in stormy weather at dusk when enough light remains to capture compelling colors in the sky. Busy downtown streets as people walk to restaurants, cafés, and diners; gasoline stations, widely spaced lights on a lonely stretch of an evening highway, the light of a ship coming into a harbor, or an outdoor fountain or waterfall that is lit by nearby streetlights are all potential subjects for dramatic pictures, as are indoor events such as concerts and recitals.

Night and evening photography practice

6.58 Never stop challenging yourself. This lunar eclipse is just one of hundreds of opportunities to expand your photography skills.

Fireworks Photography

If you want to capture the rocket's red glare, you can use lenses in the range of 28mm to 100mm, and then set the camera on Flash Off mode. Choose an ISO from 200 to 400. Because the camera may have trouble focusing on distant bursts of light, you can pre-focus manually on infinity and get good results. I also recommend using a tripod or setting the camera on a solid surface to ensure sharp images. If you want to keep it simple, you can set the camera to Full Auto, and then just point and shoot.

If you want to have more creative control, it's good to know at the start that capturing fireworks is an inexact science at best. I usually set the camera to ISO 200, use Manual mode, set the aperture to f/11 or f/16, and set the shutter on Bulb, which is a shutter speed setting that allows the shutter to stay open as long as you keep your finger on the shutter button or release cable. On Bulb, you can experiment to find the best time, usually between one and two seconds. Check the results on the LCD and adjust the time as necessary. The goal is to get a long enough exposure to record the full burst without washing out the brightest colors.

Don't worry if you miss some good displays at the beginning of the fireworks show because the finale usually offers the best photo opportunities. Practice during the early part of the display to get your timing perfected, and then you will be ready to capture the finale.

Table 6.17
Night and Evening Exposures

Subject	ISO	Aperture	Shutter Speed
City skylines (shortly after sunset)	100 [400]	f/4 [f/8]	1/30 second
Full moon	100	f/11	1/125 second
Campfires	100	f/2.8	1/15 to 1/30 second
Fairs, amusement parks	100 [400]	f/2.8	1/8 to 1/15 second [1/30-1/60]
Lightning	100	f/5.6 [f/8]	Bulb; keep shutter depressed for several lightning flashes
Night sports games	400 to 800	f/2.8	1/250 second
Candlelit scenes	100 [200]	f/2.8 [f/4]	1/4 second
Neon signs	100 [200]	f/5.6	1/15 second [1/30]
Freeway lights	100	f/16	1/40 second

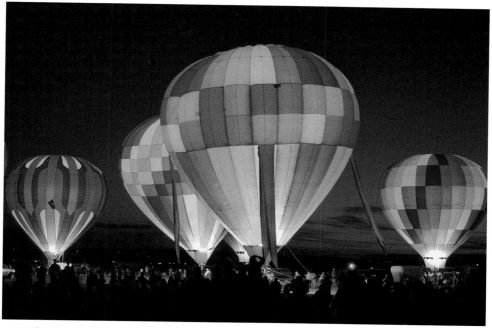

6.59 The extra drama of a late-twilight sky adds to this picture of a balloon glow that is staged every summer.

Table 6.18
Taking Night and Evening Pictures

Setup	**Practice Picture:** A summer's evening balloon glow was the scene for this image, shown in figure 6.59. This is a popular annual event, so crowds arrive early to stake out a good seating location. I took a position behind most of the crowd to get a wide shot of the balloon glow when the burners are fired.
	On Your Own: If you are photographing a busy area, find a location that is away from pedestrian traffic and is unaffected by the vibration of passing cars. Ensure that your composition has a clear message and isn't visually confusing by including too much in the frame. Be aware that passing cars and nearby lights can influence the meter reading on the camera. If it interferes, change your shooting position if possible.
Lighting	**Practice Picture:** The balloon glow took place just after twilight, although some of the sapphire color of twilight is visible in the lower right of the photo.
	On Your Own: To photograph scenes with floodlit buildings, bridges, or other night scenes, begin shooting just after sunset so that the buildings stand out from the surroundings. Check images on the LCD to ensure that the brightest lights are not blown out.

Continued

Table 6.18 *(continued)*

Lens	**Practice Picture:** Canon EF-S 18-55mm f/3.5 to f/5.6 set to 18mm.
	On Your Own: A wide-angle zoom lens set to 18mm or 24mm allows you to get a broad expanse of night and evening scenes. Telephoto lenses, of course, are great for bringing distant scenes closer, but at this time of day, a tripod is a requirement especially if you use a long lens.
Camera Settings	**Practice Picture:** Aperture-priority AE with white balance set to auto (AWB).
	On Your Own: Assuming that you have the camera on a tripod or on a solid support, Aperture-priority AE mode gives you control over the depth of field. In Basic Zone mode, you can turn off the flash and use Landscape mode.
Exposure	**Practice Picture:** ISO 100, f/2.8, Bulb mode at approximately one to two seconds. It took a good deal of experimentation to get this shot. The balloons light sequentially and sometimes randomly in time with background music. Getting a shot with many balloons glowing simultaneously and with an acceptable exposure required no small measure of patience and a good measure of luck. The original exposure was not perfect. I used the Levels and Curves commands in Photoshop to provide a better final image, and I darkened the bright areas near the balloon's burners.
	On Your Own: Just past sunset, you can usually rely on the Digital Rebel's meter to give a good exposure. It's a good idea to bracket exposures by 1-stop intervals. However, if bright lights surround the scene, the meter can be thrown off. Use a lens hood and check images often in the LCD. To keep exposure time down, you can increase the ISO up to 400.
Accessories	A tripod or setting the camera on a solid surface is essential in low-light scenes.

Night and evening photography tips

✦ **Be safe and use common sense.** Night shooting presents its own set of photography challenges, including maintaining your personal safety. Always follow safety precautions when shooting during nighttime. Be sure to wear reflective tape or clothing, carry a flashlight, and carry a charged cell phone with you.

✦ **Use a flashlight to trick the focus.** If the camera has trouble focusing, train your flashlight on the subject long enough to focus manually or automatically, and then turn off the flashlight before you take the picture.

✦ **Use a level when using a tripod.** A small bubble level designed to fit on the flash hot shoe mount is an indispensable piece of equipment for avoiding tilted horizon shots.

✦ **Try the Self-timer mode.** You can, of course, negate the advantage of using a tripod by pressing the shutter release button with your finger. Just pressing the shutter button with your finger can cause noticeable loss of sharpness. A better solution is to use the Digital Rebel's Self-timer mode.

6.61 The key to online auction photos is to show the item that you're selling in a simple setup. Here the broach includes the context of a formal dress.

6.60 The slow shutter speeds necessary in night photography also add a nice touch to this image of a fountain.

Online Auction Photography

There is a hard-to-resist primal appeal to the idea of having strangers pay real money for stuff that is stacked to the rafters in your closets, attics, and garages. This appeal alone may explain the phenomenal growth of online auction sites in the past few years. After all, who hasn't whiled away a few hours browsing through other people's closet-stuff on the cyberspace equivalent of the world's largest garage sale.

Whether you're buying or selling items, you know that pictures of the items will maximize the appeal. Never mind that because potential buyers can't examine items, simply providing a descriptive photo can make or break

the sale. Another reason to include photos is that many auction sites will allow you to advertise your item on additional areas of the auction site, such as the photo gallery.

Auction photos do not have to be works of art. But they do need to answer questions that a potential buyer might have. Buyers will likely want to know what the item looks like in accurate detail, what the color and condition of the item is, and what are the fine points, such as does it have handcrafted details and is the interior of the item clean.

The next sections highlight the basics of shooting effective photos for online auctions.

Use simple, uncluttered backgrounds

To show off the item you're selling, create a makeshift studio using poster board or a solid colored sheet for a plain background or outside on a table, stand, or chair. The area you choose should provide enough

room for you to work comfortably. Clear any items from the area that will not be included in the photo.

Use even, diffuse lighting

The goal of lighting is to provide soft, even light on the subject. Consider setting up your photography area next to a window (for small items), outside on an overcast day, or in the shade on a sunny day. If the area you're working in has natural light coming from one direction, the opposite side of the item may be dark and lack detail. You can use a reflector or small lamp in to fill in the darker area.

Ensure tack-sharp focus

The advantages of sharp focus are obvious, yet many auction photos are blurry enough that it's hard to tell what the item really looks like.

Show color accurately

If you're selling bone china, for example, you don't want a strange green or blue color tint in the photo. To avoid unwanted color tints, be sure you set the white-balance to match the type of light in the scene.

On the Digital Rebel, you can take your pick of modes. For quick shots of small items, Close-up mode is an excellent option. For items laid out three or four items deep, switch to Aperture-priority AE mode and set a narrow aperture such as f/11 or smaller to ensure good depth of field, or sharp focus front to back in the image.

Inspiration

Your inspiration will obviously be the item or items that you're selling. However, you

6.62 If you can't think of or don't have time to create a more elaborate setup, a simple white background will show off auction items nicely and give potential buyers an accurate view of your product.

can spend some time with creative arrangements of multiple items to make the items more attractive for buyers. You can also include close-up shots that show details that buyers would be interested in or that make the product unique.

Online auction photography practice

6.63 Items being auctioned stand the best chance of being sold if their images are no-nonsense and show the item or items clearly.

Table 6.19
Taking Online Auction Pictures

Setup	**Practice Picture:** I used white seamless paper to cover a small table and a background stand in figure 6.63. The plain background makes the objects being sold stand out with no distractions. I also wanted to ensure brightness throughout the image to show the condition of the items.
	On Your Own: Keep the setup for the item simple and clean. Household items including poster board, small tables, and household lamps are all you need to photograph small items. Keep the composition pleasing and simple.
Lighting	**Practice Picture:** To light the background, I pointed two lights at the background, one on the left side of the table, and one on the right side. Another lamp was placed to the left of the camera and pointed at the front of the subjects. A silver reflector was placed to the right of the subject. I subsequently lightened the background further in an image-editing program.
	On Your Own: Uniform lighting with few or no shadows are preferable for these types of images. Use two or more household lamps and a silver reflector to lessen shadows. You can use a couple more lamps to light the background separately. If the lighting creates hot spots (areas where the light is very bright) adjust the lighting to reduce or eliminate the bright areas.
Lens	**Practice Picture:** Canon EF 24-70mm f/2.8L USM set to 35mm.
	On Your Own: Your lens choice will depend on the size of the objects. For small items, I recommend using a 35mm focal length or the EF-S 60mm f/2.8 Macro USM lens. For large displays, use a 22mm or even a 16mm focal length.
Camera Settings	Aperture-priority AE mode. I set a custom white balance for this shot as described in Chapter 2.
	On Your Own: For easy, no-hassle shots, use a Basic Zone mode that is adequate for the size of the setup or Full-Auto mode. However, because you want extensive depth of field so that all the items are reasonably sharp, you can use Aperture-priority AE mode.
Exposure	**Practice Picture:** ISO 100, f/5.6, 1/10 second with exposure compensation set to +1/3 to help brighten the background.
	On Your Own: To show the items with reasonable sharpness throughout, set the f/stop no wider than f/5.6 for small items and f/8 or f/11 for large displays. For the best image quality, choose a low ISO such as 100 or 200.
Accessories	For tabletop photography, I always use a tripod to ensure sharpness and Self-Timer mode.

Online auction photography tips

✦ **Don't neglect image editing.** Don't forget to edit images on the computer to make them bright, sharp, and appealing.

✦ **Brighten images for Web display.** Because images displayed on the Web are small, I've found it best to lighten the final photo slightly. This makes it a little brighter and shows details well. Use a very light hand in making this adjustment so that you don't wash out colors or details.

✦ **Play up the best features of an item.** If there is a unique feature of the item, try showing it off by selectively casting a little more light on the detail to create a soft spotlight effect.

✦ **Use a tripod.** This is especially important if you take close-up pictures of small items. A tripod ensures a crisp image if you focus carefully.

✦ **Review your competition.** Before you begin shooting, check photos of the same or similar items that are already on the auction site. Spend some time evaluating how the pictures that you take can be better or more compelling than existing photos.

Panning

A goal with any photo is to convey the sense of the moment. With action, kid, and even wedding photography, a sense of action and motion can be conveyed by showing subject blur, but you can also pan the camera with the subject to artistically convey the motion.

Panning differs from pictures that show subject motion as a blur. In pictures that show subject motion as a blur, the subject is the only element that's blurred; the surrounding elements are in sharp focus. With panning, however, some of or all of the subject and the background are blurred creating colorful streaks of color with a single area of near or

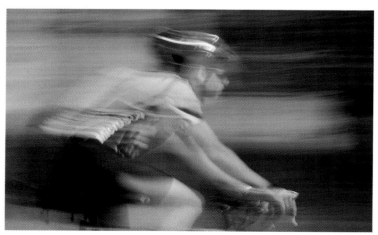

6.64 When you want to show speed and motion, there is no better technique than panning the camera with the motion of the subject.

reasonably good focus. Because the human eye is drawn to the area of sharpest focus, panning can isolate the center of interest in an interesting and creative way.

Panning is a simple technique that takes a little practice to master. But once mastered, you can create dynamic pictures that convey the scene in a singular fashion.

Here are the basic steps you need to know to pan with your camera:

✦ **Set the Digital Rebel to Shutter-priority AE mode.** This mode allows you to control the shutter speed, ensuring that you have time to move the camera during the time that the shutter is open. On a bright day, a 1/30 second shutter speed will give you a sufficient time for quick panning with the subject. One-fourth second gives you slightly more time for the pan.

✦ **If you haven't panned before, you'll get the best results if you mount the Digital Rebel on a tripod.** If you are very steady, and if the shutter speed is relatively fast, say 1/30 second or faster, then you can try handholding the camera.

✦ **Position yourself parallel to where the subject will pass.** For example, to create a panned shot of a bicycle rider, take a position along the side of the bike trail or racetrack that provides a good background. If the background is monotone, say a concrete enclosure on a racetrack, the background blur will be relatively boring. But if the background includes colorful signs, foliage, or street or car lights, the streak colors will be more interesting.

✦ **With the camera on a tripod, loosen the tripod head so that you can move the camera horizontally in a smooth, steady motion.** If you are hand-holding the camera, steady the camera by pressing your right elbow solidly against your midsection, and standing with your feet apart. This position helps stabilize the camera and keeps it level horizontally as you move, or pan, with the subject.

✦ **Focus on an object that will be at the same distance away from the camera as the subject will be when it passes in midframe.** If you're on a bicycle trail, for example, focus on a rock along the trail that is at the same approximate distance as the subject will be. Lock the focus by pressing the shutter halfway down.

✦ **As the subject comes toward you, frame the subject and follow the subject with the camera.** With the shutter button pressed halfway and the camera to your eye, frame the subject in the viewfinder, and swivel your hips without moving your feet as you follow the subject with the camera. Press the Shutter button when the subject reaches the prefocus point, and continue moving the camera in a steady sweep with the subject motion.

Inspiration

Panning is an effective technique with almost anything that moves. In addition to sports, kids, and events, you can pan with pets, birds, horses running in a field, speedboats, remote-control toys, a person mowing the grass, and cars passing on a street.

Get Creative

Panning is a great alternative in scenes where you can't use a flash. For example, if you're photographing a child's graduation and flash is prohibited, just pan the camera with the child as he or she crosses the stage.

Panning practice

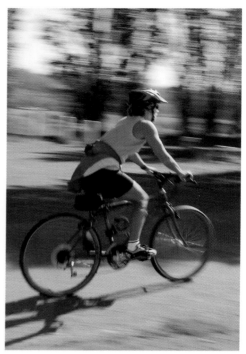

6.66 The biker's direction at a diagonal helps add a dynamic sense to this pan-blur.

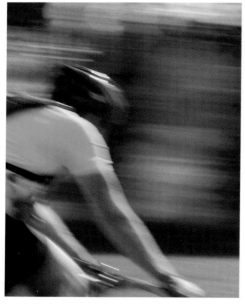

6.65 Once in awhile, background and the color the subject is wearing come together to create a complementary mix.

Panning tips

✦ **Practice makes perfect when you're learning to pan the camera.** An easy way to practice is by photographing cars passing on the street.

✦ **Try different shutter speeds.** Experiment with different shutter speeds to see which allows you to get the longest amount of time to pan the camera.

✦ **Experiment with the focus point.** You can choose to focus on the subject at the beginning, center, or end of the frame. Each produces a different "look."

Table 6.20
Taking Pictures Using Panning

Setup	**Practice Picture:** For the image in figure 6.66, I pre-focused on a rock along the bike trail before the subject entered the frame.
	On Your Own: Because panning streaks the background, you have the ability to choose shooting positions that offer complimentary colors. Usually monochromatic background such as concrete embankments, do not work as well as detailed backgrounds. To get an idea of how the background will appear in the final image, practice panning before you begin shooting subjects. If you don't like the results, find a new shooting position.
Lighting	**Practice Picture:** This picture illustrates that panning is possible in bright sunlight, the type of light present when this picture was taken. Of course, by setting a narrow aperture, the camera set a longer shutter speed for the exposure. Bright light limits shutter speed options. If I had set an aperture of f/8, it would have set a shutter speed of 1/250 second, which does not leave the shutter open long enough to pan the camera.
	On Your Own: No special lighting is required to pan, although you can experiment by using a pop of flash during the pan.
Lens	**Practice Picture:** Canon EF 16-35mm f/2.8L USM set at 35mm.
	On Your Own: You can use a moderate telephoto or wide-angle lens to pan. For example, the EF-S 18-55mm lens is adequate for many types of subjects.
Camera Settings	**Practice Picture:** Aperture-priority AE mode with white balance set to Daylight.
	On Your Own: You can choose either Shutter-priority AE or Aperture-priority AE mode for panning. In bright light, use Shutter-priority to ensure that the shutter speed is no shorter than 1/30 second.
Exposure	**Practice Picture:** ISO 100, f/18, 1/30 second.
	On Your Own: Because panning requires a slower shutter speed, be sure the shutter speed is no shorter than 1/30 second. In low-light scenes, be sure to use a tripod to avoid camera shake during panning. The tripod also makes it easy to maintain a smooth, fluid camera movement throughout the panning.
Accessories	With longer shutter speeds of 1/4 second and longer, use a tripod to ensure sharpness. The tripod also helps you move the camera smoothly as you pan with the subject.

Panoramic Photography

When the full, glorious sweep of a scene takes your breath away and makes you wish that you could capture it end to end, then the scene is a good candidate for panoramic photography. In traditional photography, a panoramic photo is longer and narrower than traditional photos, and it is taken with a panoramic camera. Panoramic cameras vary from those that scan and gradually record the entire scene to others that capture the scene all at once.

With digital photographs and the Photo-Stitch program, software that precisely aligns a series of photos side to side or top to bottom that comes with the Digital Rebel, you can easily create panoramic photos.

The technique of taking a series of pictures for a panorama is to shoot successive images of a scene from left to right or top to bottom. To make the images consistent, it's important to keep the camera exposure and settings the same and to keep the camera level across all pictures. Each successive image should include some overlap with the previous image. The overlap helps later when you align the images in PhotoStitch.

Note *PhotoStitch helps you merge two or more pictures into a panorama and print the merged images. If you're so inclined, you can create images with a 360-degree wrap-around view. And you can shoot images for the panorama in vertical or horizontal format. The program also automatically adjusts for differences in brightness and color. Because the final image is a combination of multiple single images, the file size of panoramic images is very large.*

Inspiration

Panoramic photography is most often associated with landscape subjects, but residential and commercial interiors, city skylines, and gardens are good subjects as well.

6.67 A sweeping scene such as this is a good candidate for stitching multiple images into a panorama.

Panoramic photography practice

6.68 This early winter scene with a field of pumpkins and gourds made a good panoramic subject to show the sweep of the town against the mountains.

Panoramic photography tips

✦ **Have a composition in mind before you begin.** This helps you determine where you want the center of interest in the final image. And with the final composition in mind, you can determine your starting and ending points.

✦ **Opt for extensive depth of field.** The aperture you use should be as narrow as possible to ensure extensive depth of field.

✦ **Include large objects in a single frame.** It's best to have large foreground elements such as trees and buildings in a single frame rather than stitched across multiple frames. If this isn't possible, be very careful to keep the camera level and allow at least 25-percent overlap between frames.

✦ **Take several series of the same scene.** Take a panoramic series more than once as insurance that one series will stitch together

Table 6.21
Taking Panoramic Pictures

Setup	**Practice Picture:** As I looked at the scene in figure 6.68, I determined how much of it that I wanted in the final combined image. Then I started shooting from left to right leaving about a 25 percent overlap in each subsequent shot.

Continued

Table 6.21 *(continued)*

	On Your Own: Identify the composition that you want in advance of shooting. The composition should include a center of interest and follow the traditional composition guidelines. Moving objects such as birds and planes are not good to include in panoramas. Their movement and position through the series of images can make subsequent image stitching more difficult. Technique is also important: Keep the camera level across the series of images.
Lighting	**Practice Picture:** These images were taken at mid-afternoon in bright sunlight.
	On Your Own: Choose a time of day when the lighting remains constant. If you include the sun, try to keep in entirely within one of the images, rather than partly in two or more images to make stitching easier.
Lens	**Practice Picture:** Canon EF 16-35mm 2.8L USM lens set to 35mm.
	On Your Own: Images taken with telephoto lenses are often easier to stitch than those taken with wide-angle lenses.
Camera Settings	**Practice Picture:** Use Aperture-priority with white balance set to Daylight to establish the exposure for the most important part of the panorama. Then use the same aperture and shutter speed set in Manual mode for all images in the same panorama.
	On Your Own: Good depth of field is preferable with panoramic images. A panorama need not be horizontal. You can also shoot vertical panoramic images. The more the images overlap, the easier it will be for the stitching program to combine them seamlessly.
Exposure	**Practice Picture:** ISO 100, f/11, 1/160 second.
	On Your Own: To maintain extensive depth of field, set the aperture to f/8 or f/11 also a situation where you want to avoid unnecessary digital noise by setting the ISO to 100 or 200.
Accessories	Use a tripod to keep the camera level across the series of shots.

Pattern Photography

Symmetry and repetition, whether they occur in nature, structures, or objects, hold a fascination. The human eye naturally tries to identify the similarities, differences, and the "rhythm" or geometry of the repetition. With some subjects, patterns become a free-form abstract while other patterns are more literal and emphasize similarities of texture, shape, and/or colors. For photographers, patterns offer endless opportunities for creative angles and treatments.

In nature, precise repetition and symmetry abound in the world of plants, insects, and animals. And with a strong, low-angled sun to one side of the camera, pattern photography is more intriguing when strong shadows are integrated into a composition.

6.69 Grace and symmetry are the defining characteristics of this pattern shot.

Identifying and isolating patterns photographically makes for interesting images. It is also an excellent method for new photographers to identify underlying lines and structures and learn to use them effectively in all types of photography.

The inherent characteristics of lenses are creative tools to enhance pattern photography. For example, you can use a telephoto lens's tendency to visually compress the distance between objects in a scene as a creative tool to compress distant patterns. A wide-angle lens at a close camera-to-subject distance makes near objects seem larger while distant objects seem much smaller. You can use the characteristic to create a large-to-small appearance even with objects that are the same size.

Inspiration

Look for interesting patterns in small household objects such as colored pencils, paperclips, nails, stamps, coins, bottle tops and caps, buttons, and even the spiral binding on a notebook.

In nature, good subjects include ferns, palms, spider webs, the underside of wild mushrooms, decorative grasses, evenly spaced trees in a forest or grove, the stamens of flowers, feathers, pinecones, growth rings on trees, and a bin full of fresh produce.

Also look for patterns in architecture (both interiors and exteriors), items on store shelves, window blinds, the terraces of a plowed field, fence posts, brick walkways, doors, and windows.

6.70 This macro shot of a tropical flower shows the intricate patterns that are common in nature.

Pattern photography practice

6.72 Taking a low shooting position allowed me to get this pattern shot.

6.71 Strong backlighting created an abstract sense in this picture of a huge fern frond photographed against the plastic roofing of a greenhouse.

Pattern photography tips

✦ **Look for graphic elements.** Look for strong graphic elements that make patterns stand out such as deep blue skies, water, or strong shadows.

✦ **Use the Close-up mode or one of the Creative Zone modes.** These settings combined with a macro lens will help to ferret out small pattern series in nature, such as the tiny veins on a leaf.

✦ **Use the light to your advantage.** Shoot patterns in the early morning or late afternoon when the angle of the sun is low, which creates long, deep shadows.

✦ **Use the lines and angles already present in your subject.** As you compose pattern shots, create strong, dynamic compositions where lines form a graceful curve or a strong overall diagonal across the frame.

Table 6.22
Taking Pictures of Patterns

Setup	**Practice Picture:** The picture in figure 6.71 was taken with the Digital Rebel mounted on a tripod and shooting up toward the plastic-covered roof of a greenhouse. **On Your Own:** Look for subjects that create strong graphic patterns. Isolating only the patterns is the key to these kinds of images. And be sure to choose a non-distracting background.
Lighting	**Practice Picture:** The day had heavy cloud cover creating naturally diffuse light. Additional diffusion was added with the plastic covering of the greenhouse roof. **On Your Own:** Extremes in lighting can add drama to patterns. For example, deep shadows increase the repetition of the shapes, while backlighting makes patterns in plants transparent to add interest to the image.
Lens	**Practice Picture:** Canon EF 180mm f/3.5L Macro USM. **On Your Own:** Your lens choice depends on the size of the subject and the effect you want to create. You can use the inherent characteristics of a wide-angle lens to separate the distance between patterns, or a telephoto lens to compress patterns. If you're using a zoom lens, try different focal lengths and see how they change the composition.
Camera Settings	**Practice Picture:** Aperture-priority AE with white balance set to Auto (AWB). In this image, I wanted extensive depth of field to ensure that the image would be sharp front to back, so that each leaf would be sharp. The image would be less effective with shallow depth of field or having some of the leaves soft or blurred. An extensive depth of field, achieved with f/8 and by being far from the subject, ensured crisp pattern definition throughout the frond. **On Your Own:** Aperture-priority AE allows you to control the depth of field and is a good choice for pattern photos.
Exposure	**Practice Picture:** ISO 100, f/8, 1/15 second. **On Your Own:** To keep reasonable sharpness, choose a narrow aperture such as f/8 or f/11. Or experiment with wide apertures to have patterns move from sharp to blurred.
Accessories	If you're shooting at slow shutter speeds, be sure to use a tripod.

Pet and Animal Photography

Nothing gets an "awww" quicker than a cute pet or animal photo. Next to photographing people, pets and animals are the most appealing subjects in photography. And as with people photography, the goal is to convey the spirit and personality of the pet or animal. Of course, a major difference is that pets and animals don't smile, so conveying the animal's mood hinges on eliciting its natural curiosity and interest, and then capturing the mood in the animal's eyes and gestures.

6.73 Whether you choose an indoor or outdoor location, pet and animal photography can result in great images.

Note *When you photograph pets and animals, it's important to keep the welfare of the animal in mind. Never put the animal in danger or expect more of the animal than it is capable of or willing to give.*

If you have a new pet, it's good to get the animal acclimated to the camera at a young age. Even with older pets that normally respond to verbal commands, don't be surpised if their response is less predictable when you're photographing them. After all, they can't see your face when it's behind the camera. Instead, establish eye contact with the animal as you set up the camera and talk to the animal throughout the photo session. And, of course, be patient with the animal, and offer rewards and verbal encouragement.

If you choose an outdoor location, consider an area that limits your pet's ability to roam. Otherwise you may find yourself trailing behind your pet trying to get a good shot when your pet would really rather be chasing birds in the yard.

Like people, pets quickly tire of having flash pictures taken, and some learn to look away from the camera. As an alternative to using a flash, photograph the animal outdoors or by the light of a nearby window. The Digital Rebel's Basic Zone modes, including Portrait, Sports, and Flash-off are good choices depending on the situation. Creative Zone modes come in handy when you want more control over the results.

Inspiration

You know your pet or animal best, and that means you know the expressions and gestures that are most characteristic and endearing. Have the Digital Rebel close by during everyday activities with the animal, and be sure to set a long delay for Auto power off so that the camera is ready to respond quickly. Photo opportunities include any new experiences for the animal such as getting acquainted with another pet, the animal sleeping in odd positions or with other pets, a pet watching out the window for kids to come home from school, racing after a ball or Frisbee, or performing in an arena.

6.74 Images of animals with very light coats can result in blown highlight areas. Be sure to meter on the lightest area and consider using a +0.7 Exposure Compensation setting.

Pet and animal photography practice

6.75 It's reasonably easy to simulate a studio setup using a table, white seamless paper (or a neutral color background such as an off-white or white wall), several tungsten (household) lamps or lights, and one or more silver reflectors.

Pet and animal photography tips

✦ **In most cases, shoot from the pet's eye level.** Occasionally, a high shooting position is effective to show a young animal's small size, but generally you'll get the most expression when you are on the same eye level with the animal.

✦ **Entice the animal with a treat or toy.** To get an animal to look in a particular direction, try holding a favorite toy or treat in your hand and move it in the direction that you want the pet to look.

✦ **Focus on the eyes.** Always focus on the pet or animal's eye that is nearest to the camera.

✦ **Try other techniques.** Use the techniques described in the sections "Action and Sports Photography" and "Panning" to photograph animals in action.

Table 6.23
Taking Pet and Animal Pictures

Setup	**Practice Picture:** I set up seamless paper on a stand for the background in figure 6.75 and sat my dog on the table several feet in front of the background. **On Your Own:** Indoor pictures are relatively easy to setup for small pets and animals. If you include a favorite toy, be sure that it doesn't obscure the pet's face. Outdoor setups are easiest and provide a natural background for the animal, but often it is difficult to keep the animal from wandering off. Find open areas where grass or natural foliage can be the background. Be sure to focus on the animal's eyes.
Lighting	**Practice Picture:** I used two lights to light the background. A separate light in front of, and to the left, was aimed at the dog. A silver reflector to the right of the dog reflected light back onto her. This setup also eliminates the problem of red-eye because the lights are bright and on continuously which causes the pupils to close more than under dimmer light. **On Your Own:** Indoors, you can use the basic lighting setup described for the practice picture, or you can use the light from a nearby window. Outdoors, late afternoon and sunset light provides beautiful light for animal pictures. You can also use fill flash, but you run the risk of red-eye in animals if you use the built-in flash.
Lens	**Practice Picture:** Canon EF 50mm f/1.4 USM. This lens offers excellent contrast and sharpness. **On Your Own:** Your lens choice depends in part on whether you're taking a portrait or full-body picture and the size of the pet or animal. For large animals the Canon EF-S 18-55mm lens should be sufficient. Even for headshots of animals, the EF-S 60mm f/2.8 Macro USM lens (equivalent to 96mm on a 35mm full-frame camera) is a good choice.
Camera Settings	**Practice Picture:** Aperture priority AE, with a custom white balance setting. **On Your Own:** The camera mode you choose may depend on the light. In most cases, you want to control the depth of field, so use Aperture-priority AE mode. A good starting point is f/5.6, which will create a softly blurred background.
Exposure	**Practice Picture:** ISO 100, f/16, 1/125 second. Because my pet is accustomed to being photographed, I felt comfortable with a slower shutter speed. **On Your Own:** If you use Aperture-priority AE mode, watch the shutter speed to ensure that it isn't slower than 1/30 second to avoid motion blur if the animal moves. In general, try to keep the shutter speed at 1/60 second or faster by choosing a wider aperture. If you fear that the animal will move, brighten the lights or add additional lights so that you can use a faster shutter speed. Or, you can increase the ISO to 200, or use a wider aperture, such as f/4.
Accessories	For more traditional portraits of pets indoors, such as figure 6.75, be sure to use a tripod. Outdoors, a tripod may not be practical, so be sure the shutter speed is fast enough to prevent motion blur.

6.76 Outdoor locations for large animals can add additional interest and context.

Photojournalism

Many people think that photojournalism is a specialty reserved for working journalists. But because photojournalism is capturing real-life, usually unaltered events as they happen, and real-life people pictures, you can see how the approaches and techniques used by photojournalists are especially useful for everyday photography.

Photojournalistic style includes elements from other types of photography including environmental portraiture, street, action and sports, and documentary, but with an emphasis on telling a story.

On a personal level, you and your camera are a team that can capture the story of life — yours and your family's at least.

For example, in the 2004 Presidential election, emotions and alliances ran strong on local and national levels. You can use the Digital Rebel and your photojournalism skills to capture the heartbeat of historic events such as this. All it takes is awareness that you are the photojournalist assigned to tell a story.

Getting shots that define the spirit and character of the person or event goes to the heart of the photojournalism style — all without posing or staging the scene. Getting defining shots, you need to understand the event or person, which means that you need to be there, in position, and ready to shoot when a defining moment happens.

6.77 When Pacific Northwest forest fires wore on for weeks, I took an opportunity to photograph the tireless work of firefighters who battled the blaze. The haze from nearby fires obscures the trees in the background and casts an orange glow on the grass.

In an everyday shooting situation such as a child learning to ride a bicycle, the story is the learning process. That includes the spills, the many attempts, the child's facial expressions, detail, close-up images of the child's foot on the pedal, or small hands with a tight grip on the handlebars. And finally, the defining shot that captures the child's surprise and delight as he or she finally pedals off unassisted.

Inspiration

Look for opportunities to hone your photojournalism shooting skills at local rallies, political gatherings, conventions, marches, protests, and elections. Or consider everyday scenes and milestone events including baptisms, weddings, a child's first steps, pregnancy, and the birth of a child.

6.78 A Sunday afternoon drive brought me to this scene where a pleasure boat was in danger of sinking. Sheriff's rescuers saved the boat just as it appeared that there was no hope of rescue.

Photojournalism practice

6.79 Because the 2004 presidential election stirred heated political debate, I took my camera with me to the polling place. This is one of a series of pictures from the polling booth. The defining moment for voters, of course, was marking the ballots after months of political harangues and debates.

Table 6.24
Taking Photojournalism Pictures

Setup	**Practice Picture:** After asking permission to photograph at the polling center shown in figure 6.79, I climbed up three steps to get a high view of one section of polling booths.
	On Your Own: There are no prescribed setups for photojournalism. The best advice is to find an unobstructed view of the unfolding story and stay out of the way of people in the scene.
Lighting	**Practice Picture:** The polling booth was the garage of a local fire station. The lighting was a mixture of fluorescent and daylight. With the first meter reading, I knew that I had to switch to a faster ISO and use the widest aperture because I was not using a tripod.
	On Your Own: In low light scenes or indoors, and if you're reasonably close, use the built-in or an accessory flash — provided that flash is allowed and does not disrupt the proceedings. Outdoors, conditions can run the gamut.
Lens	**Practice Picture:** Canon EF 70-200mm f/2.8L IS USM set to 70mm with Image Stabilization activated. I activated Image Stabilization because I was handholding the camera with a telephoto lens in relatively low light.

Continued

Table 6.24 *(continued)*

	On Your Own: A fast telephoto zoom lens is ideal for photojournalism shooting because in many scenes, you cannot get close to the subject. For weather-related photojournalism pictures, a wide-angle lens is ideal to include the context of bad weather surrounding a person or group coping with the weather.
Camera Settings	**Practice Picture:** Aperture-priority AE. Because I was shooting RAW files, I could experiment later with white balance. In Canon's Digital Photo Professional RAW conversion program, I set the white balance to Fluorescent and adjusted the color temperature to get a slightly warmer hue.
	On Your Own: If you are photographing a fast-moving scene, set the camera to Full Auto and shoot. Otherwise, I recommend Aperture-priority AE mode so that you can control the depth of field to blur distracting background elements. If there are lulls between shots, the camera will go to sleep. In the time it takes for the camera to wake up, shots can be missed. Set the Auto-Power Off function to a long interval or turn it off entirely, and be sure to have a spare, charged battery.
Exposure	**Practice Picture:** ISO 400, f/2.8, 1/20 second.
	On Your Own: Use wide apertures of f/3.5 or f/2.8 to blur distracting backgrounds. If the background adds context to the scene, open up to f/8 or f/11 provided that the light allows a narrow aperture.

Photojournalism tips

✦ **Review news material to get a feel for photojournalism.** Although everyone has grown up seeing news photos, few study them closely. Take time to carefully study photos in newspapers, news magazines, and consumer magazines to see how the photographers encapsulate the story through images.

✦ **Capture the defining moment.** Before you begin, think about what the defining moment might be in the scene that you're shooting. It's easy to miss capturing the defining shot by not knowing what it might be in advance. Of course, as the scene develops, the defining shot may change. Be prepared to keep up with the flow of events and anticipate events so that you can be in a good position to get the best pictures.

✦ **Reset the sleep mode on the camera.** Because the camera must be ready to shoot, set the Power Off setting to 30 minutes or Off. Of course, this will cause a drain on the batteries. For this reason, I recommend buying the accessory Battery Grip.

✦ **Get permission.** Be very cautious when photographing private events, and always ask the event organizers for permission to photograph the event.

6.80 A big part of the presidential election was the volunteers who checked voter registration cards and provided endless help to voters.

Portrait Photography

Of all forms of photography, portraiture is likely the most popular. People enjoy having a visual record of family and friends as they share years of living together. And more important, the most treasured photos are those that reveal the individual's personality and spirit. With the flexibility that the Digital Rebel offers and the high-quality images it produces, you can take many excellent portraits.

The following sections detail some of the key considerations involved in portraiture.

Lens choices

For head and head-and-shoulders portraits, normal to medium telephoto lenses ranging from 35mm to 100mm are excellent choices. With a characteristic shallow depth of field, telephoto lenses help blur the background to make the subject stand out. For full-length and environmental portraits, a moderate wide-angle lens is a good choice provided that the subject is not close to the lens. A wide-angle lens will distort facial features in ways that the subject will not appreciate.

6.81 Portraits don't require elaborate setups. Simple, straightforward images that capture the inherent happiness of a person form the foundation of good portraiture.

Backgrounds

A portrait should make the subject the center of attention, and that's why a non-distracting or softly blurred background is important. Even if you have trouble finding a good background, you can de-emphasize the background by using a wide aperture such as f/4.0 or f/2.8. If you plan to use a flash, be sure to move the subject well away from the background to avoid dark shadows.

Lighting

Lighting choices differ for portraits of men and women. For men, a strong, directional daylight can be used to emphasize strong masculine facial features. For women, soft, diffuse light streaming from a nearby window or the light on an overcast day is flattering. To control light, you can use a variety of affordable accessories including reflectors to bounce light into shadow areas and diffusion

panels to reduce the intensity of bright sunlight. These accessories are equally handy when using the built-in or an accessory flash for portraits. For the best exposure, take a meter reading from the highlight area of the subject's face, use Exposure Lock, and then recompose and take the picture.

Flash

The Digital Rebel's built-in flash offers nice images. However, you often have more flexibility when you use an accessory flash. With accessory flash units, you can soften the light by bouncing it off a nearby wall or ceiling. You can also mount an accessory flash on a light stand and point the flash into an umbrella to create studio-like lighting results. Inexpensive flash attachments such as diffusers and softbox-like attachments are also a great option for creating beautiful portrait lighting.

On the Rebel XT, you can use flash exposure compensation to dial in precisely the amount of light you want.

Regardless of the light source, be sure that the subject's eyes are well lit so that they sparkle and have catch-lights, or small, white reflections of the main light in the subject's eyes. Light also affects the size of the subject's pupils — the brighter the light, the smaller the pupil size. A smaller pupil size is preferable because it emphasizes the subject's irises (color part of the eye), making the eyes more attractive.

Posing

Entire books are written on posing techniques for portraits. A simple, quick guideline is that the best pose is the one that makes the subject look comfortable, relaxed, and natural. In practice, this means posing the subject in a comfortable position and in a way that emphasizes the attractive features while minimizing less-attractive features. Key

lines are the structural lines that form the portrait. Posing the subject so that diagonal and triangular lines are formed by the legs, arms, and shoulders creates more dynamic poses. Also, placing the subject's body at an angle to the camera is often more flattering than a static pose that has the head and shoulders on the same vertical plane.

Props

Props are helpful when you want to provide a simple context that reveals more about the subject. In addition, simple props can give adult subjects something to do with their hands and provide children with a welcome distraction from the camera. Props should compliment the subject while not becoming a distraction.

Rapport

Even if you light and pose the subject perfectly, a portrait can easily fail if you haven't established a positive connection with the subject that is mirrored in the subject's eyes. Every minute you spend building a good relationship with the subject pays big dividends in the final images.

Inspiration

6.82 A good friend was game for having a little fun with technology during a recent shoot that resulted in this iconic image.

Flash Photography

The Digital Rebel has exceptionally good flash metering for both indoor and outdoor pictures. In most cases, you can set the camera to Full Auto and get nicely exposed flash images when the camera detects that the flash is needed. Even in backlit scenes, the Digital Rebel's Flash Output Reduction feature ensures that the subject is not overexposed.

The distance covered by the flash increases as the ISO increases. In other words, if you set the camera to ISO 200, the flash distance is greater than at ISO 100. Also, to help lessen red-eye, increase the amount of room light as much as possible.

You can also use Flash Exposure Lock in the Creative Zone modes to light an off-center subject. Just turn on the flash and verify that the flash icon is lit in the viewfinder. Press the Shutter button halfway down and hold it. Place the subject in the center of the frame, and then press the Exposure Lock button on the back of the camera and hold it as you also continue to hold the Shutter button halfway down. Then move the camera to recompose the image and take the picture.

If you use an accessory flash, such as the Canon Speedlite 550EX, buy a synch cord or flash bracket so that you can position the flash unit farther away from the lens. This also helps to reduce red-eye.

With an accessory flash unit, you can also point the flash head toward a neutral color (or white) ceiling or wall to bounce the flash. The bounced light is diffused producing a much softer and more flattering light.

Once you have an accessory flash unit, you can use it to fill shadows, to stop action in lower-light scenes, and to add a pop of sharpness in panned shots.

Before you begin, talk to the subject about his or her dreams and aspirations or interests. Then see if you can create setups or poses that play off of what you learn. Consider props, for example big, floppy hats with women can become inspiration for fun improvisations. Alternately, play off the subject's characteristics. For example, with a very masculine subject, use angular props or a rocky natural setting that reflects masculinity.

Don't forget that not all portraits are so formal that you can't have fun with them.

Portrait photography practice

6.83 I used a simple studio setup for this portrait and lightened the background afterward in an image-editing program.

Portrait photography tips

6.84 I experimented with different crops for this image and finally settled on this one, which seems to complement the subject's position and eye direction.

✦ **Prepare a list of poses ahead of time.** People often feel uncomfortable posing for the camera. So, if you have a list of poses, it minimizes setup changes, and you can move through the pose list with good speed.

✦ **Flatter the subject.** To reduce wrinkles in the neck, ask the subject to lift his or her head and move it forward slightly. Watch the change to see if the wrinkles are minimized. If not, adjust the pose further.

✦ **Use natural facial expressions.** It's always nice if the subject smiles, but portraits in which the subject is not smiling can be equally effective.

✦ **Pay attention to hands.** If the shot includes the subject's hands, you can minimize the appearance of veins. You can do this by asking the subject to hold the hands with the fingers pointed up for a few minutes before you begin shooting.

✦ **Framing the subject.** In general, keep the subject's head in the upper one-third of the frame unless you are going for a specific look

✦ **Focus.** Always focus on the subject's eye that is nearest to the camera.

✦ **Always be ready to take a shot.** When a good rapport is established between you and the subject, be ready to shoot spontaneously even if the setup isn't perfect. A natural, spontaneous expression from the subject is much more important than futzing to get a perfect setting.

Table 6.25
Taking Portraits

Setup

Practice Picture: For the picture in figure 6.83, I set up white seamless paper on a stand as the background and placed a chair and table for the subject several feet in front of the backdrop.

On Your Own: Uncluttered and simple backgrounds are best because the subject stands out from the background. If you don't have white paper or a large white poster board, use a plain, neutral-color wall and move the subject four to six feet from the background. Moving the subject away from the background and lighting the background separately helps reduce or eliminate background shadows. Keep poses simple and straightforward, especially if you are just beginning.

Lighting

Practice Picture: I placed two inexpensive lights on the left and right of the background. I placed another light at camera left aimed at, and positioned slightly higher than, the subject, and set up a large silver reflector to the subject's right side to fill in shadows. Later, I lightened the background in an image-editing program.

On Your Own: If you plan to do a lot of portraits, you can buy inexpensive continuous lights that have reflectors attached. They often come in sets of three for under $100. Or you can use multiple accessory flash units and a wireless transmitter to simulate this effect. Otherwise, you can use window light alone or in combination with a silver reflector or two: For example, use one reflector to reflect window light onto shadow areas of the background, and one to fill shadows on the subject.

Lens

Practice Picture: Canon EF-S 18-55mm, f/3.5 to f/5.6, set to 35mm.

On Your Own: Most photographers prefer a focal length of 100mm to 105mm for portraits. Canon offers a variety of zoom lenses that offer a short telephoto focal length, such as the EF 55-200mm f/4.5 to f/5.6 II USM, or the EF 28-200mm lenses. Another good choice for its excellent contrast is the renowned Canon EF 50mm, f/1.4 lens (equivalent to 80mm on the Digital Rebel) and the EF-S 60mm f/2.8 Macro USM lens (equivalent to 96mm on the Digital Rebel).

Camera Settings

Practice Picture: Aperture-priority AE with white balance set to auto (AWB).

On Your Own: You will want to control depth of field for portraits, so Aperture-priority AE gives the most control. Of course, for quick portraits, you can use Portrait mode on the Digital Rebel.

Exposure

Practice Picture: ISO 100, f/22, 1/125 second.

On Your Own: It's important to avoid digital noise in shadow areas, particularly on portraits, so choose the lowest ISO possible. To ensure a depth of field that ensures that all facial features are reasonably sharp, set the aperture no wider than f/5.6 or f/8, depending on your distance from the subject.

Accessories

I always recommend a tripod for portrait work.

✦ **Take several frames of key poses.** It's entirely possible that something will be amiss with one or more frames. If you only take one picture, you won't have a backup shot of important poses.

✦ **Keep up the chitchat.** Keep up a steady stream of conversation that includes friendly directions for adjusting poses. Friendly chitchat helps put the subject at ease and allows a natural way for you to provide direction during the session.

Seasons Photography

The changing seasons are reason enough to cause most photographers to jump for joy and suddenly disappear on prolonged shooting junkets. Peak seasonal changes offer rich and varied photo ops that help offset more mundane times of the year. Mother Nature supplies endless photo opportunities, but be sure to also take advantage of the lift in people spirits during seasonal changes. Seasonal changes are great times to take pictures of people enjoying and interacting with nature.

Each season presents a unique set of shooting challenges, as is explained in the following sections.

Summer

During summer, the challenges mainly center on controlling bright sunlight and working during specific times of the day to get the best pictures. Very often for nature and landscape photography, the sunrise and early morning and late afternoon and sunset offer ideal light. The same is true if you take outdoor portraits or sports and action shots. For portraits, diffusion screens and reflectors are handy accessories to keep in your camera bag. And for landscape photography, a circular polarizer enriches colors and reduces glare while one or more graduated neutral density (GradND) filters come in very handy for balancing the extremes between darker foregrounds and lighter sky areas.

Fall

The challenges in capturing fall's riot of color usually center around timing and weather. Timing involves knowing when fall color will be at its peak and getting the pictures you want before a strong gust of wind or a sudden storm piles leaves in a heap on the ground. Due to changing weather, there tends to be more latitude in the times of day that offer great light, although sunset is always a favorite. In addition to the beautiful images you can create as the midafternoon sun creates long shadows, be sure to look for opportunities for dramatic backlighting of leaves and other foliage. As with summer, a good circular polarizer and GradND filters are good accessories to carry with you.

Winter

Not only the snow and ice, but also the holiday festivities make this a rich photo-op season. As with all seasons, the colors and cloud artistry of sunrises and sunsets change, offering limitless pictures. Snow, of course, is a primary subject during winter. The trick is to get white snow in images rather than gray snow. This is a great time to use +1 or +2 stops of Exposure Compensation on the Digital Rebel to ensure brilliant white snow. If you want to photograph holiday lights, be sure to check out the section "Holiday Lights" earlier in this chapter.

6.85 Sometimes a great seasonal photo can be right in your front yard. I woke up early one morning to find this scene outside. I took one look outside and grabbed the camera to catch this snowy sunrise.

Spring

Like fall, spring colors provide a new palette for photos. As people welcome the chance to get outdoors after the long winter months, you have a chance for excellent action and sports shots. Compared to summer, spring often offers a gentle, flattering light that's often perfect for lovely outdoor portraits and family shots. In bright sunlight, you can use a diffusion panel to diffuse the light for outdoor portraits. Landscape and nature images also benefit from the use of a circular polarizer to enhance nature's color.

Inspiration

Start with traditional ideas such as a child in a field of daisies and see what new twists and interpretations you can come up with. For example, because spring is symbolic of renewal, and because people of all ages are renewed, have a grandmother in the field of daises with the child or by herself.

Seasons photography practice

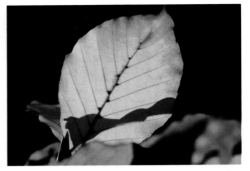

6.87 Some of the most dramatic seasonal images are often a result of backlighting. This image was taken in late afternoon on a fall day and shows how backlighting increases the intensity of the colors.

6.86 I took a low shooting position and shot upward to capture these translucent tulips against a baby-blue sky. This picture was taken in early afternoon on a sunny day.

If the weather is rainy, use it as a creative opportunity to show a child looking out of a rain-streaked window or a drenched and pathetic-looking puppy coming in from the rain.

For nature and landscapes, consider visiting places that you found you loved photographing in summer to see if winter presents a new set of wonderful images to capture. Explore how changing seasons change the photo opportunities in the same locations.

Seasons photography tips

✦ **Expose for the highlights.** To avoid blowing out highlights in bright-light scenes, it's a good idea to expose for the highlights. Even with a GradND filter, the difference in light between the foreground and sky may be more than the camera can hold. One way to ensure a picture that captures the full dynamic range is to take two or more images, exposing each for highlight, midtone, and shadow areas. Then you can combine the images in Photoshop Elements or a similar image-editing program for an image that has detail in all areas.

✦ **Show the falling snow as streaks.** You can show streaks created by falling snow by using a slow shutter speed. Depending on the amount of light, switch to Shutter-priority AE mode, and set

Table 6.26
Taking Pictures of the Seasons

Setup	**Practice Picture:** For the image in figure 6.87, I could choose to make a leaf, several leaves, or a large section of the tree the center of interest. I chose a grouping with a large leaf as the center of interest.
	On Your Own: It is easy to become enthralled with the expanse of changing seasonal scenes and to forget that having a center of interest in the image can make or break it. Find a pleasing composition first, and then choose a position that allows the light to highlight the central elements of the composition.
Lighting	**Practice Picture:** This picture was lit by natural late-afternoon sunlight. The quality of the light was brilliant without being harsh.
	On Your Own: Lighting for seasonal photography runs the gamut. For close in images, consider using fill flash to add pop to the colors or to fill shadow areas in bright sunlight. Late afternoon, sunrise, and sunset offer beautiful light for most seasonal photos.
Lens	**Practice Picture:** Canon EF 180mm f/3.5L Macro USM lens.
	On Your Own: Your lens choice depends on the scene you're shooting and your distance from it. Use a telephoto zoom lens to bring distant scenes closer and a wide-angle lens to capture breath-taking sweeps of seasonal changes.
Camera Settings	**Practice Picture:** Aperture-priority AE mode with white balance set to Daylight.
	On Your Own: You'll want to control the depth of field, so choose Aperture-priority AE mode. If the light is low, switch to Shutter-priority AE mode. For quick shooting, switch to Landscape mode. Be sure to set the white balance to match the type of light in the scene.
Exposure	**Practice Picture:** ISO 100, f/9, 1/125 second.
	On Your Own: An ISO of 100 or 200 should be good for most outdoor seasonal photography. Many scenes look best with extensive depth of field, so f/8 or f/11 is a good starting point. If the shutter drops slower than 1/60 or 1/30 second, be sure to use a tripod or solid support for the camera.

the shutter speed to 1/30 second. If you take the camera outside in the snow, be sure to cover it with weatherproof camera covers or with a plastic bag that has a lens hole cut in it.

✦ **Working with existing light.** If the only time that you have available to shoot is at midday on a sunny day, use the bright light to make beautiful pattern shots, to capture backlit shots of transparent flower petals, and to photograph colorful subjects such as balloons and colorful buildings.

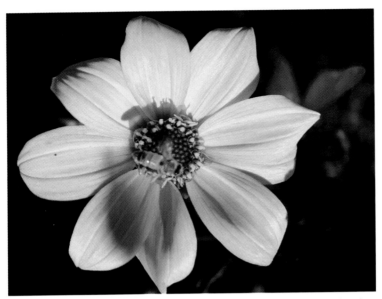

6.88 It is especially difficult to get bees to sit still, and any motion in a close-up photo shows in the final image, as it does here. This image was taken using Close-up mode. I would have done well to wait for the bee to settle down or to switch to a Shutter-priority AE mode to select a faster shutter speed.

✦ **Set a custom white balance for fog.** If the entire scene is enveloped in fog, the particles of moisture reduce the amount of contrast in the scene, subdue the colors, and reduce the sharpness. In particular, color correction can be difficult. The best advice is to use the custom white balance on the Digital Rebel to reduce the amount of post-capture color correction. Regardless, images of fog are evocative and add a sense of mystery to landscapes.

Seascape and Mountainscape Photography

Water and mountains elicit primal responses from most people probably because they represent the elemental aspects of our planet. For photographers, mountains and water, whether the water is a large lake or ocean, can be challenging to photograph from composition and exposure points of view.

Much like snow, large expanses of water can fool the camera meter resulting in gray instead of dark blue or green water. The camera always tries to create an exposure for a scene that has an average tonal range, or

midtone gray. Set an exposure compensation of -1 to -2 in scenes with large expanses of dark water to force the camera to accurately represent the scene.

Mountainscapes often offer a wide difference between light and dark areas that is often beyond the ability of the camera to record. Depending on the scene, a GradND filter may help balance the differences in light and dark areas, but in other cases, the filter won't be useful. You can take separate images exposed for the highlight, midtone, and shadow areas and combine them in Photoshop Elements or Photoshop CS to create an image that has detail in all areas.

Inspiration

Try to convey a sense of the elemental life force that mountain and water scenes represent by varying your shooting angle and by including foreground elements such as craggy rocks or seashells in the foreground. The light at sunset and sunrise adds an evocative sense to water and mountains that helps define shapes and surface textures.

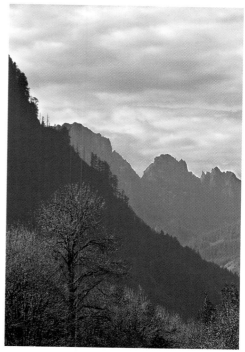

6.89 The blue haze of mountains provided the contrasting tones in this picture.

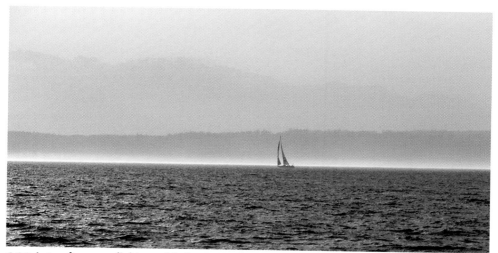

6.90 Late-afternoon light provided a monochromatic look to this seascape.

Seascape and mountainscape photography practice

6.91 In this image, I used the sweep of the clouds and the approaching sunset light to lead the eye to the shaded mountains.

Seascape and mountainscape photography tips

✦ **Make color-correction easy.** To make color correction easy, try to include a white object in the scene. The white object should not be a blown-out highlight, but rather it should contain detail such as a white cloud or rock. Then when you edit the image in Canon's Digital Photo Professional, you can click the white object for instant color correction. Then you can copy the settings to other pictures in a series of images.

✦ **Show scale in scenes.** To make images more effective, show scale of mountains, for example, by including a person, a tent, or a tree in the foreground. For seascapes, a boat, lighthouse, or dock house can help to show scale.

✦ **Control the depth of field.** Generally, extensive depth of field is desirable. This means setting an aperture of f/8 or narrower.

✦ **Use a sweep of clouds to good effect.** If you're using a wide-angle lens, try including a long sweep of white clouds on a blue sky to direct attention to the mountains or water. Experiment with this idea by taking a slightly low shooting position and tilting the camera up just slightly.

✦ **Be safe.** If you set out hiking to get mountain shots or boating or hiking for water shots, always let friends or family know where you will be hiking and when you'll return. Be sure to take a charged cell phone and a bottle of water along.

6.92 Try shooting in late-day angled sunlight to create dramatic mountainscape images.

Table 6.27
Taking Seascape and Mountainscape Pictures

Setup	**Practice Picture:** I chose a wide-angle lens for the image in figure 6.91 because I wanted the clouds to sweep inward toward the mountains. I also took a straight-on shooting position. Other positions and other lenses would be equally effective in a setting like this. **On Your Own:** Look for compositions with color contrasts and where land and sea meet to create a dynamic and symbolic image. Weather conditions including fog and steam rising from the water are wonderful opportunities to create evocative images. Include foreground elements to provide scale to masses of mountains or expanses of water.
Lighting	**Practice Picture:** This picture was taken just as the sun was beginning to set. This provided the lovely golden color on part of the mountaintops. **On Your Own:** Early morning, pre-sunset, sunset, and twilight times of day offer excellent light for seascape and mountainscape images. Try to capture rim light, created when backlighting provides a "rim" of light on the edges of an object such as a tree or mountain.
Lens	**Practice Picture:** Canon EF 24-70mm f/2.8L set to 24mm. **On Your Own:** Your lens choice depends on the scene you're shooting. Use a telephoto zoom lens to bring distant scenes closer and a wide-angle lens to capture breath-taking sweeps of scenery.
Camera Settings	**Practice Picture:** Aperture-priority AE mode with white balance set to Daylight. **On Your Own:** You want to control the depth of field, so choose Aperture-priority AE mode and set the white balance to the type light in the scene. If the light is low, switch to Shutter-priority AE mode. For quick shooting, switch to Landscape mode.
Exposure	**Practice Picture:** ISO 100, f/4.5, 1/250 second. A narrow aperture would have been equally effective here. **On Your Own:** Expose for the most important element in the scene. I often use up to -1-stop exposure compensation to provide richer colors and more saturation. If the light is low, and you don't have a tripod, adjust to a wider aperture, say f/4.0 to avoid camera shake at slower shutter speeds. If you are photographing large areas that are extremely light such as snow-covered mountains, set exposure compensation to +1 or +2 to get white snow. If you're photographing large expanses of dark water, set exposure compensation to -1 or -2 to keep the water dark.
Accessories	To get the sharpest pictures, use a tripod. You can also use a polarizer to enhance colors and reduce reflections.

Snapshots

For this photo subject, it's good to start by reviewing your family snapshots. The emotions that these simple images evoke are priceless. As you'll notice in snapshots, the traditional goals that photographers strive for really don't matter. Even if the subject is centered in the frame, part of someone's head is cropped off, the image is overexposed by the flash, or the flaws are far outweighed by the content of the image.

6.94 A simple snapshot of kids having fun will be treasured years from now.

6.93 Snapshots are our record of families and our lives. Regardless of how much your photography skills improve, never forget the value of everyday snapshots like this.

Aspiring photographers often want to move beyond taking snapshots. While that's a good goal, it's so important to realize that ordinary snapshots are beautiful and necessary. It's important to continue taking the images that trace our family history through the happy moments, awkward stages, weddings, births, and graduations.

Inspiration

Life-and-times snaps inevitably include the icons of the times. Icons can be anything that eventually will date the picture, such as the laptop computer, a kitchen or household appliance, furnishings, cars, and popular culture stores and restaurants. Clothing and hairstyles obviously add to the period look of your snapshots as well.

Perhaps more than any other genre of the snapshot, pictures of the family and friends having fun, teasing each other, or clowning around reveal moments when they are relaxed and carefree. In these happy scenes, try using exaggerated or tilted camera angles and slow shutter speeds to emphasize fun and frolic.

Snapshot practice

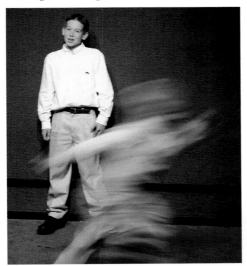

6.95 Fast shooting can result in some interesting snapshots. In this case, motion blur of the youngest boy accurately captures his most defining characteristic — perpetual motion.

Snapshot tips

✦ **The more you pose people, the less snapshot quality the image will have.** Set the Digital Rebel to Full Auto mode and just take pictures. Enjoy the freedom of not futzing with settings and the fun of taking everyday pictures of those you love.

✦ **Have your camera nearby at all times.** That's the only way you can ensure that you'll capture everyday family life that you'll treasure years from now.

✦ **The more you practice, the better your pictures will be.** As you practice the techniques in this book, the better all of your pictures will be including your everyday snapshots.

Get Creative

Once you have some snapshots, you can convert them to black and white or sepia tone in Photoshop Elements or a similar image-editing software for a retro look. This makes new photographs feel older. Use them to create a grouping with older photographs.

6.96 Children can, of course, turn the tables on the family photographer.

Table 6.28
Taking Snapshots

Setup	**Practice Picture:** The kids in figure 6.95 were practicing on a performance stage. **On Your Own:** Snapshots can be set up anywhere there is a good photo opportunity. You'll enjoy the snapshots more if you follow the basic composition guidelines provided at the beginning of this chapter. Also look for non-distracting backgrounds, or to help eliminate busy backgrounds that you can't change, take a high or low shooting position.
Lighting	**Practice Picture:** Indoor light with a spotlight to allow would-be performers to practice. **On Your Own:** Many people automatically use flash in snapshots, but, as the practice picture shows, using existing light and letting motion of the subject show creates fun images. Indoors, natural light filtering in from a window provides excellent light for snapshots. Outdoors, open shade is ideal.
Lens	**Practice Picture:** Canon EF 70-200mm f/2.8L with the lens set to 70mm. **On Your Own:** A zoom lens is indispensable for snapshots. Typically a telephoto zoom offers the focal range necessary for you to remain at a distance yet bring the subjects close to fill the frame.
Camera Settings	**Practice Picture:** Aperture-priority AE mode. The white balance was set to auto (AWB). **On Your Own:** Snapshots are often taken on the spur of the moment which makes the Basic Zone modes ideal for snapshots. In Creative Zone modes, I recommend Aperture-priority AE mode to help control depth of field. Wide apertures such as f/4.0 or 3.5 will help blur unwanted background elements.
Exposure	**Practice Picture:** ISO 100, f/2.8, 1/4 second. **On Your Own:** In Basic Zone modes, the Digital Rebel automatically sets the ISO, aperture, and shutter speed. In Creative Zone modes, your choice of ISO depends on the available light. In low light, you can set up the ISO up to 400 and get acceptable results. If you're shooting in Aperture-priority AE mode in low light, set the aperture at f/3.5. In bright light, f/5.6 or f/8 is a good choice.

Street Shooting

Henri Cartier-Bresson spoke eloquently and passionately of using the camera to tell picture stories. Making a picture story, in Cartier-Bresson's view, required that "the brain, the eye, and the heart" of the photographer work together to capture an unfolding process. For some photographers, the heart of photography exists most vibrantly in the picture stories that unfold every day on city streets. And street photography offers the singular ability to capture a broad sweep of our world in action.

Nothing is more important in street shooting than having an acute awareness of what's going on around you at all times. Certainly this awareness helps ensure your personal safety, but, more important, it puts you in touch with the heartbeat of the city — that palpable throb of life in progress that makes street photography both compelling and addictive.

Many professional photographers began their careers by shooting on city or small-town streets. The street is an excellent venue to develop skill shooting in all sorts of lighting conditions and with a variety of subjects and scenes. The Digital Rebel performs well in street-shooting situations. But because you have to be ready to shoot at any time, it's best to set the Auto Power Off delay to a long delay time. Also carry one or two spare batteries with you for backup.

6.97 Any place where people gather for transportation, such as this monorail station in downtown Seattle, is a good place to begin practicing street shooting.

For flexibility, a fast telephoto zoom lens is ideal. It allows you to get in close to the scene while maintaining a distant, background shooting position. And because street shooting varies from bright sunlight to deep shade, a fast f/2.8 lens gives you a better chance of getting sharp handheld pictures in low-light scenes.

Street shooting is also a great way to hone your skill at composition and using selective depth of field. Your composition skills improve because you're continually evaluating what scene elements to include and exclude. Likewise, you're also forced to make quick decisions on choosing the aperture and camera-to-subject distance to control depth of field.

6.98 Out-of-the-way locations often provide interesting shooting opportunities. This image was taken in Post Alley in Seattle.

Inspiration

On the street, the initial impulse is to photograph everything you see. But as you become more selective in street shooting, try doing a thematic series. Potential subjects for thematic series abound. For example, you could do a study on how people react to the wait for a traffic light to change or do a photo series on a day in the life of a metropolitan bus terminal.

Or choose a spot that is slated for improvement. Assign yourself to document the reconstruction. You can photograph the area as it is now and capture the "life" of the area. Then you can follow up every week or so to see how the construction changes not only the look of the place, but also the sense of place.

Street shooting practice

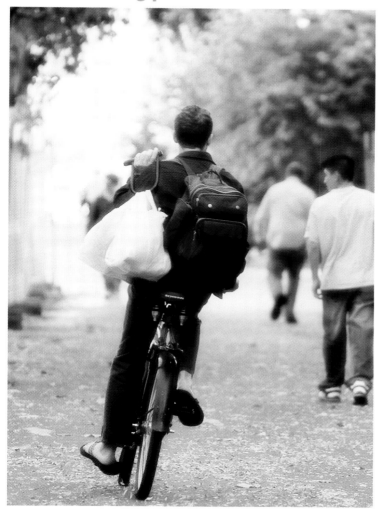

6.99 Street photography requires quick reflexes, as I had to have to get this shot of a bicyclist moving through a local tourist center. I cropped the image significantly and desaturated the picture in Photoshop Elements. Then I added a soft-focus filter to create a more evocative image.

Table 6.29
Taking Pictures on the Street

Setup	**Practice Picture:** The bicyclist in figure 6.99 rode by me as I was taking pictures. I quickly moved the camera to my eye and shot four quick shots without checking settings. **On Your Own:** Look for shooting positions that offer the cleanest background possible. Vary shots by taking a high or low shooting position. Watch for iconic shots that describe our life and culture. Street photography is also a great time to capture humorous scenes of people interacting or people juxtaposed with background billboards and signs.
Lighting	**Practice Picture:** Dappled late-afternoon light created a contrasty scene for this image. In Adobe Photoshop, I lightened shadows and darkened highlight areas. **On Your Own:** Lighting for street photography can run the gamut. Watch for highlight areas on the subject and use negative exposure compensation or bracketing to ensure that highlights are not blown out.
Lens	**Practice Picture:** Canon EF 70-200mm f/2.8L IS USM set to 200mm. **On Your Own:** A zoom lens is indispensable for street shots. Typically a telephoto zoom offers the focal range necessary for you to remain at a distance yet bring the subjects close to fill the frame.
Camera Settings	**Practice Picture:** Aperture-priority AE mode. The white balance was set to Daylight. **On Your Own:** To control the depth of field, choose Aperture-priority AE mode and set the white balance to the type light in the scene. If the light is low, switch to Shutter-priority AE mode.
Exposure	**Practice Picture:** ISO 100, f/3.5, 1/160 second. **On Your Own:** In low-light scenes, switch to Shutter-priority AE mode and set the shutter to 1/30 or 1/60 second. At 1/30 second, you may get some blur if the subject moves, which is not necessarily undesirable. If you want sharpness throughout the image to show the surroundings, set a narrow aperture such as f/8 or f/16, or to blur the background, choose a wide aperture such as f/5.6 or wider.

Street shooting tips

✦ **Watch for photo "stories."** Photo stories involve subjects and sequences that tell the story of a place, building, or group of people. Shoot the photo story sequence over time and edit images carefully to include only the photos that follow your story line.

6.100 Be sure to watch carefully while you are on the street shooting. I happened to notice these policemen as I was about to conclude an afternoon of street shooting. I stayed and shot the ensuing scene as police apprehended a sniper.

✦ **Use light to your advantage.**
There's nothing like the warm light of sunset to make city streets and buildings glow. This is a good time to use the EFS 18-55mm lens or another wide-angle lens to photograph the skyline. Set a narrow aperture, such as f/11 or f/8, to ensure extensive depth of field. Or try A-DEP mode and let the Digital Rebel automatically calculate the best depth of field for near and far objects.

✦ **Always keep a spare memory card handy.** If a drama unfolds suddenly on the street, it's good to have an empty card that you can slip into the Digital Rebel and know that you can continue shooting uninterrupted.

✦ **Experiment with mode settings.** If you're unsure what settings to use on the camera, don't be afraid to switch to a Basic Zone mode that matches the scene you're photographing.

✦ **Pack wisely and travel light.** Always carry a fully charged cell phone with you and carry only the lenses with which you plan to shoot. The lighter load gives you greater mobility, and it lessens the chance that equipment might be stolen.

Still Life Photography

Poetic arrangements reminiscent of paintings are what jump to mind first when many people think of still-life photography. And, of course, artistic arrangements of pottery, flowers, fruit, and personal mementos are popular subjects. But still-life arrangements also can be found in existing scenes in old homes and buildings, along sidewalks, and in stores.

6.101 Still-life photos are a great way to exercise and/or expand your creative skills on all levels, from setting up scenes to the final image composition.

While some photographers shy away from still-life photography because of its slower pace, still life offers photographers a chance to expand their creative skills. And it offers ample opportunity to try varied techniques both in the camera and on the computer.

Still-life subjects invite you to experiment with dramatic lighting and to think of ways to modifying existing light. The goal of lighting and light modification is to enhance the overall mood of the setup so that it complements the subject. For example, you might use a diffusion panel or a sheer curtain to modify incoming window light for a delicate floral arrangement, giving it a soft, romantic look.

The choice of lenses for still-life photography depends, of course, on the subject. In general, normal, short telephoto zoom, or moderate wide-angle zoom lenses are ideal for most still-life subjects. That makes the Canon EF-S 18-55mm lens a good choice because it includes the normal range (approximately 35mm considering the 1.6x conversion factor) plus room to move on either side.

Inspiration

Traditional still-life subjects are a great way to start learning the art of still-life photography. Subjects include fruit, flowers, pottery, antiques, clothing, meal entrees, beverages, bottles, soaps, coins, watch and clock parts, and decorative holiday display items.

Almost anything that catches your eye for its beautiful form, texture, shape, and design is a good candidate for a still-life photo. Because the success of the image often depends on the setup and arrangement, study art and design books and publications can help spark ideas for creating your own setups.

Still life photography practice

6.103 Very often, great still-life scenes are in everyday places including the office. This is a picture of a lounge that can be seen from a hallway window.

6.102 This stuffed Easter bunny became the inspiration for a simple still-life photo that I sent to the person who gave me the stuffed bunny.

Table 6.30
Taking Still-Life Pictures

Setup	**Practice Picture:** I was walking through an office complex when I saw this picture that intrigued me. The light, the colors, and the sense of isolation in figure 6.103 were appealing as a still-life scene. **On Your Own:** You can find many existing still life images around your home or outside the home. Just watch carefully for small, discrete settings that form a composition on their own. To set up your own composition, review the composition guidelines earlier in this chapter.
Lighting	**Practice Picture:** Overhead fluorescent lighting illuminated the chair. **On Your Own:** For small still-life arrangements that you set up on your own, the diffuse light from a nearby window is often the most attractive light. For still-life settings you find, you can modify the existing light using silver reflectors to fill shadow areas, or you can use an inexpensive diffusion panel to reduce the harshness of bright light.
Lens	**Practice Picture:** Canon EF-S 18-55mm f/3.5-5.6 USM set to 48mm. **On Your Own:** Your lens choice depends on the scene you're shooting and your distance from it. Use a telephoto zoom lens to bring distant scenes closer and a wide-angle lens to capture larger scenes. The Canon EF-S 18-55mm lens is a good, all-around lens for still-life subjects. The EF-S 60mm f/2.8 Macro USM lens is also a good choice (equivalent to 96mm on the Digital Rebel).
Camera Settings	**Practice Picture:** Aperture-priority AE mode with white balance set to auto (AWB). **On Your Own:** You want to control the depth of field, so choose Aperture-priority AE mode and set the white balance to the type of light in the scene. If the light is low, switch to Shutter-priority AE mode.
Exposure	**Practice Picture:** ISO 100, f/5.6, 1/6 second. **On Your Own:** If you want background objects to appear as a soft blur, choose a wide aperture such as f/5.6 or wider. This will bring the focus to the main object in the scene.
Accessories	Silver reflectors and diffusion panels are handy accessories for still-life photography.

Still life photography tips

✦ **Choose items with the most aesthetic appeal.** If you're photographing fruit or food, spend time looking for the freshest and most attractive pieces of fruit, or the freshest plate of food. With other subjects, be sure that you clean, polish, or otherwise ensure that the subject is as clean and attractive as possible.

✦ **Try out the Digital Rebel's various parameters.** For example, if you've set up a subject and you want a soft and subdued look,

6.104 This is another example of a simple still-life arrangement.

switch to Parameter 2. To switch settings, press the Menu button, and on the Shooting menu, press the down-arrow key to select Parameters. Press the Set button, and then press the down-arrow key to select Parameter 2. Press the Set button again and you're ready to shoot.

On the Rebel XT, you will use the Shooting 2 menu.

✦ **Experiment with focus.** Either with a filter on the camera or later on the computer, try adding a soft-focus effect to your still-life shots.

✦ **Experiment with different backgrounds.** A draped sheer curtain, a black poster board, or a rough adobe wall can make interesting backdrops.

Sunset and Sunrise Photography

The colorful drama that unfolds at the beginning and end of each day has inspired photographers to capture the images of sunrises and sunsets since the dawn of photography. At no other times of day does the sky offer such compelling color.

Tip *To protect your eyesight as well as the image sensor, don't point the Digital Rebel directly at the sun. Instead, shoot the sun at a slight angle and be sure to use a lens hood to avoid flare (reduced contrast when light from outside the intended image strikes the lens).*

Choosing a lens depends on how you want to show the sunrise or sunset. A wide-angle lens provides a large sweep of sky that can lead the eye to the distant horizon, but it also reduces the apparent size of the sun to a small spec on the horizon. By contrast, a telephoto lens gives the sun a more prominent role so that you can isolate objects, such as a sailboat, as they pass in front of the sun.

6.105 Take advantage of the intense colors of sunrise and sunset to capture dramatic images.

Silhouettes

A solid subject such as a person, tree, or boat that is positioned between the camera and a bright light source such as the setting sun creates a silhouette when you expose the image for the brighter background. Of course, any solid subject that is backlit can produce a silhouette. For example, whole or partial silhouettes are often used in portraits. Because detail in the silhouetted subject will not be visible in the image, choose a subject that has an identifiable shape, and strive to keep the composition clean and simple. In sunset images, silhouettes are especially effective in the light just after the sun sets.

To create a silhouette with the Digital Rebel, select Creative Zone Av (Aperture-priority AE mode). This mode allows you to control both the depth of field and the part of the scene that the camera meters. Focus on a bright part of the background (which simultaneously sets the exposure), and press the AE lock button. Then focus and shoot.

Because sunrise and sunset images include the sun, it's important to preserve the color of the sun in the image. If you meter on the sky, it's certain that the sun will be white — colorless and without detail — in the final image. For this reason (and because sunrises and sunsets pictures look great with rich, deep color), use a –1 to –2-stop exposure compensation and also bracket the exposure to be safe.

 Cross-Reference *For more information on exposure bracketing, see Chapter 1.*

Inspiration

While sunrise and sunset photography is exceedingly popular, successful pictures should have more interest than just the glorious colors of the sky. A foreground object

6.106 Strong cloud patterns, backlighting, and lingering sunset color provide a nice backdrop for this skyline silhouette.

or even a distant object can add context and symbolism that makes the picture stand out from run-of-the-mill sunrise and sunset pictures. For example, a beautiful farmland sunset becomes more appealing when it includes a farmer or a tractor in the distance.

Sunrise and sunset shooting is a good time to experiment with the different parameters on the Digital Rebel. To create a high-color, dramatic scene, use Parameter 1; for a subdued look, choose Parameter 2.

Sunset and sunrise photography practice

6.107 After a lovely day of sunshine, clouds moved in and rain began just as the sun was setting, darkening the sky, but, despite this, rays of light radiating from the setting sun provided a lovely image.

Table 6.31
Taking Sunset and Sunrise Pictures

Setup	**Practice Picture:** I was driving when the sunset, shown in figure 6.107, began. I moved to a position that gave a good view of the sun on the horizon and took pictures at various stages as the sun set.

On Your Own: To set your sunset pictures apart from others, compose the image so that the effect of the light is shown such as on ripples on a lake. Add interest by including objects in the foreground or mid-ground. The practice picture would be stronger with foreground or mid-ground interest. Keep the horizon in the upper or lower third of the image. Sunrises and sunsets happen over a very few minutes of time. Be sure that you are in position well before the time of sunrise or sunset and ready to shoot.

Lighting

Practice Picture: Sunset light on a rainy evening.

On Your Own: Sunrise and sunset happen within a few minutes of time and the colors of the sky can change dramatically during those minutes. The temperature of sunrise is 3,100 to 4,300 degrees Kelvin, and sunset is 2,500 to 3,100 degrees Kelvin. Knowing these approximate temperature ranges allows you to fine-tune color when you shoot RAW images and process them in Digital Photo Professional.

Lens

Practice Picture: Canon EF-S 18-55mm lens set to 55mm.

On Your Own: Your lens choice depends on the scene you're shooting and your distance from it. Use a telephoto zoom lens to bring distant scenes closer and a wide-angle lens to capture breath-taking sweeps of color.

Camera Settings

Practice Picture: Aperture-priority AE mode. The white balance was set to AWB.

On Your Own: Aperture-priority AE mode is a good choice so that you can control the depth of field. If you want to shoot in a Basic Zone mode, Landscape is a good option.

Exposure

Practice Picture: ISO 100, f/8, 1/15 second.

On Your Own: Light fades quickly during sunrise and sunset. You can set the ISO to 100 to 400 and perhaps even switch from a lower ISO at the beginning of the light change to a higher ISO as the light fades. For expansive scenes, keep good depth of field by setting the f/stop to f/8 or f/11. If the shutter speed drops below 1/60 or 1/30 second, set the camera on a solid surface or use a tripod.

Accessories

A tripod is a necessity in the early hours of sunrises and toward the latter part of sunsets.

Sunset and sunrise photography tips

✦ **Capture the full range of colors.** The color of the sky before, during, and just after sunset and sunrise changes dramatically. Be sure to use all of the time to capture the changes.

✦ **Get in position early.** Be in place and have the camera set up 15 minutes or more before the sunset or sunrise begins. Once sunset or sunrise begins, you have only about 10 minutes to capture the shots you want.

✦ **Use the sky to your advantage.** Clouds help diffuse sunlight and create colorful and dramatic sunsets. On clear days, the best time to shoot is just before or just after the sun falls below the horizon.

✦ **A tripod or monopod is your friend.** You'll get sharper images by using one.

Travel Photography

Because the Digital Rebel is lightweight, small, and extremely versatile, it is ideal for use when traveling. With a set of compact zoom lenses and plenty of memory cards, you'll have everything you need to take postcard quality-shots to document your travels.

Before you begin any trip, clean your lenses and ensure that the Digital Rebel is in good working condition. Consider buying spare batteries and memory cards. If you're traveling by air, check the carryon guidelines on the airline's site and determine if you'll carry the camera separately or as part of your carry-on allowance. An advantage of being a digital photographer is there's no worry about film being fogged by the X-ray machines.

Another pretrip task is to research the destination by studying brochures and books to find not only the typical tourist sites, but also favorite spots of local residents. When you arrive, you can also ask the hotel concierge for directions to popular local spots. The off-the-beaten-path locations will likely be where you get some of your best pictures.

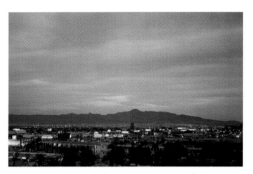

6.108 Sunrise and sunset are good times to get broad views of city skylines against a colorful horizon.

6.109 Architecture that is characteristic of an area you visit can become a theme throughout a series of travel photos.

Here are some additional tips for getting great travel pictures:

✦ **Research existing photos of the area.** At your destination, check out the postcard racks to see what the often-photographed sites are. Determine how you can take shots that offer a different or unique look at the site.

✦ **Include people in your pictures.** To gain cooperation of people, always be considerate, establish a friendly rapport, and show respect for individuals and their culture. If you do not speak the language, you can often use hand gestures to indicate that you'd like to take a person's picture, and then wait for their positive or negative response.

✦ **Keep the composition simple with a clear center of interest.** This is where a telephoto lens comes in handy. With it, you can eliminate distracting elements on either side of the subject or eliminate a dull overcast sky. In larger scenes, a wide-angle lens is the ticket.

✦ **Waiting for the best light pays big dividends.** Sometimes this means that you will return to a location several times until the weather or the light is just right. And once the light is right, take many photos from various positions and angles.

✦ **Photographing people and landmarks.** If you want to include family in a shot at a famous landmark, use Landscape or Aperture-priority AE mode with an aperture of f/8 or f/11 to keep the foreground and background sharp.

✦ **Add bold, bright color to your images.** Look for colorfully painted storefronts, boats, gardens, cars, buses, apartment buildings, and so on to add interest to your pictures.

✦ **Explore areas by hiking up or down to get another perspective.**

Inspiration

If the area turns out to have a distinctive color in the scenery or in architecture, try using the color as a thematic element that unifies the images you take in that area. For example, the deep burnt-orange colors of the southwest U.S. can make a strong unifying color for vacation images.

Watch for details and juxtapositions of people, bicycles, and objects with backgrounds such as murals and billboards. Also watch for comical or light-hearted encounters that are effective in showing the spirit of a place.

Travel photography practice

6.110 After you've satisfied the need to take the standard shots of popular location attractions, look for more creative perspectives and viewpoints from which to photograph the attraction.

6.111 This antiquated boat rigging shop caught my eye for the variety of antique objects around the shop. The rusted tools and weathered exterior provide lots of visual interest.

Travel photography tips

✦ **Do you homework.** The more study you do before you travel, the better understanding you'll have of the people and area, and the better your pictures will be.

✦ **Be cautious about deleting images.** As your trip progresses and you fill your memory cards or portable storage unit, it's tempting to delete pictures to free up storage space. Be very careful in deleting pictures that you haven't seen at full size. It is easy to delete images that with a little editing could be the best of the trip.

✦ **Keep an eye on your equipment.** Cameras such as the Digital Rebel are extremely popular and that makes them a target for thieves. Be sure to keep the camera strap around your neck or shoulder and never set it down and walk off. This sounds like common sense, but it's easy to get caught up in activities and forget to keep an eye on the camera.

6.112 As you enjoy activities such as a scenic dinner train ride, spend a few minutes beforehand capturing pictures of the experience.

Table 6.32
Taking Travel Pictures

Setup	**Practice Picture:** This picture, shown in figure 6.111, was taken at a semi-operational boat yard that is being preserved as an historic area.
	On Your Own: Carefully choose locations that are iconic, or classic, and then try different positions, angles, or framing to show the location to give a fresh perspective on a well-photographed area. Include people in your images to provide an essence of the location. Narrow the scope of your image so that you present a clear story or message. Always ask permission to photograph local people. Even if you don't speak the language, you can use gestures to indicate your intent and question.
Lighting	**Practice Picture:** Bright midday sunlight helped make the yellow trim on the gray building stand out.
	On Your Own: Inherently, light for travel photos runs the full range. The trick is to know when to shoot and when not to shoot. Ask yourself if the existing light is suited for the subject. If it isn't, wait for the light to change or come back at a different time of day when the light is more appealing. Often just waiting for a cloud to pass by offers enough diffusion to make a better picture.
Lens	**Practice Picture:** Canon EF 24-70mm f/2.8L USM lens set to 52mm.
	On Your Own: Your lens choice depends on the scene you're shooting and your distance from it. Use a telephoto zoom lens to bring distant scenes closer and a wide-angle lens to capture large scenes such as festivals and fairs, or to include environmental context for people shots.
Camera Settings	**Practice Picture:** Aperture-priority AE mode. The white balance was set to Daylight.
	On Your Own: You'll want to control the depth of field, so choose Aperture-priority AE mode and set the white balance to the type light in the scene.
Exposure	**Practice Picture:** ISO 100, f/14, 1/160 second with a -1/3 Exposure Compensation set to provide richer color.
	On Your Own: Set the ISO as low as possible given the existing light. If you're photographing people of the area, use a wide aperture such as f/5.6 to blur the background without making it unreadable. Watch the shutter speed in the viewfinder to make sure it isn't so slow that subject or hand motion will spoil the picture.

✦ **Use reflectors.** Small, collapsible reflectors come in white, silver, and gold, and they are convenient for modifying the color of the light. They take little space and are lightweight.

✦ **Don't take too much equipment.** Carry just enough to fill your camera bag and ensure that the camera bag will pass airline requirements for carry-on luggage.

Weather Photography

Just as with sunset and sunrise, weather and the events it brings create compelling photography subjects. Whether you photograph rain, snow, a unique cloudscape, or fog, you can use the weather to set the mood of the image, to add streaks of falling rain or snow, and to show classic human and animal reactions to the weather.

A variety of techniques are effective in weather photos, but the first consideration is to protect the camera from moisture and dust. Many companies sell affordable and weatherproof camera covers, and they are well worth the price. Or you can fashion your own covering from water-repellant fabric or from a large plastic bag. Keep the covering in your camera bag to use in case there's an unexpected shower or snowfall.

Many of the techniques covered in earlier sections in this chapter can be used when you're taking weather photos. The following sections detail some tips for shooting in specific types of weather.

Falling rain and snow

You can choose to freeze the motion created by falling rain or snow by using a fast shutter speed. Conversely, you can show the rain or snow as streaks by using a slow shutter speed of 1/30 second or slower. The slower the shutter speed, the longer the streaks. Try to choose a medium to dark background to help show the rain or snow streaks best.

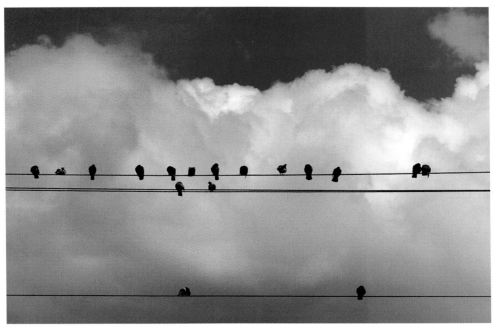

6.113 While weather extremes provide compelling photo opportunities, good weather is equally compelling. Use bright white clouds to silhouette subjects, or use beautiful cloud formations as the subject of your image.

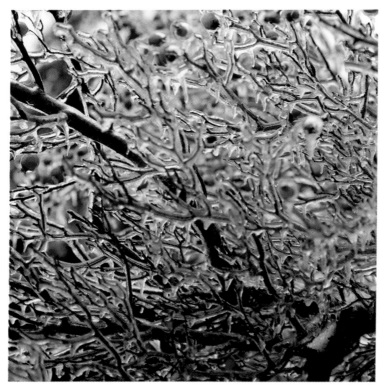

6.114 Icy patterns of a frozen bush create an interesting seasonal pattern shot.

Fog

Fog adds a sense of mystery and intrigue to a scene, but because the moisture in the air decreases sharpness, it enhances the soft, mysterious atmosphere of the image. Fog varies in color from light gray to almost white. Exposing fog scenes can be tricky. Meter for the subject, and to ensure accurate color, try using custom white balance. Custom white balance, detailed in Chapter 2, is a simple process of shooting a white object that fills the viewfinder, selecting the image so that its white-balance data is imported, and then setting the camera for custom white balance.

Once custom white balance is set, it will be used for subsequent pictures until you switch to another white-balance option.

Snow

Regardless of where you live, the first snow of the season has the magical quality that brings almost everyone outdoors to enjoy it. Snow, like large expanses of dark water, will fool the camera meter. To get beautifully white snow, override the camera's tendency to underexpose the snow by setting a +1 to +2 exposure compensation.

Stormy skies

Huge, heavy, looming clouds with deep, rich colors are a favorite subject of photographers everywhere. When storm clouds begin forming, grab the Digital Rebel and head to your favorite shooting location with a wide-angle lens. Find a good foreground object and let the storm clouds lead the eye to the object. As the clouds grow darker, press the AE Exposure compensation button and turn the Main dial to -1/3 or -1/2 compensation to avoid overexposed images.

Inspiration

While weather can often make a stand-alone subject, it's fun to photograph how the weather affects people, plants, and animals. In rain scenes, look for people with umbrellas, wet animals, rain-beaded flora and fauna, or a farmer in a field looking up at the ominous clouds.

Also look for contrasts that underscore the weather. For example, you might find a pair of summer flip-flops frozen solidly to a deck or rain collecting on cacti.

Weather photography practice

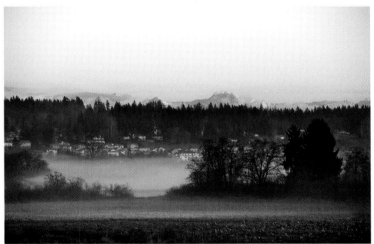

6.115 A combination of late-afternoon sunlight on the mountains and a heavy fog created this scene. The combination of very bright areas and very dark areas creates challenges for the photographer determining exposure and getting the camera to hold detail in both areas.

Table 6.33
Taking Weather Pictures

Setup	**Practice Picture:** The winter scene in figure 6.115 was taken in late afternoon as fog began to settle over the pumpkin field and city in the foreground and mid-ground of the scene. **On Your Own:** Watch the weather forecast and get a sense of when good weather photos might happen. Then watch the skies for dramatic cloud formations. Show images of how the weather affects people, buildings, and the flora and fauna.
Lighting	**Practice Picture:** The light was still bright over the mountains while the city below in enveloped is the darker fog. **On Your Own:** Extremes in light characterize weather photography and can provide priceless opportunities as shafts of light break through forested hillsides, fog-covered landscapes, and, of course, illuminate rainbows. Watch carefully for the best opportunities to capture scenes with spectacular light.
Lens	**Practice Picture:** Canon EF 70-200mm f/2.8L set to 180mm. **On Your Own:** Your lens choice depends on the scene you're shooting and your distance from it. Use a telephoto zoom lens to bring distant scenes closer and a wide-angle lens to capture expansive scenes.
Camera Settings	**Practice Picture:** Aperture-priority AE mode. The white balance was set to auto (AWB). **On Your Own:** You want to control the depth of field, so choose Aperture-priority AE mode and set the white balance to the type light in the scene.
Exposure	**Practice Picture:** ISO 100, f/5.6, 1/45 second. **On Your Own:** For most weather photos, an extensive depth of field is the ticket. Set the aperture at f/8 or f/11 and use a tripod if the shutter speed is slower than say 1/30 second. To deepen the color and saturation, set -1/2 to -1 exposure compensation setting.
Accessories	Having a tripod handy is a good idea for weather photos. Light can vary tremendously, and in lower light scenes, a tripod is necessary for slower shutter speeds.

Weather photography tips

✦ **Use contrast to your benefit.**
Take advantage of the extra-saturated color that overcast and rainy weather provides by including color-saturated flowers and foliage in your weather images.

✦ **Get the best color from your image.** To photograph a rainbow, set the Digital Rebel to ISO 100, press the AE Exposure compensation button, and then set a −1 to −1.5 compensation to deepen the colors.

✦ **Know your weather.** Veteran storm chasers and weather photographers emphasize the importance of learning as much as possible about weather and observing how the sun strikes different types of clouds.

✦ **Don't put the camera away when the weather clears.** Use the time after a rain shower to capture the sparkle on freshly washed streets and buildings.

6.116 Using a slower shutter speed, you can show streaks of falling rain or snow, as illustrated here, to help put the viewer in the scene.

Downloading and Editing Pictures

Downloading digital images has come a long way in the past few years. Rather than crawling behind the computer to hook up cables, you can use the USB cable supplied with the camera, or you can use an accessory card reader or PCMCIA (Personal Computer Memory Card International Association) card. And with direct-printing capability, you often don't need to download images, but you can print directly from the memory card.

And if you're using RAW capture, you have lots of latitude with Canon's Digital Photo Professional conversion software to improve the original exposure, white balance, and more. Once the editing cycle is finished, you can back up images to secure media for long-term storage.

Download with a USB Cable

Downloading using a USB cable is as simple as plugging the USB cable into the camera and the computer. The computer recognizes the camera as a removable drive. Because the camera must be turned on during download, you should ensure that the battery charge is sufficient to complete the download without interruption.

 Note *If you are using a Mac with your Digital Rebel, you will see the Rebel as a Digital Capture that can be downloaded.*

Canon provides programs for downloading and organizing images. Other programs are available for these tasks, but for this chapter, I use the Canon programs in the examples.

Organize and Back Up Images

One of the most important steps in digital photography is establishing a coherent folder system for organizing images on the computer. With digital photography, your collection of images will grow quickly, and a well-planned filing structure helps ensure that you can find specific images months or years from now.

Another good practice is to add keywords to image files. Some programs allow you to display and search for images by keyword—something that can save a lot of time as you acquire more and more images.

The most important step is to back up images on a CD or DVD regularly. Many photographers make it a habit to burn a backup disc right after downloading pictures to the computer. And, as with images on the computer, it's a good idea to have a filing system for your backup discs as well.

Cross-Reference *For details on choosing JPEG or RAW capture options, see Chapter 2.*

To download images using the USB cable, follow these steps:

XT *For the Rebel XT, perform these steps **before** you connect the camera to the computer.*

1. **Press the Menu button on the back of the camera, and then press the right arrow key to select the Set-up 2 menu.**

2. **Press the down arrow key to select Communication, and then press the Set button.**

3. **Press the down arrow key to select PC connection, and then press the Set button.** You can use the Print/PTP (Picture Transfer Protocol) option with Windows XP to download JPEG images to the computer without having to start the software provided on the Canon Solution Disk.

4. **Press the Menu button to turn off the LCD.**

Follow these steps to download or continue downloading pictures to the computer.

1. **Install the Canon EOS Digital Solution disc on your computer.**

Tip *Before you begin the following steps, make sure that the camera battery has a full charge.*

2. **With the camera turned off, insert the camera's USB cable into an available USB slot on your computer.**

3. **Insert the other end of the USB cable into the Digital terminal located on the side of the camera, and then turn on the camera.** If Windows displays a Found New Hardware Wizard dialog, click Cancel.

4. **If Windows asks to select a program to launch the action, click Canon Zoom Browser EX, click Always use this program for this action, and then click OK.** If a Device Connected dialog box appears, select Canon CameraWindow, and then click OK.

5. **The CameraWindow appears, and then click either the option to download all or selected images.** The Download Settings dialog box appears.

6. **Click Browse to locate an existing folder on the hard drive, or click Create new folder and type a file-name.** If the Save File dialog box appears, images are downloaded to the computer and are sorted in folders by date and saved in the My Pictures folder. When images are downloaded, ZoomBrowser EX is launched and downloaded pictures are displayed.

 Note *It's a good idea to create a logical and orderly file structure for your photo collection. For example, create a series of sub-folders under the My Pictures folder and name the sub-folders by subject. Organizing photos in sub-folders makes it much easier to find images as your collection grows.*

7. **Click OK to download the selected images to your computer.** ZoomBrowser EX displays the image(s) along with the folder structure, file location, and a list of tasks.

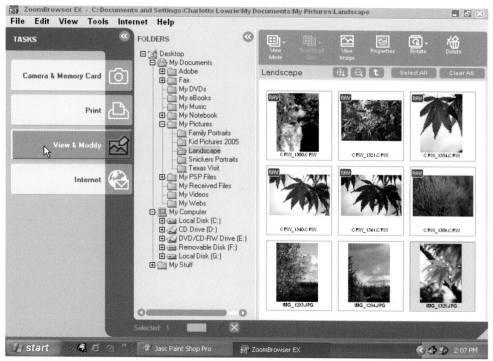

7.1 Canon's ZoomBrowser EX (for Windows) displays both JPEG and RAW images and includes tools for basic image-handling tasks. ImageBrowser is the comparable program for Mac computers.

8. **Choose the task you want.** You can rotate, delete, zoom and scroll, view images as a slide show, stitch photos for a panorama, send the image in e-mail, and lay out and print images in the ZoomBrowser EX dialog.

9. **To edit images, click View & Modify.** For JPEG images, click Edit to automatically launch Adobe Photoshop Elements. To edit and convert RAW images, click Process RAW images. Additional information on editing RAW images is included later in this chapter.

Download with a Card Reader

An easier and faster way to download images is to use a card reader. A card reader is a small device that plugs into the computer with its own USB cable. When you're ready to download images, you insert the media card into the corresponding card-reader slot.

You can leave the card reader plugged into the computer indefinitely, making it a handy way to download images. Plus, with a card reader you don't have to use the camera battery while you download images.

Card readers come in single and multiple card styles. Multiple-card-style readers accept Compact Flash card (CF), microdrives, and other media card types. Card readers are inexpensive, virtually indestructible, and have a small footprint on the desktop. All in all, they are a bargain for the convenience they offer.

After installing the card reader according to manufacturer recommendations, follow these steps to download images:

1. **Remove the CF card from the camera and insert it face-up into the card reader, pushing firmly to seat the card.**

2. **On the Windows desktop, double-click My Computer.**

3. **In the list of Devices with Removable Storage, double-click the icon for the CF card.** The card reader appears in the list as a Removable Disk.

4. **Drag the DCIM folder to the computer's hard drive.** You can also double-click the DCIM folder to display and drag individual image files to a folder on the hard drive.

Note *You can use Canon's Zoom-Browser EX to view JPEG images, and Canon's File Viewer Utility to view and edit RAW images.*

Viewing and Organizing Programs

The Canon File Viewer Utility and ZoomBrowser EX/PhotoRecord ImageBrowser are capable programs for viewing and arranging images. And they have the advantage of coming at no additional cost. However, you may want to consider other programs such as ACDSee (www.acdsystems.com) for viewing, managing, and performing batch operations on both JPEG and RAW images.

Download with a PCMCIA Card

If you're on the go and use a laptop computer, an easy solution for downloading images is to use a PCMCIA card. About the size of a credit card, the PCMCIA card fits into an available PC card slot on the laptop, and the media card fits into the PCMCIA card. Be sure to look for a card that accommodates CF cards and/or microdrives. The transfer rate with PCMCIA cards is approximately 10MB per second.

If you are a laptop user, the advantages of a PCMCIA card make them well worth the small investment. And the process of downloading is the same as with the card reader.

Converting RAW Images

If digital technology revolutionized photography, then the next mini-revolution is the ability to capture and subsequently modify the original image data *after* the picture is taken.

A RAW image is unprocessed data directly off the image sensor with none of the internal camera processing that is applied to JPEG images. While the settings you used for exposure and white balance are recorded, they are not made permanent until you convert the image in a conversion program on the computer, and then save the image in TIFF or JPEG format. In fact, you can re-process RAW

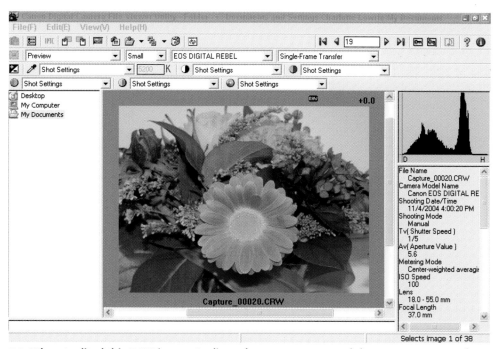

7.2 When I edited this RAW image, I adjusted exposure to spread the tones more evenly across the full range of tones.

files months or years from now as upgrades to conversion programs are released, thereby potentially improving the image.

Cross-Reference For more details about JPEG and RAW file formats, see Chapter 2.

Capturing images in RAW format is like getting a second chance to correct important settings such as the exposure compensation, white balance, and contrast — just as if you made the adjustments on the camera. And, unlike working in JPEG format, RAW offers the opportunity to work at full resolution and in 16 bits per channel, which offers more color information than 8-bit images, to make adjustments with no degradation to the image.

Tip As bonus, Canon embeds a medium-quality JPEG image with the RAW file. You can use the JPEG as a quick proof and for sending in e-mail.

On the Solutions disc, Canon provides a Digital Camera File Viewer Utility for adjusting and converting RAW files and for extracting the medium-quality JPEG images that are embedded with RAW files.

To use the File Viewer Utility provided on the Solutions disc, follow these steps:

1. **Choose Start ⇨ All Programs ⇨ Canon Utilities ⇨ FileViewerUtility 1.3 ⇨ FileViewer Utility.** The File Viewer utility opens.

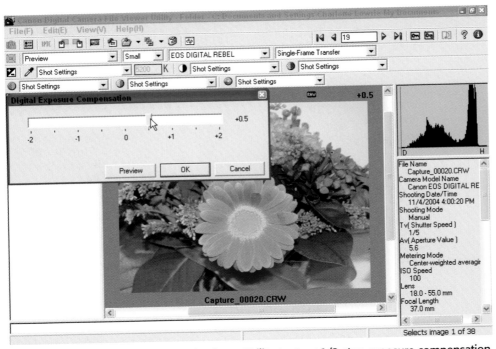

7.3 Using Canon's Digital Camera File Viewer Utility, I set a +1/2-stop exposure compensation.

Note *These steps will not work unless you have already installed the FileViewerUtility from the Canon Digital Solutions disc.*

2. **Locate the folder with the RAW images that you want to process, and then double-click a RAW image.** You can use the left-hand file navigation list if necessary.

3. **Click the dropdown arrow for Thumbnail display, and then click Preview.** To change the size of the preview click Small, and then click the size you want in the dropdown. Be sure that EOS DIGITAL REBEL is displayed in the next dropdown. If you select Common Processing, the processing toolbar is hidden, and you can't change settings.

4. **To change the exposure, click the Digital Exposure Compensation (+/-) icon on the next row, drag the slider to set the amount of compensation you want, and then click OK.** Compensation is provided in half-stop increments up to +/- 2 stops. To see the exposure changes, click Preview.

5. **To change white balance, click the White Balance (eyedropper) icon, and then click an area in the image that should be white.** In general, try to click an area in the image that should be white and that has detail in the white, such as clouds. Alternatively, you can select Color Temp. from the list, and then type the color temperature in degrees Kelvin in the adjoining field. You can tweak the white balance to warm or cool the color balance by adjusting the Blue and Amber (B and A) and/or the Green and Magenta (G and M) sliders.

6. **Click each of the remaining settings to make additional adjustments (Contrast, Color Saturation, Color Tone, Sharpness, and Color Space).** A color tone setting of −2 makes skin tones redder as does −1, but to a lesser degree. A color tone setting of +2 makes skin tones more yellow as does +1 to a lesser degree.

 On the Rebel XT, you can also choose the black-and-white (B/W) parameter, and then set the Filter and Toning effects that you want.

7. **Choose File ➪ Save File ➪ Convert and save in file.** The Save File dialog box opens.

8. **In the Save File dialog box, click the down arrow next to Do not convert, and then click the JPEG or TIFF option you want.** The Exif-TIFF(8bit/ch) and TIFF(16bit/ch) offer you the option of converting to this format and saving the EXIF data in 8-bit color per channel, or discarding the EXIF data and saving in 16-bit color per channel. Choosing 16-bit color preserves all of the original color data, while 8-bit color per channel discards some color information.

9. **Choose any other options you want in the Save File dialog box, and then click OK to save the file.** You can open and edit the converted image in an image-editing program such as Photoshop Elements or Photoshop CS to make finishing edits to the image.

 Note *The Save in RAW+JPEG Format option is not supported with Digital Rebel files, and the option will be grayed out in your software.*

Tip *If you have a series of images taken in similar conditions, you can save the RAW conversion settings from one image and apply them to other images. To copy the processing parameters of an image, right-click the processed image, and then click Copy Current Conditions. Finally, Right-click the image you want to apply the settings to, and click Paste Current Conditions.*

In addition to Canon's program, Adobe offers the Adobe Camera RAW (ACR) plug-in for Adobe Photoshop CS to process RAW images. ACR offers some of the same features as the Canon program, as well as a few additional features to correct for RAW conversion. For example, the ACR includes controls for correcting lens aberrations such as fringing, a colorful border around high-contrast objects in an image, and vignetting, images where the corners of the image are noticeably dark.

Tip *ACR updates for the plug-in can be downloaded from the Adobe Web site.*

When you capture in RAW format, the Digital Rebel embeds a medium-quality JPEG image with the file. You can extract the JPEG by following these steps:

1. **Open a RAW image as described in the previous set of steps.**

2. **Click File, Save File, and then click Extract Save JPEG.** The Extract & save JPEGs dialog box is displayed.

3. **Choose the folder options and naming that you want, and then click OK.**

Editing Images

Whether you capture images as JPEG or RAW, there are very few images that can't be improved with at least some basic image editing. During the editing process, it's a good idea to follow a sequence of steps or an editing workflow. The workflow not only helps preserve and enhance image data, but it saves you time overall.

Tip *Good image correction begins with a properly calibrated monitor. Many devices are available in a range of prices to calibrate your monitor, or you can use the calibration wizard that Adobe includes in its products.*

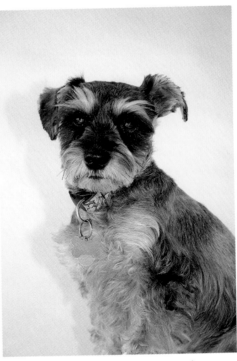

7.4 To illustrate the difference it makes to do final edits, compare this before pet portrait...

What follows is a basic, sample workflow for editing images. You can follow this workflow using either Adobe Photoshop Elements or Photoshop CS. Each step builds on the previous step. Of course, you can modify or rearrange the steps, but it's a good idea to establish a standard editing process that helps ensure that steps aren't overlooked and that you get the best possible results from your images.

| Note | *While it is beyond the scope of this book to provide step-by-step instructions for Photoshop Elements or Photoshop CS, you can access the Help menu of both programs to get detailed instructions.* |

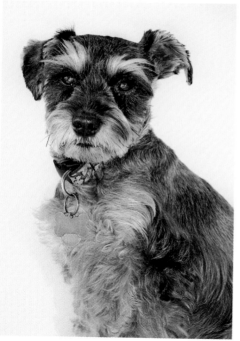

7.5 ...to this after pet portrait. Even images that require only minor tweaks benefit from the polish that editing provides.

✦ **Process, convert, and save a copy of RAW images in TIFF or JPEG format.**

✦ **Adjust the tonal range of the image.** To adjust overall tonal levels, use the Levels command in Photoshop Elements or Photoshop CS. In the Levels dialog box, move the black and white point sliders inward to where the image data is higher than one pixel per tonal level, and then move the midpoint to the left or right to lighten or darken the image.

7.6 In this histogram, I moved the white point slider to the left in the Levels dialog box.

✦ **Color-correct the image.** In the Curves or Levels dialog box, click the white and black points in the image using the eyedropper tools, and set the midtone (the middle eyedropper) by clicking an area in the image that should be midgray. If you set the midtone in the RAW conversion program, you don't need to repeat that step here.

✦ **Straighten the image.** If the horizon is tilted, or if lens distortion makes objects appear to fall toward the center of the image, you can use the Measure tool or Free Transform command to straighten horizontal and vertical lines in the image.

✦ **Crop the image.** Cropping the image eliminates areas that do not complement the composition or are distracting. It's best to use the Crop tool judiciously because each crop results in a smaller image.

Improving Images with Curves

If you're using Photoshop CS, set a gentle S-shaped curve using the Curves command. The curve will add punch to the overall image by brightening highlights and midtones and darkening shadows slightly. Use the Curves command to nudge up image contrast. Avoid using it as a hammer to impose dramatic changes.

This image shows a slight classic S curve set in the Curves dialog in Photoshop CS.

And the smaller the image, the smaller the enlargement you can print from it. This fact alone is reason enough to frame images carefully as you shoot.

✦ **Correct imperfections.** Spots or blotches on an image may be a result of dust within the scene, or, more often, a result of dust on the image sensor. You can make quick work of some spotting tasks by converting the image to LAB mode and using the Dust and Scratches command on the A and B channels. For remaining spots, you can use the Healing Brush or Clone Stamp tool to clean up the image.

✦ **Dodge and burn select areas of the image.** Dodge and burn are tools used in a chemical darkroom to lighten or darken areas of an image respectively. The same type techniques are available in Adobe Photoshop programs. However, rather than using the Dodge and Burn tools, you can use the Levels command to lighten or darken the entire image, then use the History brush to paint in the darker or lighter effect.

✦ **Convert the image to 8-bits per channel, if necessary.** If you want to save a copy of the image in JPEG format to post on a Web site or share with friends, you have to convert the image to 8-bit mode before saving a copy in JPEG format. Sixteen-bit images can only be saved as TIFFs or in Photoshop format. In Photoshop CS, the Mode command on the Image menu offers the 8/bits/Channel command.

✦ **For print or Web use, make a copy of the image.** Once copied, you can size it for printing or Web use as needed. Web images should be saved in JPEG format before sizing them.

✦ **Sharpen the image.** If you are preparing an image for printing or the Web, use the Unsharp Mask command to tweak image sharpness.

 I don't recommend using the Brightness and Contrast command because it can overcompresses highlight and shadow values—a process that often results in a loss of image detail.

Printing Images

Printing the images that you take with the Digital Rebel is half the fun of digital photography. The Digital Rebel offers not only great

Color-Correction Values

Setting the white, midtone, and shadow target values in Photoshop helps ensure consistent color correction. In the Levels dialog, you can double-click each of the eyedroppers and reset the default values. For example, double-click the black eyedropper. In the Color Picker dialog box, you can type values for Red, Green, and Blue (RGB). Many photographers recommend resetting the RGB values as follows: White (R 240, G 240, B 240), Midtone (R 128, G 128, B 128), and Black (R 20, G 20, B 20).

When you exit the dialog, you have the option to save the values as the default. By clicking Yes to save the values as the defaults, these values will be used the next time you click the eyedropper tools in these dialogs.

prints from images edited on the computer or from ZoomBrowser EX, but also images printed directly from the CF card.

Direct to printer

Direct printing from the CF card to a PictBridge-compatible printer, such as those offered by Canon and other manufacturers, is handy for quick prints if you're shooting in JPEG format. Printers with PictBridge capability allow you to print directly from the media card in the camera. During the printing, you can control the process from the camera.

To print JPEG images directly from the card to the printer, follow these steps:

1. **Set up a PictBridge-compatible printer with the correct paper and ink, and then turn off the printer.**

2. **Turn off the camera and connect the camera to the printer using the USB cable.**

3. **Turn off the printer and the camera.**

4. **Connect the camera to the printer with the appropriate cable.** (See the printer instruction manual for details.)

5. **Turn on the printer, and turn on the camera.** The Connected Printer Icon is displayed on the top left of the LCD.

 Note *Ensure that the camera battery has a full charge before starting, or use the optional AC Adapter Kit to power the camera.*

6. **Press the left- or right-arrow key to select the image you want to print.**

7. **Press the Set button when you find the image you want to print.** The screen changes to the Print setting screen.

8. **On the Print setting screen, select Style, and select the border, date, and number of prints you want.**

9. **Press the arrow key to select Print.**

Updating firmware and software

One of the greatest advantages of owning a Digital Rebel is that Canon often posts updates to the firmware (the internal instructions) for the camera to its Web site. New firmware releases can add improved functionality to existing features, and in rare

cases, new firmware can add entirely new features to the camera.

New firmware along with ever-improving software keeps your camera and your ability to process images current as technology improves.

To check the current firmware version installed in your camera, follow these steps:

1. **Press Menu.**

2. **Press the right arrow key to select the Set-up 2 tab.** The current version of your firmware is displayed.

3. **Write down the number of the Firmware Ver. shown.**

To download the latest version of firmware from the Canon Japan Web site at `www.canon.co.jp/Imaging/eosdigital/E3kr_firmware-e.html`. Or check `www.robgalbraith.com` Web site, and then type Digital Rebel firmware into the "search news" section to find the URL for the latest firmware updates. Then follow these steps:

1. **Ensure that the camera battery is fully charged.**

2. **Insert an empty, formatted CF or microdrive (at least 8MB and less than 2GB) in the card reader on your computer.**

3. **Go to** `www.canon.co.jp/Imaging/eosdigital/E3kr_firmware-e.html`.

4. **Download the firmware update procedure PDF file from the Web site.** Be sure to read the steps.

5. **Choose the operating system that you use, and then download the firmware.** The file is a self-extracting compressed file.

6. **Double-click the downloaded file to extract it.** Verify the contents and file size as described on the Web site.

 Caution

> *Once you begin installing the firmware, do not open the CF card slot door, turn off the camera, or press any buttons on the camera. Doing any of these actions may disable the camera.*

7. **Copy the** `E3kr111.fir` **file, to the formatted CF card.** The filename reflects the update version number, so your filename may be different from the one given here.

8. **Insert the CF card with the firmware into the camera.**

9. **Turn on the camera.** The Execute Upgrade dialog will appear.

10. **Press the Set button to select OK.** The Checking Firmware message is displayed, and then the Replace Firmware dialog is displayed.

11. **Press the Set button to select OK.** A Re-writing Firmware progress dialog is displayed. Updating firmware takes approximately four minutes. When complete, a Firmware Replaced Successfully message appears.

12. **Click the Set button to select OK.**

13. **Reformat the CF card before using it again.**

You can check that the firmware is updated by repeating the first procedure in this section.

You can also download new versions of Canon image-viewing and processing software from the Canon Web site. It's a good idea to check the site every month or so for new updates.

Appendixes

Resources

A wealth of valuable information is available for photographers. This section is a handy resource to help you discover some of the many ways to learn more about the Digital Rebel and about photography.

Photoworkshop.com

Photoworkshop.com (www.photoworkshop.com) is a respected Web site that covers all aspects of photography. It is Canon's educational site and the home of the Canon Digital Learning Center, which is a rich resource that includes free online tutorials on the Digital Rebel, photography contests, and the twice-monthly newsletter *Double-Exposure*.

You can find the Digital Rebel tutorial, written by Rick Sammon, professional photographer, at www.photoworkshop.com/canon/lessons/index.html.

You can preview Double Exposure at www.photoworkshop.com/double_exposure/publish/index.shtml

Canon's Web site

When you want to access the technical specifications for the camera or if you want to register your camera online, visit the Canon Web site.

You can visit the Canon Digital Rebel Web site at http://consumer.usa.canon.com/ir/controller?act=ModelDetailAct&fcategoryid=139&modelid=9430

To learn more about the EOS SLR systems, visit the Canon Advantage page at http://consumer.usa.canon.com/ir/controller?act=CanonAdvantageCatIndexAct&fcategoryid=111.

To download new firmware updates for the Canon Digital Rebel, see Chapter 7. On the Canon site, the Download Library includes an option to download the setup guide and camera manual in English, Spanish, French, or Chinese. You can visit the

Download Library at `http://consumer.usa.canon.com/ir/controller?act=DownloadDetailAct&fcategoryid=314&modelid=9430#New%20Window`.

When you want accessories for the Digital Rebel, the Canon Accessory Annex offers everything from AC adapters, battery grips, battery packs, and macro ring lights. You can find the Accessory Annex at `www.canoncompanystore.com/cgi-bin/annex.storefront`.

You can get information on Canon lenses at `http://consumer.usa.canon.com/ir/controller?act=ProductCatIndexAct&fcategoryid=111`.

Share Experiences with Others

Many Web sites devote space to public forums where Digital Rebel photographers share experiences. Other forums offer an exchange of general photography ideas, questions, and suggestions.

Here are some of the more popular Internet forums.

✦ **Rob Galbraith Professional Digital Photography Forums:** `www.robgalbraith.com/ubbthreads/postlist.php?Cat=&Board=UBB8`

✦ **Imaging Resource:** `www.photo-forums.com/WebX?13@20.uEYObQuetRD.0@.ee6f773`

✦ **ZugaPhoto:** `www.zuga.net/forums/forumdisplay.php?s=621b286cb14bb184ff8712b64a7ffc09&forumid=7`

✦ **Digital Photography Review (dpreview.com):** `forums.dpreview.com/forums/forum.asp?forum=1031`

✦ **Steve's Digicams:** `www.stevesforums.com/forums/view_forum.php?id=15`

✦ **Photo.net:** `www.photo.net/bboard/forum?topic_id=1545`

✦ **Popular Photography & Imaging:** `www.popularphotography.com/idealbb/forum.asp?forumID=12`

✦ **Bytephoto.com:** `www.bytephoto.com/forums/f11.html`

✦ **Photography on the Net:** `http://photography-on-the.net/forum/showthread.php?t=50175`

✦ **DC Views:** `www.dcviews.com/share.htm`

✦ **MSN Groups: Canon Digital Rebel (300D) Support Group:** `http://groups.msn.com/CanonDigitalRebel300DSupportGroup/messages.msnw`

✦ **PhotographyReview.com:** `http://forums.photographyreview.com/showthread.php?t=7783`

✦ **Photoworkshop.com**

✦ **The Digital Darkroom:** `www.digi-darkroom.com/forumdisplay.php?s=32307b993102984f9d61b93d15511527&f=60`

✦ **MakeItSimple.com:** `www.mis-forums.com/vbbs/`

Learn More About Photography

Some of the popular photography magazines also have Web sites that offer photography articles. Here are a few of the venerable photography magazines' Web sites.

- ✦ *Double Exposure*: www.photoworkshop.com/ double_exposure/publish/ index.shtml

- ✦ *Popular Photography & Imaging*. Online site: www. popularphotography.com/

- ✦ *Petersen's PHOTOgraphic*. Online site: www.photographic.com/

- ✦ *Shutterbug*. Online site: www.shutterbug.net/

- ✦ *Digital Image Café*: www. digitalimagecafe.com/ default.asp

- ✦ *PC Photo*. Online site: http:// pcphotomag.com/

- ✦ *Digital Photographer*. Online site: www.digiphotomag.com/

- ✦ *Outdoor Photographer*. Online site: www.outdoor photographer.com/

Share Your Pictures Online

Here are some of the sites where you can share pictures with other family, friends, and other photographers on the Internet.

- ✦ **Photoworkshop.com**: www. photoworkshop.com/

- ✦ **Yahoo! Photos**: http:// photos.yahoo.com

- ✦ **Picturetrail**: www. picturetrail.com/

- ✦ **ofoto**: www.ofoto.com/ Welcome.jsp

- ✦ **pixagogo**: www.pixagogo.com/

- ✦ **PhotoBox**: www.photobox. co.uk/

- ✦ **Club Photo**: www.clubphoto.com/

- ✦ **photofun.com**: www.photofun.com/

- ✦ **PBase.com**: www.pbase.com/

- ✦ **Card Fountain**: www. cardfountain.com/online-photo-album.php?aid=101632

- ✦ **AlbumTown**: www.albumtown.com/

- ✦ **Shutterfly**: www.shutterfly.com/learn/ online_photo_album.jsp

- ✦ **bytephoto.com**: www.bytephoto.com/ photopost/

- ✦ **MediaStreet**: www.mediastreet.com/cgi-bin/tame/mediastreet/ PhotoAccess.tam

- ✦ **MSN Groups**: http://groups.msn.com/

- ✦ **Webshots**: www.webshots.com/

Glossary of Terms

If you're confused by digital photography language, this list of commonly used terms should be helpful.

A-DEP (Automatic Depth of Field AE) The camera mode that automatically calculates sufficient depth of field for near and far subjects within the coverage of the 7 AF focusing points, such as when several people are sitting at various distances from the camera.

AE Automatic exposure.

AE lock Automatic exposure lock. A camera control that lets the photographer lock the exposure from a meter reading. Once the exposure is locked, the photographer can then recompose the image.

AF lock Autofocus lock. A camera control that locks the focus on a subject and allows the photographer to recompose the image without the focus changing. Usually activated by pressing the Shutter button halfway down.

Ambient light The natural or artificial light within a scene. Also called available light.

Angle of view The amount or area seen by a lens or viewfinder, measured in degrees. Shorter or wide-angle lenses and zoom settings have a greater angle of view. Longer or telephoto lenses and zoom settings have a narrower angle of view.

Aperture The lens opening through which light passes. Aperture size is adjusted by opening or closing the diaphragm. Aperture is expressed in f-numbers such as f/8, f/5.6 and so on.

Aperture priority (Av Aperture-Priority AE) A semiautomatic camera mode in which the photographer sets the aperture (f-stop), and the camera automatically sets the shutter speed for correct exposure.

Artificial light The light from an electric light or flash unit. The opposite of natural light.

Autofocus The camera automatically focuses on the subject using the selected autofocus point shown in the viewfinder, or tracks a subject in motion and creates a picture with the subject in sharp focus. Pressing the shutter button halfway down activates autofocus.

Automatic exposure The camera meters the light in the scene and automatically sets the shutter speed and aperture necessary to make a properly exposed picture.

Automatic flash When the camera determines that the existing light is too low to get either a good exposure or a sharp image, it automatically fires the built-in flash unit.

Av Abbreviation for Aperture Value that indicates f-stops. Also used to indicate Aperture-Priority mode.

Backlighting Light that is behind the subject.

Bit The smallest unit of information used by computers.

Bit depth The number of bits used to represent each pixel in an image. Bit depth determines the number of colors the image can display and tonal range.

Bounce light Light that is directed toward an object such as a wall or ceiling so that it reflects (or "bounces") light back onto the subject.

Buffer Temporary storage for data in a camera or computer.

Bulb A shutter speed setting that keeps the shutter open as long as the shutter button is fully depressed.

Burn A traditional darkroom technique for making an area of an image darker by giving it more exposure (or light). Image-editing programs have adapted the technique to achieve the same effect. Also called burning in.

Cloning In image-editing programs, the process of replacing part of an image by copying another area of the image over it. Often used to remove or add objects to a digital image, or to cover dust spots and other image imperfections.

CMOS An abbreviation for complementary metal-oxide semiconductor, the type of imaging sensor used in the Digital Rebel to record images. CMOS sensors are chips that use power more efficiently than other types of recording mediums.

Color balance The response by film, or by a digital camera's image sensor, to the colors in a scene. In a digital camera, color balance is achieved by setting the white balance to match the scene's primary light source.

Color cast The presence of one color in other colors of an image. A color cast appears as an incorrect overall color shift often caused by an incorrect white-balance setting.

Color space In the spectrum of colors, the subset of colors included in the chosen space. Different color spaces include more or fewer colors.

Color temperature The color of light measured in degrees Kelvin (K). Warm, late-day light has a lower temperature. Cool, early-day light has a higher temperature. Midday light is often considered to be "white" light (5000 degrees K). Flash units are often calibrated to 5000 degrees K.

Compositing The process of combining all or part of two or more digital images into a single image. Usually performed using an image-editing program.

Compression A means of reducing file size. Lossy compression permanently discards information in the original file. Lossless compression does not discard information in the original file.

Contrast The range of tones from light to dark in an image or scene.

Crop To trim or discard one or more edges of an image. Cropping can be done when taking a picture by changing position (moving closer or farther away) to exclude parts of a scene, by zooming in with a zoom lens, or it can be done in an image-editing program.

Depth of field The zone of acceptable sharpness in a photo extending in front of and behind the plane of focus.

Digital zoom A method of making a subject appear closer by cropping away the edges of the scene. Digital zoom reduces the overall file size. Some cameras then increase file size by estimating where to add similar pixels to bring file size back up to full resolution.

DPI An abbreviation for dots per inch. DPI is a measure of printing resolution.

Dye sublimation A photo printer that uses gaseous color dyes to create a continuous tone image that resembles a traditional photograph.

Exposure The amount of light reaching the light-sensitive medium — the film or an image sensor. It is the result of the intensity of light multiplied by the length of time the light strikes the medium.

Exposure compensation A camera control that allows the photographer to overexpose (plus setting) or underexpose (minus setting) images by a specified amount from the metered exposure.

Extension tube A hollow ring attached between the camera lens mount and the lens that increases the distance between the optical center of the lens and the sensor, and decreases the minimum focusing distance.

Fast Refers to film, digital camera settings, and photographic paper that has high sensitivity to light. Also refers to lenses that offer a very wide aperture, such as f/1.4, and to a short shutter speed.

File format The form in which digital images are stored, such as JPEG, TIFF, or RAW, and so on.

Filter A piece of glass or plastic that is usually attached to the front of the lens to alter the color, intensity, or quality of the light. Filters are used also to alter the rendition of tones, reduce haze and glare, and to create special effects such as soft focus and star effects.

Flat Describes a scene, light, photograph, or negative that displays little difference between dark and light tones.

F-number A number representing the maximum light gathering ability of a lens or the aperture setting at which a photo is taken.

It is calculated by dividing the focal length of the lens by its diameter. Wide apertures are designated with small numbers, such as f/2.8. Narrow apertures are designated with large numbers, such as f/22.

Focal length The distance from the lens to the focal plane when the lens is focused on infinity. The longer the focal length is, the greater is the magnification.

Focal point The point on a focused image where rays of light intersect after reflecting from a single point on a subject.

Focus The point at which light rays from the lens converge to form a sharp image. Also, the sharpest point in an image achieved by adjusting the distance between the lens and image.

Frame Used to indicate a single exposure or image. Also refers to the edges around the image.

Front light Light that comes from behind or beside the camera to strike the front of the subject.

F-stop See Aperture.

Gigabyte Slightly more than 1 billion bytes.

Grain A speckled appearance in photos. In film photographs, grain appears when the pattern of light-sensitive silver halide particles or dye molecules becomes visible under magnification or enlargement. In digital images, grain appears as multicolored flecks, also referred to as noise. Grain is most visible in high-speed film photos and in digital images captured at high ISO settings.

Grayscale A scale that shows the progression of tones from black to white using tones of gray. Also refers to rendering a digital image in black, white, and tones of gray.

Histogram A graph that shows the distribution of tones in an image.

Hot shoe A camera mount that accommodates a separate flash unit. Inside the mount are contacts that transmit information between the camera and the flash unit, and that trigger the flash when the shutter button is pressed.

Infinity The farthest position on the distance scale of a lens (approximately 50 feet and beyond).

ISO A rating that describes the sensitivity to light of film or an image sensor. Also commonly referred to as film speed. ISO is expressed in numbers, such as ISO 125. ISO rating doubles as the sensitivity to light doubles. ISO 200 is twice as sensitive to light as ISO 100.

JPEG Acronym for Joint Photographic Experts Group. A lossy file format that compresses data by discarding information from the original file.

LCD Acronym for liquid crystal display. Commonly used to describe the image screen on digital cameras.

Lossless A term that refers to file formats that discard no image data. TIFF is a lossless file format.

Lossy A term that refers to file formats that discard image data, often in the process of compressing image data to a smaller size. The higher the compression rate, the more data that's discarded, and the lower the image quality. JPEG is a lossy file format.

Manual (mode) A camera mode in which you set both the aperture and the shutter speed.

Megabyte Slightly more than 1 million bytes.

Megapixel One million pixels, sometimes referred to as picture elements.

Memory card In digital photography, removable media that stores digital images, such as the Compact Flash media used to store Digital Rebel images.

Middle gray A shade of gray that has 18 percent reflectance.

Midtone A tone with medium brightness or middle gray in an image.

Mode Dial The large dial on the top right of the camera that allows you to select shooting modes in the Basic and Creative Zones.

Noise The digital equivalent of grain in film. Noise appears as unwanted multicolor pixels especially in shadow and dark areas of images.

Normal lens or zoom setting A lens or zoom setting whose focal length is approximately the same as the diagonal measurement of the film or image sensor used. In 35mm format, a 50 to 60mm lens is considered to be a normal lens.

Open up To switch to a lower f-stop, which increases the size of the diaphragm opening.

Optical zoom Subject magnification that results from the lens.

Overexposure Exposing film or an image sensor to more light than is required to make an accurate exposure. The picture is too light.

Panning A technique of moving the camera to follow a moving subject, which keeps the subject sharp but creates a creative blur of background details.

Pixel Acronym for picture element. The smallest unit of information in a digital image. Pixels contain tone and color that can be modified. The human eye merges very small pixels so they appear as continuous tones.

Polarizing filter A filter that reduces glare from reflective surfaces such as glass or water at certain angles.

PPI Acronym for pixels per inch. The number of pixels per linear inch. Commonly used to describe the resolution of a computer monitor, digital camera, or digital image.

RAM Acronym for random access memory, the memory in a computer that temporarily stores information for rapid access.

RAW A proprietary file format that has little or no in-camera processing. Processing RAW files requires special image-conversion software such as Canon's Digital Photo Professional or Adobe Camera Raw. Because image data has not been processed, you can change key camera settings including exposure and white balance in the conversion program after the picture is taken.

Reflected light meter A device, usually a built-in camera meter, that measures light emitted by a photographic subject.

Reflector A surface, such as white cardboard, used to redirect light into shadow areas of a scene or subject.

Resampling A method of averaging surrounding pixels to add to the number of pixels in a digital image. Sometimes used to increase resolution of an image in an image-editing program to make a larger print from the image.

Resolution The number of pixels per side of a 1mm x 1mm square, or the number of pixels in a linear inch. Resolution is the amount of information present in an image to represent detail in a digital image.

RGB Acronym for red, green, and blue. A color model used to define the relative amounts of red, green, and blue components they contain.

Saturated As in saturated color. A strong, pure hue undiluted by the presences of white, black, or other colors.

Sharp The point in an image at which fine detail and textures are clear and well defined.

Shutter A mechanism that regulates the amount of time during which light is let into the camera to make an exposure. Shutter time or shutter speed is expressed in seconds and fractions of seconds such as 1/30 second.

Shutter priority (Tv Shutter-Priority AE) A semiautomatic camera mode allowing the photographer to set the shutter speed and the camera to automatically set the aperture (f-number) for correct exposure.

Side lighting Light that strikes the subject from the side.

Slow Refers to film, digital camera settings, and photographic paper that has low sensitivity to light, and, therefore requires relatively more light to achieve accurate exposure. Also refers to lenses that have a relatively small aperture, such as f/3.5 or f/5.6, and to a long shutter speed.

SLR Acronym for single lens reflex, a type of camera that enables the photographer to see the scene through the lens that takes the picture. A reflex mirror reflects the scene through the viewfinder. The mirror retracts when the Shutter button is pressed.

Speed Refers to the relative sensitivity to light of photographic materials such as film, digital camera sensors, and photo paper. Also refers to the ability of a lens to let in more light by opening the lens to a wider aperture.

Spot meter A device that measures reflected light or brightness from a small portion of a subject.

Stop See Aperture.

Stop down To switch to a higher f/stop thereby reducing the size of the diaphragm opening.

Telephoto A lens or zoom setting with a focal length longer than 50 to 60mm in 35mm format.

Telephoto effect The effect a telephoto lens creates that makes objects appear to be closer to the camera and to each other than they really are.

TIFF Acronym for Tagged Image File Format, a universal file format that can be read by most computers. Commonly used for images, TIFF supports 16.8 million colors and offers lossless compression to preserve all of the original file information.

Top lighting Light, such as sunlight at midday, that strikes a subject from above.

TTL Acronym for through the lens, a system that reads the light passing through a lens that will expose film or strike an image sensor. A TTL system is useful when using accessories such as filters, extension tubes, and teleconverters, which reduce the amount of light reaching the film or sensor.

Tungsten lighting Common household lighting that uses tungsten filaments. Without filtering or adjusting to the correct white-balance settings, pictures taken under tungsten light display a yellow-orange color cast.

Underexposure Exposing film or an image sensor to less light than required to make an accurate exposure. The picture is too dark.

Unsharp mask In digital image editing, a filter that increases the apparent sharpness of the image. The unsharp mask filter cannot correct an out-of-focus image.

View finder A viewing system that allows the photographer to see all or part of the scene that will be included in the final picture. Some viewfinders show the scene as the lens sees it. Others show approximately the area that will be captured in the image.

Vignetting Darkening of edges on an image that can be caused by lens distortion, using a filter, or using the wrong lens hood.

White balance The relative intensity of red, green, and blue in a light source. On a digital camera, white balance compensates for light that is different from daylight to create correct color balance.

Wide angle Describes a lens with a focal length shorter than 50 to 60mm in 35mm format.

Index

Continued